Art & Artists of the Middle Ages

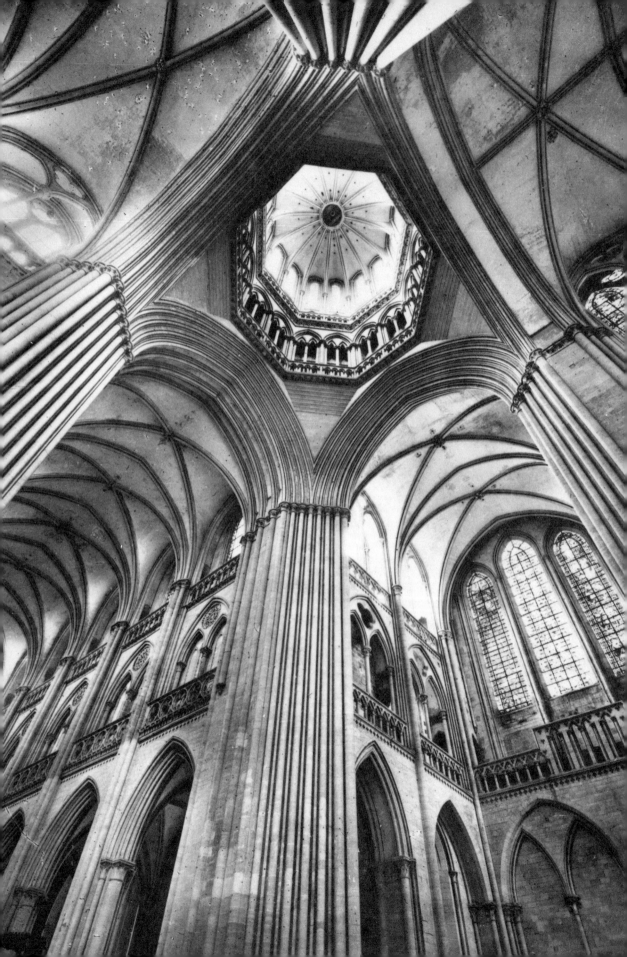

Emile Mâle

Art & Artists
of the
Middle Ages

translated by Sylvia Stallings Lowe

BLACK SWAN BOOKS

Acknowledgements to the following photographic archives: Alinari-Giraudon; Anderson-Giraudon; Archives photographiques; Bertrand; Bibliothèque Nationale; Jean Bottin; Le Boyer; Brera Museum; The Cloisters; Dieuzaide-Zodiaque; Flammarion; Fotomas; Franceschi-Zodiaque; Houvet; R. Josset; Mas; Musée de Cluny; The National Trust; Jean Roubier; Frankfurt Städelsches Kunstinstitut; Superintendent of Antiquities of Lombardy; Zodiaque.

*Published in co-operation with the Medieval Studies Program
at the University of Connecticut, and the French
Ministère de la Culture.*

First English translation

Published by

BLACK SWAN BOOKS Ltd.
P. O. Box 327
Redding Ridge, CT 06876
U.S.A.

ISBN 0-933806-06-X

French Medieval Art Series

Contents

Preface

WHEN, in the days of my youth, I wandered the length and breadth of France, I went from church to church without ever encountering an archaeologist, an artist, or even a traveller. A few women kneeling in the gloom near the altar lamp; an old priest teaching some children their catechism; the modest procession of a baptism—these were all that I habitually saw, whether in the most humble monuments or in the most famous. I spent hours admiring the statues on a portico or the windows of a nave, without anyone's ever appearing to share my admiration. I asked myself whether there was still someone in France who was moved by these splendors. I grieved to think that these churches, which spoke through their thousand images of stone and glass, were no longer listened to by anyone, and I promised myself, if I were able, to restore the renown of this magnificent art that I saw ignored. My joy was great the day at Chartres that a peasant from the Beauce, a descendant of those who harnessed themselves to wagons to fetch the stone for Notre-Dame, came to contemplate the statues on the west portal beside me. "I never come to Chartres," he said to me, "without admiring the cathedral." I had at last found a Frenchman who loved the art of France.

With youth's happy ignorance that is its strength—for it is because one knows little that one dares to attempt much—I greatly exaggerated the indifference of my contemporaries toward the monuments of the past. There were archaeologists in France at that time, and the art of the Middle Ages had its friends, even though I had not met them in churches. But how much more numerous those friends are today! The automobile has at last enabled Frenchmen to complete the conquest of France and to possess themselves of its treasures. Foreigners display as much enthusiasm as we ourselves; I have met Americans who will not take leave of any of France's provinces until they have seen all of its churches that are deserving of interest. Whether Frenchmen or foreigners, not all of these visitors are archaeologists, but more than one of them has returned from his travels with the wish to understand better what he has seen. For this reason, it has seemed to me that certain articles, several of which were originally written for scholars, might today be read by a wider public. Some of these are recent; some are from a much earlier date, which is not ordinarily a virtue in scholarly studies. But rest assured; they have all been gone over with care and revised when it was necessary, with the result that they all come before the reader as though newly composed.

1st edition, 1927; 4th edition revised and corrected, 1947

I THE STAGES OF CHRISTIAN ART

CHRISTIANITY, which from an early hour became the religion of the most cultivated of the Mediterranean races, welcomed art as a friend. It might seem that the Church could easily have dispensed with the help of line and color; the beauty which she brought to the world was of another sort. But she did not so judge; she saw in art an ally. Since man does not exist as spirit only, she considered that she might reach him through the senses as well as through the soul. Her great doctors, moreover, pointed out that beauty bears the divine imprint, the foreshadowing of a higher realm. To condemn art would have been to distort human nature, to smother one of its noblest instincts. Thus we see the Church through the ages warring against iconoclasm, supporting civilization's struggle against the constant resurgence of barbarism.

It is to the Church that we owe our art; this art which can for nearly fifteen hundred years be called Christian. During those long centuries, the art of Christianity was as fluid as life itself. One might have thought that having an immutable dogma to expound, the same supernatural legend to relate, it would have been subject to a premature rigidity; the contrary has proven itself to be true. Humanity, meditating on its faith, discovered new elements in it from one age to another. Art lent a voice to those shades of meaning, and sometimes expressed them with an astonishing accuracy. One of the beauties of Christian art, which possesses so many, is that it retraces the history of Christian thought. Not in every detail, to be sure, since art is not theology; nonetheless, the different ways of understanding or, better yet, experiencing Christianity which characterized successive generations are recaptured in Christian art. In the space of a few pages, it might not perhaps prove impossible to illustrate this.

I

THE VISITOR who wanders through the Catacombs, and glimpses in their shadows the half-obliterated paintings of the funerary chambers, is surprised to recognize the same subjects depicted over and over again. What appear, nearly always, before him are: the resurrection of Lazarus; the healing of the paralytic; the young Hebrews in the fiery furnace; Daniel in the pit of lions; Susannah among the elders; and Jonah thrown to the sea monster. Why were these scenes, which no common thread seems to unite, the ones chosen by the earliest Christian artists? For a long while we remained in ignorance, but today we know why.

From a very early time, a prayer was recited for the dead whose original phrasing was rediscovered a few years ago. It ran approximately thus: "Father," it was said, "deliver this soul as Thou didst deliver Jonah from the sea monster, the young Hebrews from the furnace, Daniel from the lions' pit, Susannah from the hands of the elders. . . ." Then, addressing the Son, it continued, "Thou also, Son of God, I beseech Thee who didst open the eyes of the blind, restore life to the

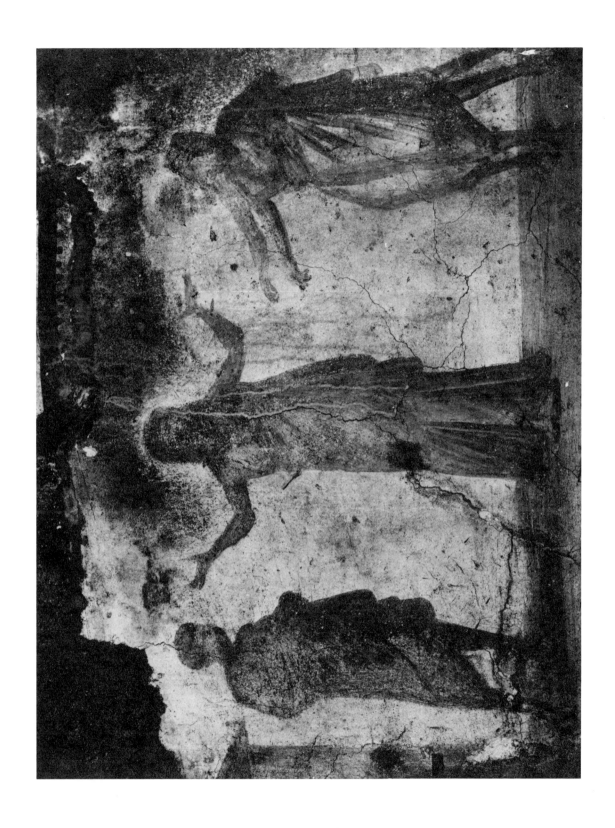

The story of Susannah. Fresco from the catacomb of Priscilla, Rome, 2nd century.

limbs of the paralytic, raise Lazarus. . . ."

Thus the funeral liturgy led to the uniformity in the art of the Catacombs. The paintings in the underground chambers were nearly always nothing else than the verses of a prayer for the dead. The earliest Christian art is therefore neither narrative nor symbolic; it is an intercession for the faithful who are buried in that darkness and who await the light. Nothing could be more moving. Those long-ago generations of Christians saw in Christianity the assurance of immortality. The miracles of both Testaments were for them a guarantee of Christ's promise, and the raising of Lazarus became the very affirmation of the Christian resurrection. So we sometimes find, near the dead, a small figure of Lazarus wrapped in a winding-sheet. The pagans, hesitating between the dreams of their poets and the systems of their philosophers, did not know what to make of death; they vacillated between the fear of annihilation and the hope of a shadowy after-life, and that uncertainty was for many the cruellest of sufferings. Pagan tombs were decorated with a funerary spirit who leaned, weeping, over an extinguished torch. In contrast, on the marble slab which covered the tomb of the Christian, an anchor was engraved, the symbol of his invincible hope. *Life*—that is the assurance that the paintings of the Catacombs express. That is the word which reveals itself everywhere by the flickering light of lanterns. It was at these depths, among these shadows, under the weight of this deep volcanic ash, heavy as the cover of a sepulcher, that man believed most fervently in life. A Christian of those early generations, who came to the cemetery of Callixtus to pray for a beloved wife, wrote in several places on the walls these touching words: "Gentle Sophronia, may you live in God." But as he draws nearer to the tomb of the martyrs, his hope becomes a certainty and he writes, "Sophronia, you shall live."

<div align="center">II</div>

THE PAINTINGS in the Catacombs are not the work of Roman artists, as has long been assumed, but of Greek ones. The graceful genius of Greece is recognizable in that representation of the Good Shepherd who is imagined as one of Theocritus' shepherds, or in that Orpheus who charms the beasts with his lyre—and who is the Christ.

After the Church's triumph, when the art of Christianity, emerging from the night of the tomb, began to proclaim the Gospel in the full light of day, it was still the Greeks who created the historic art of Christendom. That art had its birth not at Rome but in the great Hellenistic cities of the East: Alexandria, Antioch, Ephesus. Nowhere was Christian thought more fertile than in this Hellenized East, whence subsequently came Orthodox theology—as well as heresy. These Greek artists created an art in their own image, an art which retains for us an ingenuous charm, a delicate flavor of youth. It has in large part perished. We no longer possess the frescoes which decorated the churches of Alexandria or of Antioch, but the chiseled sarcophagi remain to us, the ivories, and a few ancient manuscripts decorated with miniatures. Scholars today give the name "Hellenistic" to this Christian art which springs from Greek roots.

Often these Greek artists make us think of the Church fathers of the fourth century, of St. Basil and St. Gregory of Nazianzus who came seeking enlightenment at Athens; who delighted in Homer and in Plato, and cried out in grief when Julian wished to tear these from them. The hearts of the Greek artists were Christian; their imaginations pagan. Nothing could be more charming than the figure of Christ which they created at this time: it is that of a beardless young man with long hair, almost an adolescent. He wears the Greek tunic with elegance and suggests a young Sophocles. It is a vision without historical authenticity, but which conforms to the secret desires of the heart. In this way, after they had read the Gospels, the Greeks visualized Christ: he was for them beauty, gentleness, and poetry.

Scenes from the Gospels, as these artists imagined them, astonish us at times by the particular details in which Greece reveals herself. The baptism of Christ comes as a surprise. St. John the Baptist, with his fawn-skin and his crooked staff, resembles not the last of the prophets but a shepherd from some eclogue. Submerged like Christ in the water, another figure lifts a head crowned with rushes: it is the river-god, the personification of the Jordan, and one seems to see Homer's Scamander. The Ascension is even more startling. Christ does not rise into heaven; He climbs the slopes of a mountain, as an immortal hero would make his way toward the summit of Olympus, while the hand of God emerges from the clouds and reaches out toward Him. There is scarcely a scene where the Hellenic imagination does not show itself. The episodes of the Passion display a serene nobility, for the Greek does not consent to the humiliation of his God. A soldier holds a garland over the head of a Christ who stands erect like a conqueror; this is the crown of thorns. It is not Christ who carries the Cross, but Simon of Cyrene. The Holy Women's visit to the sepulcher resembles an early-morning idyl: the tomb is a splendid monument with sculptured portals such as one sees in the outskirts of Alexandria; ivy clings to it, and a handsome young man, sitting on the stone, greets the three women, while birds sing among the branches. This happy union of the old world with the new holds an inexpressible charm for us; this is the marriage of Eudorus and Cymodocea.

At the instant when the Greeks were creating this primal Christian art, another art was appearing among the Syrian peoples in the East. It had its birth at Jerusalem and in Palestine.

We know that Constantine had imposing monuments constructed on the rediscovered site of Calvary. A magnificent rotunda enclosed the Holy Sepulcher; facing it rose up one of the most superb basilicas of Christendom, the Martyrium. Between the Holy Sepulcher and the Martyrium, at the very spot where the Cross had stood, arose a great golden crucifix set with precious stones. A vast portico enclosed this space, which became for Christians the most sacred spot on earth. Hardly were these monuments in Jerusalem completed before pilgrims flocked to them. Other basilicas arose at those places hallowed by the Gospels: on the Mount of Olives, on Mount Zion, at Bethlehem, at Nazareth, and on the banks of the Jordan. All of these churches were decorated with mosaics which made the events of the life of Jesus Christ live again on the very sites where they had taken place.

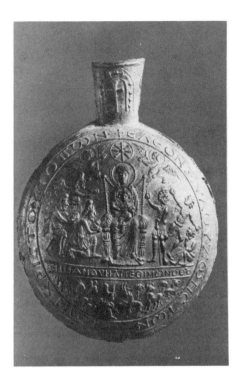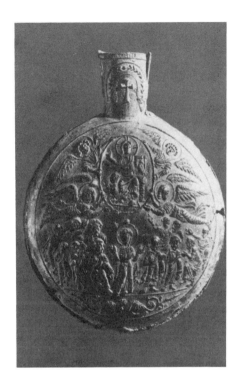

The Adoration of the Magi and the Ascension. Silver ampullae from Palestine, 6th century. Treasury of Monza cathedral.

These mosaics are long since destroyed, but we still have evidence of their existence. The silver *ampullae* that are preserved in the cathedral of Monza were made in the Holy Land in the sixth century. And the scenes that decorate them are copies of the mosaics from all the principal shrines of Palestine. Thus an art which is vastly different from Hellenistic art is disclosed to us. This Syrian art spread throughout the entire Eastern world; it was adopted by the monks, who left an even deeper imprint upon it. One encounters it in the desert, on the walls of Egyptian monasteries sinking into the sands, and one recognizes it in the chapels carved out of the rocky hill-sides of Cappadocia by the monks of St. Basil.

This Eastern art presents a vivid contrast to Hellenistic art; it testifies to a different spirit. The Gospel story—which the Greeks had situated in a sort of Arcadia—now took on a local character, a Syrian coloration. Christ was no longer a beardless adolescent but a Hebrew of the House of David, with glossy hair and a black beard. The Virgin has hidden her hair under the long veil of the young girls of Nazareth, the *maphorion*. In several scenes, there were exact details borrowed from the topography of Palestine and its monuments. The Nativity no longer had for its setting the simple rustic shelter beneath which Greek artists placed the cradle; the Syrians showed the Child's birth in the crypt beneath the church at

Bethlehem which was exhibited to pilgrims. The Holy Women, bearing their perfumes, no longer made their way toward an Alexandrian tomb but toward a sort of baldaquin enclosed within a screen—identical to the structure which enclosed the Holy Sepulcher at the center of Constantine's rotunda.

The art of Palestine was thus infinitely more faithful to reality than was Hellenistic art; while less exalted, it was more accurate.

There thus existed in the sixth century two representations of the Gospels, in which the two great peoples of the Christian East, Greek and Syrian, exhibited their genius. That dual representation can be recaptured today almost in its entirety. No two scenes are identical and nothing would be more interesting than to make a detailed study of these interpretations, which differ so greatly. One example will serve here. The Ascension as the Greeks imagined it resembles, as we have said, a hero's entry into Olympus. It was impossible to take greater liberties with the text of the scriptures. The art of Palestine, on the other hand, interprets the account given in the Acts to the letter: Jesus, surrounded by an aureole, rises majestically, while two angels address the apostles who look upon their master for the last time. More literal, the art of Syria was at the same time less intellectual; it was moved by the sufferings of Christ and dared to illustrate His Passion. One of these two interpretations of the Gospels thus represented the ideal, while the other, the real.

Although perfectly distinct, Hellenistic art and Syrian art nevertheless occasionally came together. There were works from the earliest times that drew upon both interpretations. What we call Byzantine art is nothing else than the harmonious union of these two great artistic traditions. At Byzantium, the Greek spirit was at all times dominant; it purified and uplifted the art of the Syrian East and subjected it to a new beginning.

Hellenistic art and Syrian art had an extraordinary destiny: they set their stamp upon the West for centuries. The artists of the Carolingian period borrowed sometimes from one and sometimes from the other. Even in the twelfth century it is easy to distinguish the two traditions. Our Middle Ages were nourished by the great works of the East; they never renounced these entirely but modified them through subtle adaptation, and the time arrived when they themselves became originators.

III

THE REVIVAL of sculpture at the beginning of the twelfth century is one of the great events of human history. It has frequently been said that the triumph of Christianity precipitated the decline of sculpture; that the Church, after her victory, immediately declared war on statues, which she regarded as idols. The facts do not bear out those claims. Christian statues have been discovered which go back to the first centuries and we know that Christian sarcophagi adorned with bas-reliefs are to be found everywhere in our museums. The true cause of the disappearance of sculpture is due not to the hostility of the Church, but to the arrival of a new art.

Indeed, the sixth century saw the conclusive victory of the decorative genius of the East over the plastic genius of Greece. Persia, whose magnificence fascinated the Byzantine emperors, imposed her taste upon the Christian world. It was for this reason that sculpture was displaced by mosaic, by colored inlay, by facings of marble. In this totally Eastern concept of design, there was no longer a place for statuary, and relief work henceforth disappeared from the basilicas of Christendom, which came to be embellished, like the palaces of Persia, with color alone. Thus it was that the great tide from the East which swept over the world carried away sculpture, whose secret appeared to be lost for more than five hundred years.

So far was the Church from condemning sculpture that it was she who brought about its revival. The honor of that rebirth belongs to southern France. Opinion [as to where exactly] has been divided between Burgundy and the South-West, but the most recent studies decide in favor of Toulouse. It does not appear that any body of work exists which antedates the capitals in the cloister of La Daurade at Toulouse: these were carved between 1060 and 1070 A.D. The capitals and the bas-reliefs of the magnificent cloister at Moissac, completed in 1100, are somewhat later. The monks of France thus began anew the work of Greece. Moissac and La Daurade were both Cluniac priories. Let us salute here the genius of Cluny, so generous and so human, which we can never admire enough. Within a few years, one witnesses the spread of sculpture throughout the Midi, its arrival in Burgundy, and finally in the Ile-de-France.

The monks of Cluny, who carried sculpture along with them to as far as Spain, saw in it the strongest ally of their Faith. Their sculptured *tympana* spoke thenceforth with as much eloquence as their doctors. What message did they write across the façade of their churches? A profound one that could leave no man unmoved: the concept of Judgement. The God of the Apocalypse, seated in majesty between the four beasts and the twenty-four elders, appears at the end of time, ready to pronounce sentence. The pilgrim who journeyed from church to church met with this powerful image again and again. Bas-reliefs often underlined the message: in the porch at Moissac, near the God of Judgement, the sculptor has told the story of the wicked rich man. The poverty-stricken Lazarus is lying before the door of the hall where the rich man and his wife are feasting: only the dogs take pity on him and come to lick his sores. But, when Lazarus dies, angels bear his soul away, while the devil is at the bedside of the rich man stretched upon his funeral bier. It was beneath this bas-relief that beggars came to sit within the church porch: poverty there assumed a dignity of its own. Everywhere the sculptor speaks to man of his duties and obliges him to think of his judge. Over the portals of the churches of Poitou and Saintonge, the struggle between the vices and the virtues is like a reflection of human existence. The parable of the wise and the foolish virgins, which nearly always accompanies this psychodrama, marks the climax of the action: to those who have fought valiantly, those who have not allowed the flame of the lamp to go out, Christ, from the apex of the archivolt, holds out a crown. On a few grand, resplendent portals, at

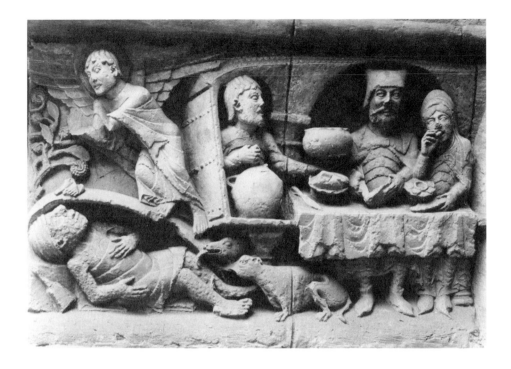

Lazarus and the evil rich man. Detail from the tympanum of Saint-Pierre de Moissac (Tarn-et-Garonne), 12th century.

Conques and at Autun, the idea of judgement finds its most perfect expression. One sees the archangel hold in his hand the mighty scales where good and evil are weighed. Can any scene more agonizing be imagined? How could the spectator avoid being caught up in the anguish of those souls who waited with trembling for the moment when the balance would begin to tip?

Such was the first great lesson that sculpture taught: it went straight to the point.

Not over the portals, but on the capitals, the newly-born sculpture told the story of the Gospels. But next to the life of Christ, one saw the lives of the saints begin to appear, an innovation which is easily understandable. Never before had

the saints played so large a part in Christian belief. The most precious treasures of the twelfth century were the relics of some ancient bishop or monk. In a period when there was nothing to be expected from human knowledge, one asked everything of these mediators between God and man, who had themselves experienced human suffering and must therefore be all the more compassionate. The mother brought her sick child before their reliquary; the husband came to pray for his dying wife. Calvin made a mockery of these relics of the Middle Ages—which was easy to do—but how could he not be touched by so much faith? Thousands upon thousands of men marched months-long, beneath the rain and under the sun, in order to kneel for a moment beside the tomb of a saint. The twelfth century was the heroic age of pilgrimage. We know today that the roads to Rome and to St. James of Compostela were the highways of civilization. An Italian sculptor of the twelfth century has pictured pilgrims accompanied by an angel on the façade of the cathedral of Borgo San Donnino; he might also have placed beside them two celestial figures: poetry and art. Our epic poems were born on the pilgrims' roads and our epic heroes can still be seen today, in France and in Italy, on more than one church along the way: Arthur and the knights of the Round Table decorate one of the portals of Modena cathedral. It was along these highways that French sculpture spread into Spain and Italy. Architecture itself seems to have journeyed with the pilgrims. They found splendid churches constructed after the same model at all their principal halting-places: Sainte-Croix at Orléans, Saint-Martin at Tours, Saint-Martial at Limoges, Conques, Figeac, and Saint-Sernin at Toulouse; and a church like these welcomed them at Compostela, at the end of the journey. Such were the splendid milestones along the road to St. James.

IV

THE THIRTEENTH CENTURY carried those artistic themes that the twelfth century had initiated to their point of perfection; at the same time, it gave them an incomparable majesty. Christian thought (which came to full awareness of itself at the young University of Paris) sought to encompass everything and to give order to whole. Art wondrously expressed that order which the great doctors established over the world of the spirit. The thousand figures on French cathedrals came to take their places in the four great divisions of the *Speculum Majus* (the *Universal Mirror*) within which Vincent of Beauvais had encompassed the world: the *Mirror of Nature*, the *Mirror of Science*, the *Mirror of Morality*, and the *Mirror of History*.

The *Mirror of Nature* of Vincent of Beauvais calls on us to admire the infinite richness of creation. Just so, the cathedral as well seems to wish to gather all living things together, the vegetable kingdom as well as the animal. The plants that unfurl about the capitals have a most touching beauty, for it is the most humble among them—those which we ignore, which we trample underfoot—that are given the place of honor and seem the fairest: the clover, the plantain, the poppy. The artist gives us a splendid lesson; he teaches that beauty exists everywhere but that she reveals herself only to the deepest reaches of our understanding.

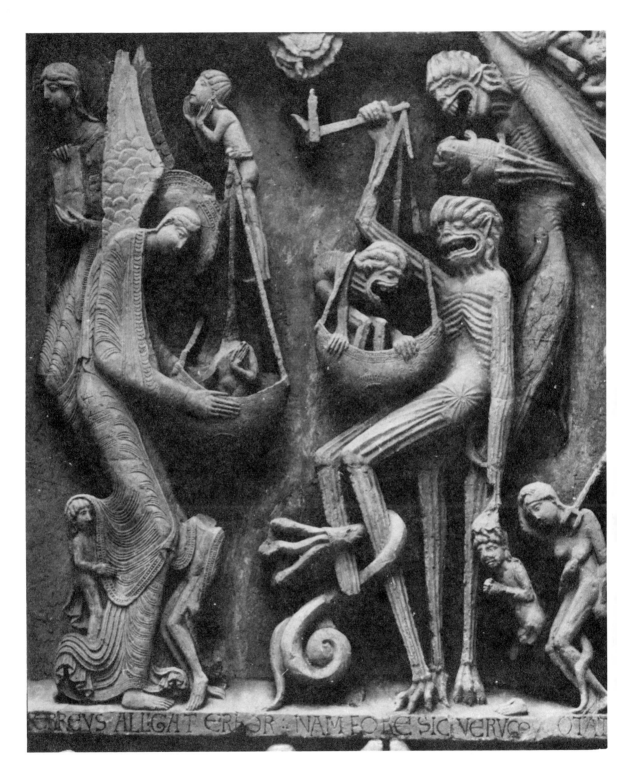

The Weighing of Souls. Detail from the tympanum of Autun cathedral (Saône-et-Loire), 12th century.

The *Mirror of Science* glorifies both work and thought with equal emphasis. The cathedral, like Vincent of Beauvais, acclaims knowledge but makes, as he does, a place for the labor of the peasant. We see him, like one of the peasants out of Homer, reaping, harvesting, dancing in the wine vats, casting the seed in the furrow, fattening swine beneath the oak trees when the strong winds of autumn begin to blow. Over each one of these scenes hovers the mysteriously ancient symbol of a constellation, which sets above the earth the starry sky. One seems to breathe in all the perfume of the France of long ago. But here, higher yet, are seven figures of women who resemble seven muses: these majestic queens live in the stately world of ideas. They personify the three sciences of the *trivium:* grammar, rhetoric, and dialectic, and the four sciences of the *quadrivium:* arithmetic, geometry, astronomy, and music. At times philosophy, a sceptre in her hand, her brow in the clouds, accompanies them. These eight figures sum up the whole of human knowledge. Thus the Church glorifies science, but she does not look down on any form of labor, even the humblest. Knowledge and labor have the same character of sanctity in her eyes, for, as Vincent of Beauvais declares, by work and by understanding man begins the task of his redemption.

But virtue is far above knowledge: this is what the *Mirror of Morality* teaches us, and it is this that the cathedral proclaims in its representations of the Virtues. We no longer see them, as in the twelfth century, battling against the Vices: such agitation does not become these serene figures. With a much deeper understanding of what is essential to virtue, the artist has shown them in repose: thus he instructs us that their presence in the soul causes peace to reign there. In contrast, the Vices which take their stand against each of the Virtues are pictured for us in action, and scenes of violence illustrate the disorder that they bring with them. Thus art gently directs us toward those pure images of the Virtues and makes us love them for their celestial calm.

After showing us man in the abstract, the cathedral, like Vincent of Beauvais, makes us see humanity upon its way; this is the *Mirror of History*. The cathedral recounts history to us as the Middle Ages recounted it; she sees there only the Christ, she seeks nothing there but the Christ. The Redeemer divides the passage of the centuries in half, and He is everywhere present. That which creates the grandeur of the Old Testament, the early history of man, is the messianic: in every line, the Bible speaks to us of the Savior. Symbolic everywhere, it is this symbolism that the artists, faithful interpreters of the theologians, set themselves to express. They love to place a scene from the Old Testament parallel to one from the New, to illustrate the harmonies of Providence. Near Christ bearing His cross, they show Isaac carrying the wood for the sacrifice; near the standing cross, they show Moses raising up the brazen serpent in the desert. Those figures from the Old Testament whom the sculptors place on the cathedral portal are also representations of the Christ. Nothing is more impressive than the Biblical statues which greet the visitor on the north portico of Chartres cathedral. Melchisedek, Abraham, Moses, Samuel, David, Isaiah, Jeremiah, Simeon, St. John the Baptist, St. Peter follow one upon the other like the centuries, and relate the history of the

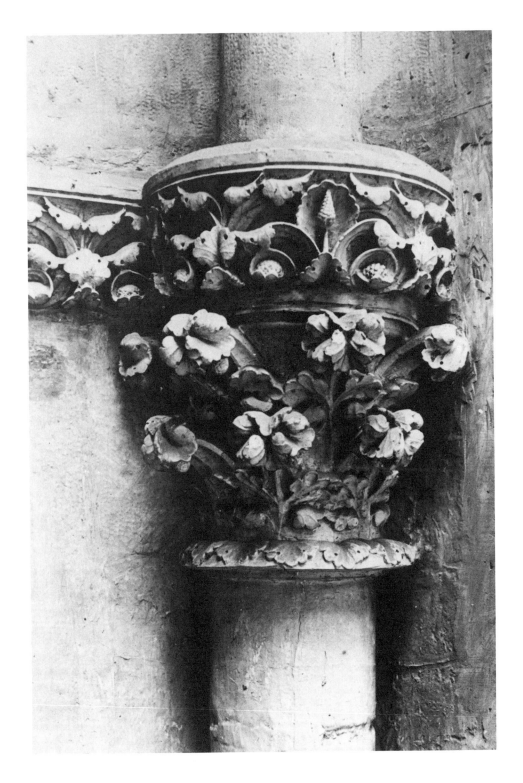

The Mirror of Nature: capital with foliage in Rheims cathedral (Marne), 13th century.

world. But at the same time each of them heralds the Christ; each of them holds in his hand a mysterious symbol which announces the Christ. The chalice carried by Melchisedek reappears, when time has come full circle, in the hand of St. Peter.

The life of Christ is the culmination of history, but these artists do not show it in its entirety; they give preference to scenes of His childhood and His passion. One recognizes in this the strict discipline of the Church, which has prescribed everything that has to do with the cathedral. Determining the essential in the New Testament, she did not wish to place before the eyes of the faithful any but the climactic moments of the liturgical year, those passages from the Gospels upon which she meditates continuously at the seasons of Christmas and Easter.

Following Christ, the history of the world is the history of the saints. They are themselves images of Christ, whom they no longer announce, as the patriarchs and the prophets did once upon a time, but whom they strive to make live anew. The apostles, the martyrs, the teachers, the saintly bishops and the saint-like monks, the sainted kings and the saintly beggars—for sainthood exists in every walk of life—make up a chain unbroken across the centuries. Their statues stand in the cathedral porch; their legends fill its windows. Popular piety multiplies their images, for in them the faithful see friends who can be approached without fear. It is the common people—the masons, the stone-cutters, the shoemakers— who gave to the cathedrals of France the greatest number of those windows dedicated to the saints; therefore popular legend plays as great a role there as history. The Virgin occupies the highest place in this company. The twelfth century had already sculpted her image, but it was an image wholly regal; the thirteenth added to it beauty, loving-kindness, and a radiant purity. The coronation of the Virgin that adorns the cathedrals of France gives her a place apart from all other created beings.

Thus an idealized history of humanity unfolds—a splendid history which is concerned solely with perfection. When time has at last come full circle, the trumpet sounds and Christ appears to judge men. There is no cathedral that does not confront us with the Last Judgement. This is the final act in the great drama of history; the cycle is henceforth complete. Issuing from God, mankind returns to Him and rests in His bosom.

Never has art summed up the thought of an age with such magnificence. The cathedral was the open book in which the people could learn all that it was necessary for them to know. We are in the age of certainty here; for that reason art, which always reflects our innermost being, is all serenity. Every violent emotion has been put away from it; what one reads on the faces of the statues is neither suffering nor anguish nor the uncertainty of the infinite, but a profound peace, the strength of repose, love without words. Death itself is seen as an all-conquering beauty, like a diadem. Stretched upon their tombs, the dead are shown in all the grace of youth and, instead of closing their eyes, open them upon a light which we do not yet perceive.

The spectacle of these cathedrals, with their thousand images arising at the same moment in the great cities of France, is one of the wonders of history. Today

The Mirror of Science: Grammar, Geometry, Astronomy, and Philosophy. Central doorway of Notre-Dame of Paris, bas-reliefs from the base of the trumeau.

The Mirror of Morality: Justice and Injustice, Hope and Despair, Gentleness and Harshness, Humility and Pride. Central doorway of Notre-Dame of Paris, bas-reliefs in the embrasure.

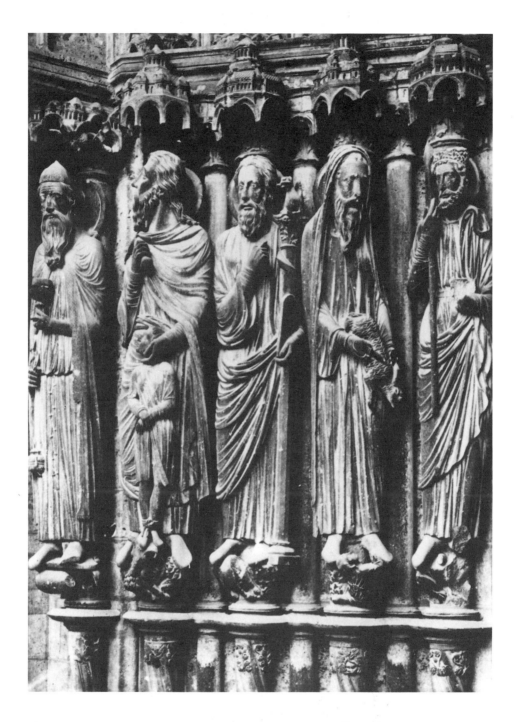

The Mirror of History. From left to right: Melchisidek, Abraham, Moses, Samuel, and David. North portal of Chartres cathedral (Eure-et-Loir), left embrasure of the the central bay, 13th century.

we can scarcely comprehend it, so different are we from our forefathers. We excavate harbors and canals, we build factories; our ancestors believed that nothing could be more urgent than to raise up on the earth an image of heaven. Unorthodox economists, they sank all the wealth of their day in works that could enrich no one. But did they not know, those idealists, how to recognize true riches? The man who enters the cathedrals of France and feels himself surrounded by strength, by purity, by prayerful silence, recognizes that they were not mistaken, and that they bequeathed to France her greatest treasure.

<div align="center">V</div>

IN THE THIRTEENTH CENTURY, art addresses itself to the intelligence; in the fourteenth and fifteenth, it speaks to the feelings. From the late thirteenth century onward, one detects in Italian painting something tender and melancholy that surprises us. What thrilled Cimabue, Giotto, and the School of Siena? We know today that this tide of emotion came from the East. Italian painting took itself, in the thirteenth century, to the school of Eastern art; but Christian art in the Near East at that time was characterized by a sentimentality that was missing from the art of the West. Little by little, Syrian realism, which did not draw back from the sufferings of the Passion, had triumphed over Hellenic calm. Eastern art had already for a long while lent poignancy to the scenes of the Passion. At the moment of the Descent from the Cross, the Virgin caught up the nail-pierced hand of Jesus and carried it to her lips. Later, when the body was laid out upon the stone, she threw herself upon it to enfold her Son for a last time in her arms, to hold her cheek against His; the Holy Women wrung their hands at the sight in desolation and the angels lamented in heaven. The painters of Italy copied these moving scenes, which surprise us when we see them appear wholly unannounced in Western art.

But before this Eastern tenderness could bring something of greatness to birth in Italy, it had first to be understood. St. Francis of Assisi had, however, made men's souls ready. Superb poet, he disclosed that the essence of all living creatures is love. It seemed as if, before him, the Italians had never looked at the world. It also seemed as if they had never read the Gospels. St. Francis himself seems always to be reading them for the first time, and he experiences the sufferings of the Passion so deeply that he bears their scars.

It can be said that Francis of Assisi actually transformed the Christian temperament, for after him his innumerable disciples, the Franciscans, brought about the triumph of feeling in the world. No other book except the Gospels has had a more profound influence on art than the famous *Meditations on the Life of Jesus Christ*, written in the thirteenth century by an unknown Franciscan. The author is a true disciple of St. Francis, who enriches the Gospels with all of his sensitivity. He imagines for himself the angel kneeling before the Virgin at the moment of the Annunciation; he sees St. Joseph preparing the shed for the Nativity, making it comfortable; he sees the wise men kissing the foot of the Child;

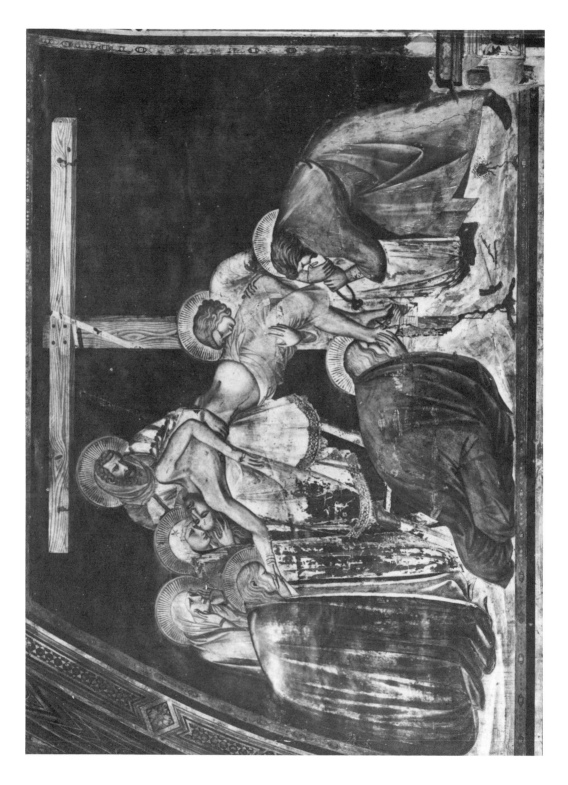

Pietro Lorenzetti, The Descent from the Cross, 14th century. Fresco from the lower church of St. Francis of Assisi.

he is aware of the Virgin in the crowd watching as her Son, burdened with the weight of the Cross, makes his way toward Calvary. All these gestures, and a host of others, appear again and again, first in Italian and then in French art. The *Meditations* entered deeply into popular imagination, for the theater took them over. In the mystery plays there is scarcely any scene from the Gospels where one does not recognize an episode, a detail, an attitude, a setting borrowed from the *Meditations*. For its part, the theater thus served to fix these new scenes in the artists' awareness; it gave them, as it were, a liturgical character. And thus Franciscan sensitivity stimulated poetry and art alike.

These, then, are the reasons which explain why an art of such intellectual distinction, in the thirteenth century, was replaced in the fourteenth by a new art fraught with human feeling. A warm breeze began to blow which thawed men's souls. This emotional Christianity is marvellously expressed in art; tenderness brings to the figures of Virgin and Child an unfamiliar charm. In the thirteenth century, the Virgin bore her Son with deference and gravely offered Him for the adoration of men without so much as turning her eyes upon Him; now, mother and Child exchange a smile. The childhood of the Son of God resembles the childhood of men: He plays with a bird, pats His mother's chin, drinks thirstily from her breast, falls asleep against her shoulder. The painters expend on this divine pair, bathed in the light of springtime, all the tenderness which Christianity has at its heart. They sought to prolong those years of happiness, but now and again one of them thinks with anguish of the future. In the splendid painting by the Master of Flémalle in the Frankfurt museum, the Child, suddenly alarmed, clutches at the breast of His mother while the Virgin sadly bows her head.

For suffering is the great source of inspiration in this age. The art of the thirteenth century, which upholds the soul in the serene latitudes of thought, had recoiled from the sufferings of the Passion; in the fourteenth and fifteenth centuries, these are the normal themes of art. Thus we witness the appearance of the most heart-rending pair that has ever been imagined; it is still that of mother and Son, but this time the mother is holding her dead Son upon her knees. Art attempted something even yet more daunting. It sought to express the greatest spiritual anguish imaginable, that of the Christ whom all have abandoned, waiting for death on Calvary, while the executioners prepare His Cross. This is the significance of that poignant figure of the seated Christ that one often finds in French churches: exhausted, almost naked, His hands bound, He retains in His eyes a pained astonishment at man's cruelty. At no other time did art descend so deeply into suffering. More than once the bounds of art were exceeded; in the fifteenth century, we see Christ's blood streaming from the Cross and filling a great basin where humanity comes to cleanse itself.

Thus while the thirteenth century had expressed the divine aspect of Christianity, the fourteenth and fifteenth spoke above all of its human side. Taking as their example the Franciscans and the mystics of their school, the artists brought God and man closer together. It was Christ's humanity which touched the mystics, which wrung tears from them; it was this same humanity which, in

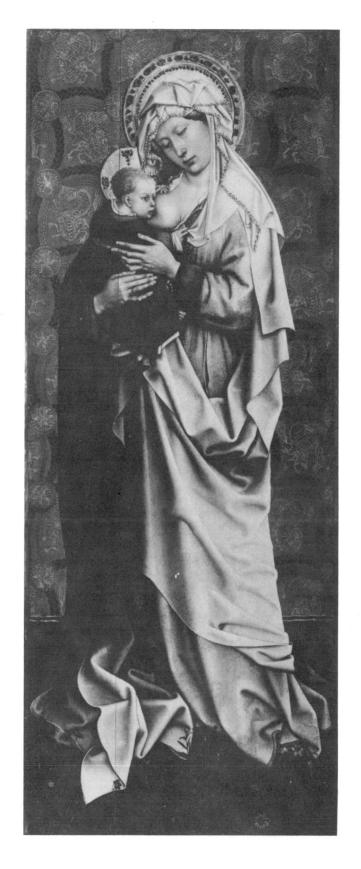

The Master of Flémalle, Virgin and Child. Panel of the retable said to be "by Flémalle," 15th century. Frankfort-on-Main, Städelsches Kunstinstitut.

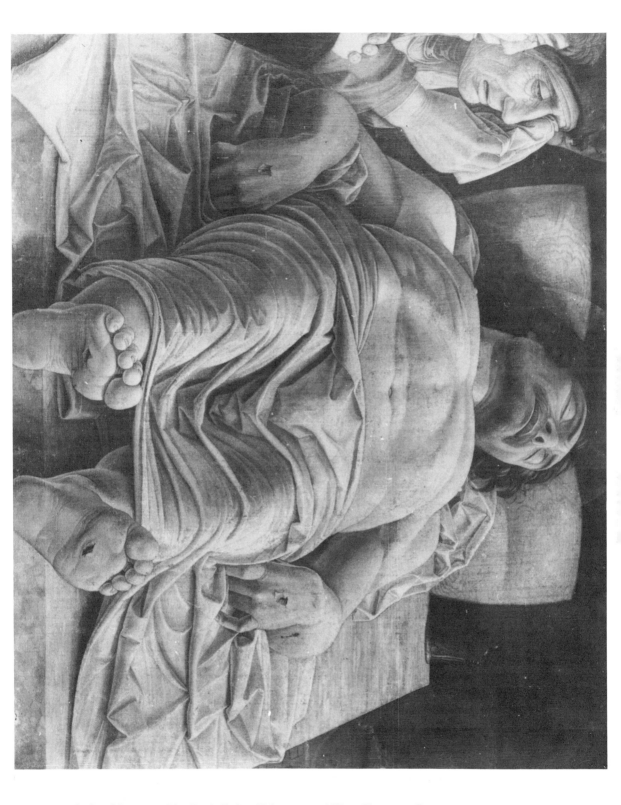

Andrea Mantegna, The Dead Christ, 15th century. Milan, Pinacoteca Brera.

the art of that age, disturbed men's hearts. The Christian of the fifteenth century, gazing upon his stricken God, covered with bloody sweat, said to himself, "He was like one of us."

VI

IN THE FIFTEENTH CENTURY, this moving art, whose characteristics we have just sketched, is the art of the North, the art of those lands where the veiled sky turns the soul back upon herself, making her seek her light within. It is the art of the French sculptors and the Flemish painters who preferred moral expressiveness before beauty—an art of restrained tenderness, of gentleness, of humility, of resignation, in profound harmony with the spirit of the *De Imitatione Christi*.

But what are we to make of the Italian art of the Renaissance? Does it still deserve the name of Christian? Is it not wholly taken up with earthly things? Has it any other love except the love of nature?

The history of *Quattrocento* art is a splendid and heroic one. It is made up of a series of conquests. The first of these was the conquest of perspective, which intoxicated the early Florentine painters and remained a passion for Mantegna. Next came that of the human body, scrupulously studied with regard to its skeleton, its tendons, its muscles, and its proportions. Then came the conquest of shadow and light, and above all, *chiaroscuro* which gave a quality of magic to the work of Leonardo. Italian art developed with the majesty of a science, and it built itself up, like a science, by observation and by reason. Such an art appears remote from religious feeling; none, however, is closer. The seductiveness of fifteenth-century Italian art, that which gives it its perpetual charm, lies in the artist's astonishment before the beauty that he discovers in the world. He is all sympathy, all admiration, all respect, before the divine handiwork. The Church did not err in judging this art to be religious and in bringing it inside the sanctuary. Even pagan art remains imbued with the spirit of Christianity. Botticelli's Venus herself leads the imagination toward the Creator God of Genesis, for how is one to believe that these outlines, supple as those of a Greek vase, could be the work of blind chance? How can we not distinguish the fingerprints of the great artist on that exquisite clay? This modest Venus is a Christian; her regard has that sadness which has been before our eyes since the catacombs.

Nothing could be more touching than to witness the Italian painters of the fifteenth century paying the homage of their new-born science to the Virgin who carries the Child in her arms. They seat her beneath a portico whose lines diverge in an irreproachable perspective; they set an antique bas-relief beneath her feet, suspend a garland of fruits and flowers above her head. The offering has some-times a childish appeal: a lemon among its leaves, a branch of coral, a cluster of cherries. The beauty that the painters pursue here with such zeal is an additional homage; they pour it like a perfume over the head of the Virgin, of the Child, of the saints of both sexes.

It is nevertheless true that this charming art does not express the whole of

Christianity. It loves the serenity that brings peace into the soul, but it has no feeling for suffering or death. Florentine art did not portray the Virgin of the Sorrows, nor Christ brought down from the Cross, except during those years when the artists became disciples of Savonarola; but they soon reverted to their true nature. One recognizes that such art could become overly humanistic but, in the fifteenth century, it still retains the Christian imprint.

When the art of the fifteenth century had achieved its conquests, Raphael appeared, the inheritor of all the knowledge of the past, but in addition the recipient of the divine gift of genius. Nothing is more religious than his art. Why has Raphael so often been called the greatest of all painters, when so many others surpass him in their understanding of color? It is because he offers us the vision of humanity at its highest. In Raphael's work, man has not been cast aside; one senses the presence of God everywhere. The noble beings whom he places before us have the mark of their exalted destiny upon their brows. By their divine purity, his Virgins seem to prove the existence of God. Whence could these angelic beings spring, before whom we hold our breath as before a cloudless mirror, were their origin not a heavenly one? Virtue itself emanates from his chaste figures.

From Raphael the Church demanded one of the greatest glorifications of Christianity that has ever been conceived. In the Vatican's Stanza della Segnatura, he harmoniously brings together Parnassus, the School of Athens, and the Debate on the Blessed Sacrament: the old world and the new. Through him, Christianity became the inheritor of all the wisdom and beauty of antiquity. Christianity, he seems to tell us, did not come to destroy, but to fulfill. The beauties of Homer, of Pindar, and of Virgil belong to the Christian; the sublime anticipations of Plato, the profound thought of Aristotle, are his; but Christianity lifts itself higher. Ancient philosophy explained the world by way of the intelligence, an interpretation that was accurate but incomplete, for above intelligence Christianity sets love.

Such is the meaning of that great work, of which Raphael was doubtless not consciously aware, but which he grasped in all its implications. Never has a great idea been clothed in a more fitting form.

As for Michelangelo, his superhuman heroes—who seem to be the sons of Deucalion rather than the sons of Adam—should not mislead us as to his real thought. He was a Christian. The ceiling of the Sistine Chapel is executed like a medieval church window: he shows us the Creation, the Fall, and the expectation of the Redemption. The brazen serpent, David's victory, Judith's devotion, are figures in whom we can read in anticipation the history of Christ. It is Christ of whom the sibyls and the prophets foretell; it is He who will be born, when time has accomplished its revolution, to that mysterious family, hidden beneath the feet of the prophets; that eternally renewed couple that is the elected one. There is nothing here that does not conform to the oldest traditions of Christianity.

Christians both, Raphael and Michelangelo participated wholeheartedly in the spirit of the Renaissance; they succumbed to the heroism of antiquity and felt an overmastering antipathy for the representation of suffering, even the suffering

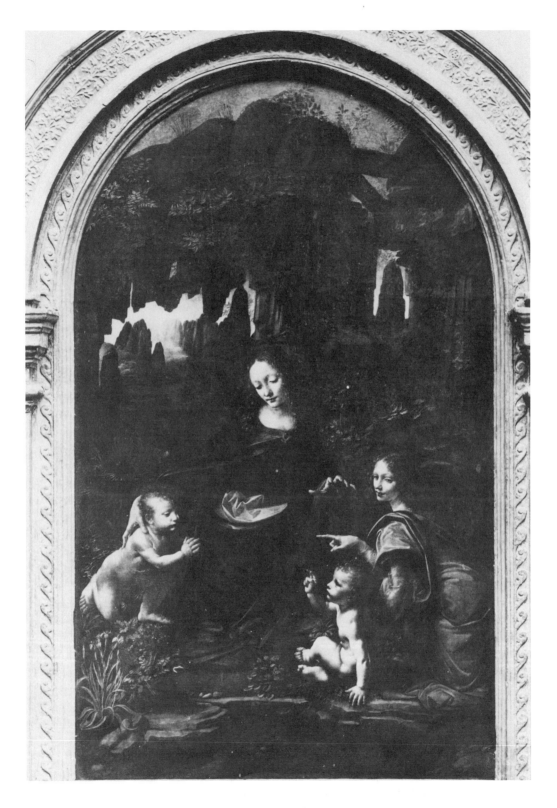

Leonardo da Vinci, The Virgin of the Rocks. Paris, Louvre Museum.

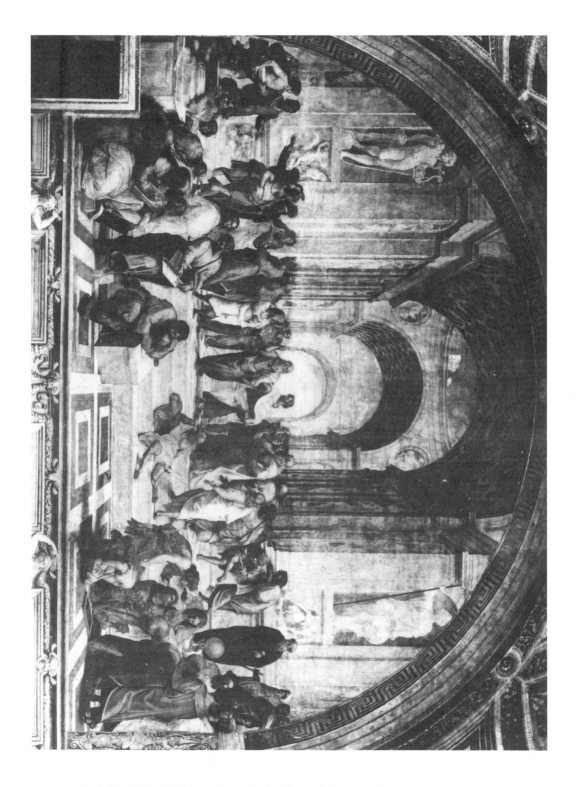

Raphael, The School of Athens, fresco in the Vatican's Stanza della Segnatura.

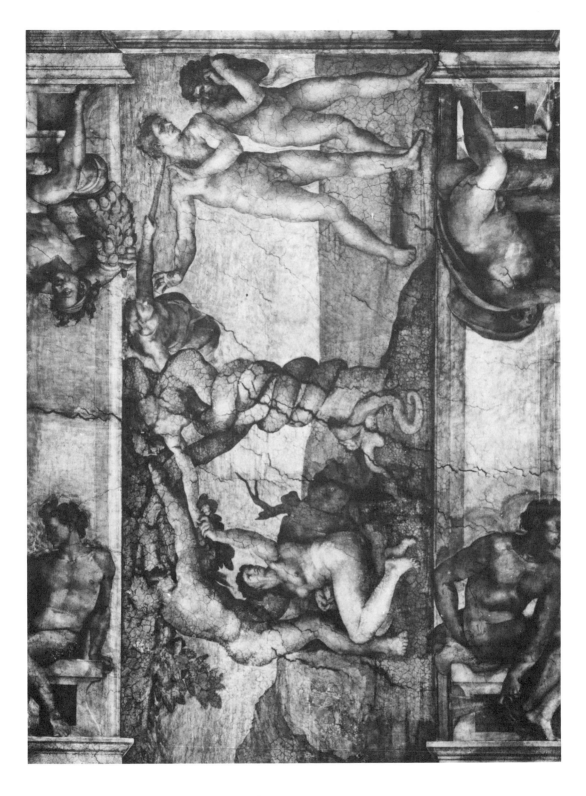

Michelangelo, The Original Sin and the Expulsion from Paradise, fresco from the ceiling of the Sistine Chapel in the Vatican.

of resignation. Michelangelo's art is like his indomitable slave; it is a protest against all that humiliates. In Christ bearing His Cross, in the church of Santa Maria sopra Minerva, he has pictured a hero who triumphs over all indignity.

<div align="center">VII</div>

THE CONCLUSION of the Council of Trent in 1563 is a milestone in the history of Christian art. The critical spirit that arose out of Protestantism and the iconoclastic zeal of the reformers obliged the Church to oversee those painters and sculptors to whom she had until then permitted a great deal of liberty. She showed herself harsh toward the spirit of the Middle Ages that lived on in the art of northern Europe; harsh, as well, toward the spirit of the Renaissance that triumphed in Italy. Did she succeed in imposing her will upon the artists? Did she bring about the birth of a new iconography? It is a question that we have set aside to take up elsewhere.

We have said enough, we hope, to make the richness of the art born of Christianity that constituted for centuries the entire art of the West understood. Funerary in the age of the catacombs, narrative after peace was made with the Church, all-embracing in the thirteenth century, tender and full of pathos during those centuries dominated by the Franciscan spirit, Christian art reflects the thought of the Church like a mirror. One finds in it all the sentiments that have a place in men's hearts, and those sentiments are thereby carried, one might say, into eternity.[1]

[1]We have examined the art which followed the Council of Trent, and which is that of the 17th century, in a fourth volume entitled *L'art religieux après le Concile de Trente* (Paris, 1932).

II THE GREAT MOSQUE AT CORDOBA AND THE CHURCHES OF AUVERGNE AND VELAY

S OME WEEKS AGO, I was in the Great Mosque at Cordoba. I had no thought but to enjoy the shade and the poetry of that enchanted forest, when I glimpsed something that left me no further peace of mind. At the head of each column, at the springing of the pillars that carry the tall horseshoe-shaped arches, I saw modillions like those that decorate the cornices of the churches of Auvergne. Seen from before, this modillion has the shape of a Pan-pipe, whose regular cylinders seem to be held together by a central cord. In profile, it is hollowed into a quarter-circle. At Cordoba, near the door by which one enters, those modillions seemed somewhat heavy; but as one advanced in the direction of the *mihrab*, they grew more elegant; the central rib, now more pronounced, gave them greater style.[1] Some displayed on either side volutes like those of the modillions of Auvergne. The similarity now became remarkable. This was indeed what we call the "wood-shaving" modillion. Viollet-le-Duc, imaginative as always, sees in the wood-shaving modillion a vestige of the architecture of timber: it is the projection of the beam that carried the weight of the roof. "This," he observes, "is evidently an imitation of an exposed joist. These curls that accompany the central spine are nothing else than the shavings made by the hand of the carpenter to expose the central rib. . . . Observing that those shavings produced a decoration, the idea will have arisen not to detach them. Later, this decoration will have reappeared in stone."[2] The hypothesis remains plausible as long as the wood-shaving modillion continues to be placed beneath the cornice, to the extent that it represents a projecting beam, but what becomes of the theory when one discovers that the very earliest served as imposts for a pilaster?

The part of the mosque in which I found myself was the most ancient. This was the original mosque founded by Abderrahman in 785. The wood-shaving modillion therefore had a remote origin. But by what miracle did that modillion, which appeared in Cordoba in the eighth century, suddenly reappear in the twelfth in the churches of Auvergne? Had the architect of Notre-Dame-du-Port at Clermont thus seen the mosque at Cordoba? The hypothesis was so unlikely that I scarcely ventured to entertain it.

I continued on into the midst of the forest of columns, under arches that curved upon themselves like palm fronds. I arrived at that marvel, the *mihrab*, which the Caliph Al-Hakem began after 961. All at once, I noticed small arches

This study appeared in the *Revue de l'art ancien et moderne* in 1911. It contains in essence the ideas that will be more fully developed in the following chapter.

[1] Occasionally an exquisite leaf is sculpted in high relief on the rib; this is a detail that is not found in Auvergne.

[2] *Dictionnaire de l'Architecture*, vol. IV, p. 309.

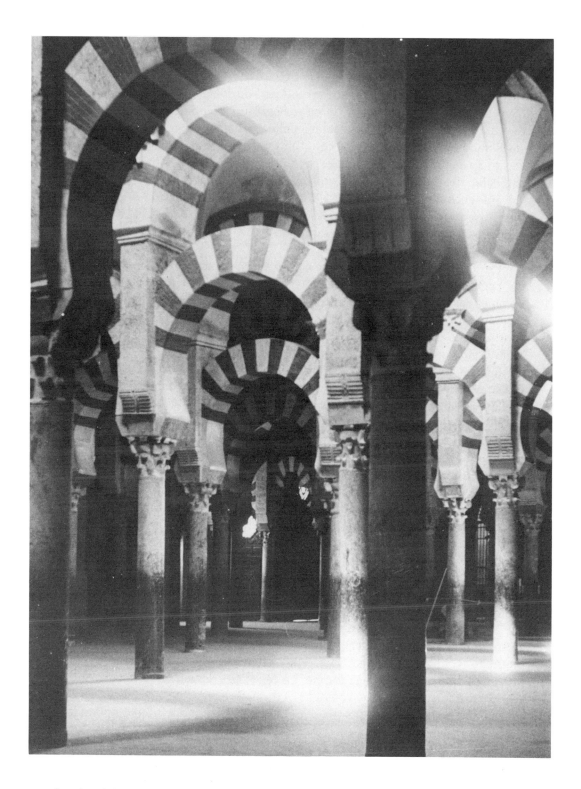

Interior of the Cordoba mosque.

above the entrance in the shape of a trefoil, and instantly I thought again of Auvergne. I remembered that in Notre-Dame-du-Port, on the right side of the nave, the gallery is pierced with trefoil arches. These trilobate arches are unusual; they are rare in French Romanesque architecture and are only to be found in a small number of the churches in central and southern France. One must go all the way to Spain to find other examples, as far as Barcelona, where the old cloister of San Pablo del Campo also opens through trilobate arcades.

This encounter in the mosque at Cordoba of the wood-shaving modillion and the trilobate arch was astonishing. It seemed to me that accident could not explain such similarities and I began to reformulate, with more confidence, the hypothesis that I had just rejected.

I entered the Holy of Holies, the *mihrab*, whose marble pavement is worn by the knees of the faithful. The Arab imagination, exulting within the sanctuary, becomes dazzling. This is lacework of marble, letters of gold traced upon the air by the fingers of genii, a setting delicate as morning mist that crystallizes into stars of hoarfrost. Beside these gossamer wonders, the richest fantasies of Western art seem ponderous.

Raising my head, I noticed a little dome that had the shape of a flower, cut out of a single block of marble. And now there returned to my memory a drawing by Viollet-le-Duc that represents the cornice of Notre-Dame-du-Port. The wood-shaving modillions support blocks that are decorated in a highly original manner: the artist has hollowed out a tiny dome that has, from beneath, the appearance of an open flower. The resemblance between this motif and the dome of the *mihrab* struck me; it struck me even more when, on returning to France, I was able to compare Viollet-le-Duc's drawing with photographs of the Cordoba mosque. I realized that in the sanctuary that opens out of the *mihrab* and which, like it, is roofed over with small domes, or rather small scallop-shells carved out of the marble, there is one which is in every way like the full-blown flower of Notre-Dame-du-Port.

To me these three instances, all taken together, seemed convincing. Henceforth, it appeared certain to me that the architect of Notre-Dame-du-Port had seen the mosque at Cordoba.

I left the sanctuary and returned along the long aisles of columns that seemed to stretch on into infinity. This time it was the arches, with their voussoirs of alternate white and red, that caught my attention. That alternation of colors summoned up another image for me: I recalled the Romanesque cloister of the cathedral at Puy. At Puy, the voussoirs of the arches are white and black, but the effect is the same: it expresses the same richness, together with that unfamiliar essence that lends the art of the East its charm.

But was it reasonable, in the Cordoba mosque, to think of the cloister of Notre-Dame at Puy? Was it not my imagination that fabricated these similarities? I was asking myself this when the façade of the cathedral at Puy, with some of its details, rose up in my memory. I recalled that the trefoil arch appears on each of its levels. But it was not only the trefoil arch, the arch with three lobes, that I saw

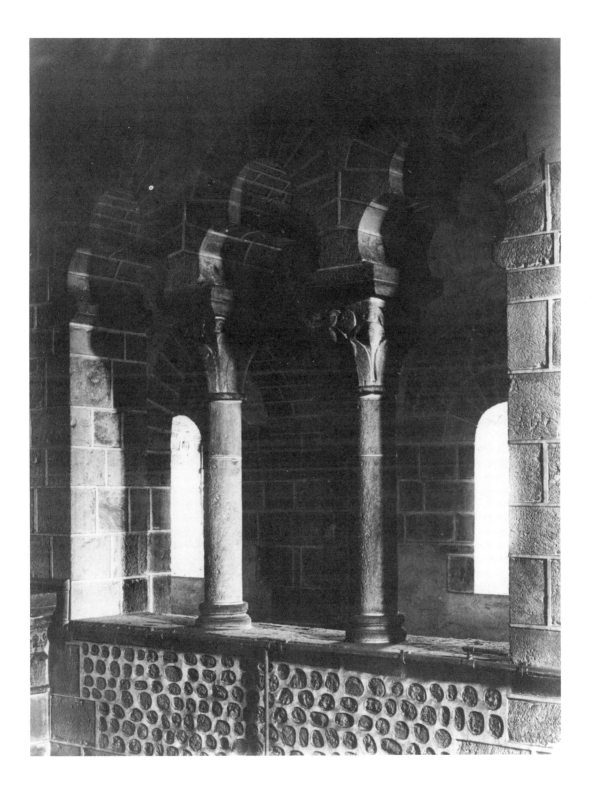

Clermont-Ferrand (Puy-de-Dôme). Notre-Dame-du-Port: trefoil arch in the triforium, 12th century.

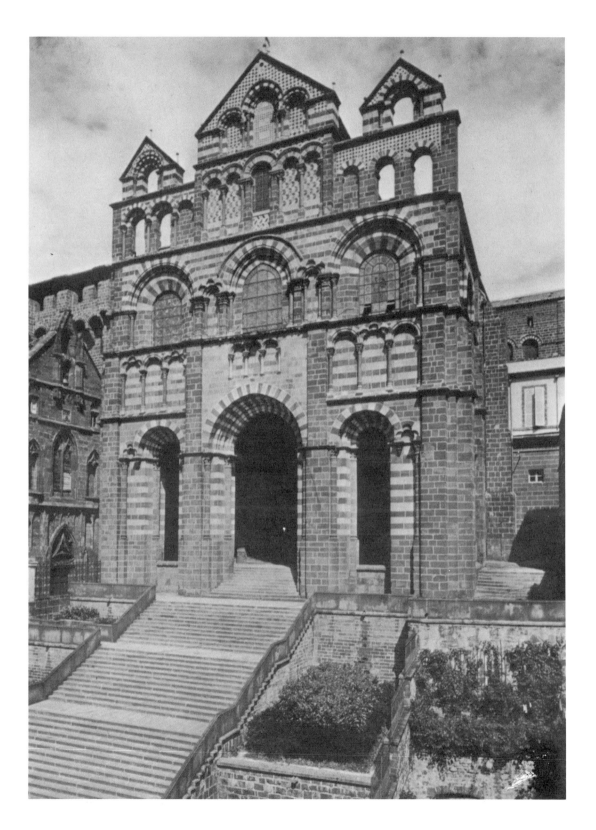

West façade of Puy cathedral (Haute-Loire), late 12th century.

Carved panels of the cathedral doors at Puy (Haute-Loire).

there; it was also the polylobate arch, the scalloped arch which is one of the most graceful fantasies of the art of the East.[3] I had a charming example before my eyes at Cordoba, in the *maqsura* of the former *mihrab*. There was more yet to come. Three great arches lead into the portico of the cathedral at Puy and the two lateral ones open out in an arch in the shape of a horseshoe. Those exaggerated arches, with their voussoirs of two colors, are almost identical with those in the Cordoba mosque.

But the decisive argument presented itself to me only at the very last. At length, I recalled the doors of the cathedral at Puy. One of those is decorated with carved panels that represent the Adoration of the Magi, the Presentation in the Temple, and the Massacre of the Innocents. This carving is unusual: it is not done in relief; it resembles the designs which in the East are stamped on plaster through the use of molds. And, to make the similarity exact, the doorway is set within a frame of beautiful Arab lettering. One cannot help but think, before that remarkable door, of the Mozarabic art of Spain.

All of these coincidences, coming one after the other, ended by enforcing conviction. It cannot be by accident that in the cathedral at Puy one finds the trilobate arch, the horseshoe arch, and the voussoirs of two colors from the Cordoba mosque. The Eastern origin of all these designs is confirmed by the Arab lettering which serves as a frame for the door.

I quitted the mosque by the Puerta de las Palmas and I read the inscription on the pair of milestones that stand at the two sides of the portal, as if in splendid witness to the grandeur of Rome. Those inscriptions tell us that the Romans have completed the highway which led from Rome across Gaul and Spain and that they have carried it *usque ad oceanum*, as far as the ocean. It is a prose equal in its majesty to the finest verse of the Latin poets.

In the great courtyard of the mosque, the flowering orange trees, the fountains, and the tall palms brought me back from the heroic world of Rome to the voluptuous world of the East. Before me rose up the bell tower that has replaced the famous minaret the Arab poets sang. The Giralda in Seville may be a copy of it. For a last time my memory carried me back to Puy and I recollected that the campanile of the cathedral has polylobate openings like the Arab minarets of Spain.

II

ONE PROBLEM remains to be solved. Can it be possible that near the beginning of the twelfth century, French architects could have visited and studied the mosque at Cordoba?

It has recently been denied that Gerbert made a stay in Cordoba, on the grounds that it was extremely difficult, not to say impossible, for a Christian to travel and study in the holy city of the Muslims in the West. To be sure, Gerbert's

[3] There are two polylobate arches at the top of the façade, in the pediment.

journey to Andalusia, which has been mentioned by only one of his biographers, cannot be established as a proven fact, but such a journey was not impossible, for the Muslims of Spain were highly tolerant. Not only were there a great many Christians in Cordoba, but it was possible for them to worship there with complete freedom. It was only asked that they not provoke the faithful by openly attacking the laws of the Prophet. They had three churches in the city: Saint-Acisle, Saint-Zoïle, and Saint Fauste, and three monasteries: Saint-Cyprian, Saint-Genet and Sainte-Eulalie; and in the mountains outside of Cordoba, they still had eight abbeys. The bells called the believers to prayer as before; the priests and monks went about the streets in their habits. The schools of the Christians stood open beside those of the Muslims, and they also had famous teachers whose talents rivalled those of the Arab doctors. Men came from every part of Spain to listen to Saint Eulogius; if one is to believe the saint himself, they came from France as well. So great was the tolerance of the Muslims that the Spanish bishops met several times in Cordoba to hold their councils.

Cordoba was thus far from being a city closed to Christians. Frenchmen did come there. In 858, two monks from Saint-Germain-des-Prés paid a fairly long visit to Cordoba; they took back with them the relics of two Spanish martyrs, Saint George and Saint Aurelius. In Paris these relics attracted such crowds of the faithful that Charles the Bald sought to learn in all their details the histories of these two martyrs. For that reason, he once more dispatched a learned man to Cordoba, by the name of Mancio, to make inquiries into this subject.[4]

At the beginning of the twelfth century, the journey had doubtless not become more difficult than it had been in the ninth. By that time, there were many Frenchmen in Spain: the monks of Cluny had monasteries in Aragon, in Castile, and in the kingdom of Leon; the churches that arose in those regions bore the stamp of French art. Let us assume that some of those monk-architects had pushed on as far as Cordoba, and the mystery is then explained.

It was some of the details on the Cordoba mosque that intrigued the French architects. It could not have been otherwise. A building roofed over with timber, where the problem of the vault had not been faced, had nothing to teach them; they knew a great more about that than the Arabs. But they could not resist the appeal of those new curvilinear forms, of that alternation of colors. They took note of the shape of a bracket, of the design of a dome. Over their solid churches of stone and lava, they spread those airy graces of the East. Hence that profound seductiveness of the cathedral at Puy, which I had felt so often without being able to explain. One glimpses there the nostalgia of the artist who has once seen the kingdoms of light and cannot be consoled.

[4] Aimoin, *De transtat. SS. martyrum.*

III ARAB SPAIN AND THE ART OF THE ROMANESQUE

W HEN THE FIRST ROMANTICS spoke of the French monuments of the Middle Ages, they sometimes praised the "Arab" fantasy to be found there. They thought to render them thus more mysterious and more splendid. Since they understood the art of Islam no better than they did the art of Christianity, they would have been seriously embarrassed if obliged to substantiate impressions that were as airy as dreams. Those forerunners were succeeded by several generations of strict archaeologists who scrutinized the monuments of France and could discover none of those "Arab" characteristics that their precursors had thought to recognize in them.

But it occasionally occurs that the instinct of poets sees further than the learning of scholars. It was the Romantics who were right. Today, it would be difficult to argue, and I for my part do not, that the architects of the Middle Ages did not more than once adopt the designs of Islamic monuments. I had felt this in the mosque at Cordoba; I was even more vividly aware of it in Morocco. Travelling through that landscape of dreams, where it seems as though a magician makes the civilization of Granada at the time of Boabdil live again before one, I admired monuments that were without equal. The minarets of the Almohad dynasty, superb as the might of those sultans whose empire stretched from Tunis to the gates of Toledo; the Koutoubia mosque in Marrakesh, dominated by its three golden spheres, crowned with blue faience set into the stone like sapphires; the Tour Hassan in Rabat, the "gilded tower" that stands out against the snowy whiteness of a distant village. The tombs of the Sa'adians are there, graceful as the Alhambra, where all the sensual pleasures of life seem to keep the sultans company in death. The *madrasas*, the colleges of Fez, are so beautiful that they transformed meditation and learning into the highest form of poetry. There stand the gates of cities, perhaps the most magnificent that have ever been constructed, majestic as Roman gateways but sheathed in a festive tapestry of arabesques, that exquisite design which is a greeting to the traveller, an offer of hospitality to the brother in Islam.

All of these wonders, to be sure, were new to me, and yet it happened that in the decoration of a doorway, in the shape of an arch, I recognized designs that had been familiar to me for many years.[1] Was it by accident that the Romanesque churches of France sometimes display the same ornamentation as the minarets and the mosques? Was I to invoke, as one does in the case of something one cannot explain, the homogeneity of the human imagination at every latitude? I did not think so. A more careful study led me to identify certain similarities between Christian and Muslim art, certain analogies between Christendom and the world of Islam, that I would like to point out here.

Revue des Deux Mondes (Nov. 15, 1923). [1]*See* the preceding chapter.

I

WHEN ONE VISITS Cluny, after having read the history of that great abbey which, as Viollet-le-Duc says, was "the mother of Western civilization," one is sadly surprised to see that nothing is left standing but a single bell tower and the arm of one transept. This is all that the demolition experts, who would have been the most sacrilegious of nineteenth-century vandals had they not been the most ignorant, have let stand of the most celebrated Romanesque church in France. These remains nevertheless allow one to guess at the beauty of the whole. This fragmentary transept, with its vault suspended thirty-three meters in the air, is filled with grandeur; Gothic art nowhere exhibits greater vitality. The interior proportions are those of the churches of Burgundy: between the tall arches of the lower story and the windows above them, one sees attached to the wall an elegant band of decorative arcades, forming a sort of blind triforium. Now this triforium possesses an unusual characteristic: each semi-circular arch that composes it is bordered by a series of small contiguous half-circles, which describe a festoon about the arch. No doubt the same design could once have been observed on the triforium of the nave. One does not find this curious edging of half-circles either on the triforium at Paray-le-Monial nor on the triforium at Beaune, the daughter-churches of Cluny. It would appear to be the hallmark of the mother-church.

This detail for a long while struck me as a mysterious eccentricity, but it suddenly took on significance in my eyes when I realized that it had been borrowed from the art of Islam. I saw those semi-circular lobes a hundred times in Morocco, framing the curve of a door or the arch of a window. Their origin is very ancient. Those decorative semi-circles appear for the first time around the exaggerated archway that leads into the palace of the Sassanid kings at Ctesiphon. It was the sole decoration on that gigantic doorway, which is reported to have collapsed. The Arabs, who borrowed so many things from Persia, owe this motif to her. They carried it with them. We find it in the ninth century in the mosque at Kairouan, at the base of the beautiful dome that soars above the *mihrab*. It reappears in Spain, magnificently expanded, in the mosque at Cordoba. Amazingly, it appears at the end of the eleventh century on the church of St. James at Compostela, where it decorates the exterior arch of the two windows that open into the south transept above the Puerta de las Platerias, the Goldsmiths' Portal. This design, that was so characteristic of the infidel, must have possessed an irresistible charm, since the Spanish did not hesitate to set it in the façade of the most holy of their churches. Had they, then, forgotten that the caliph Almanzor had once upon a time destroyed it and had its bells carried on the backs of Christian prisoners as far as Cordoba? No doubt they did remember, since long afterward Ferdinand, the conqueror of Andalusia, in his turn had the bells of St. James carried from Cordoba to Compostela on the backs of Muslim prisoners. But in this art of Islam there lay an enchantment, a sorcerer's secret magic, so that all who saw it were obliged to love it.

The Arab decoration on the triforium at Cluny also comes, without question, from Spain, and nothing seems more natural when one knows the history of the

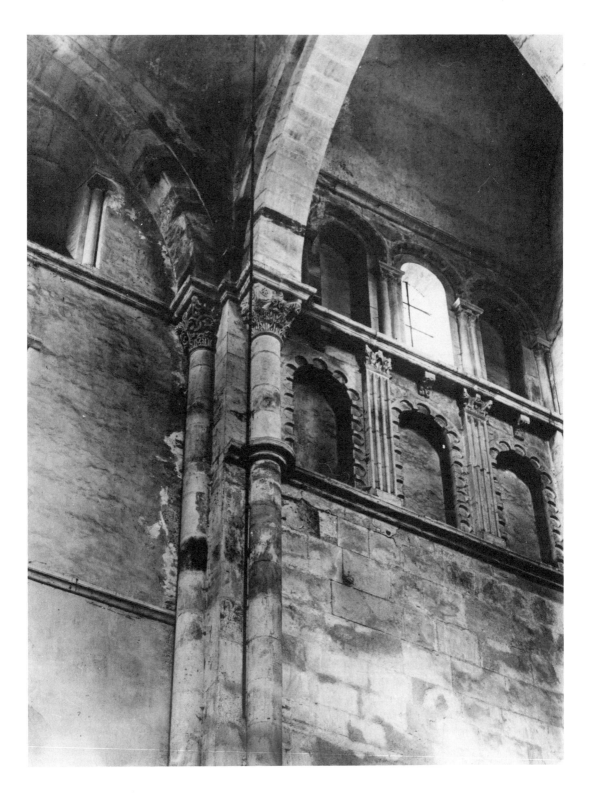

Abbey church at Cluny (Saône-et-Loire), 12th century. Upper level of the south transept.

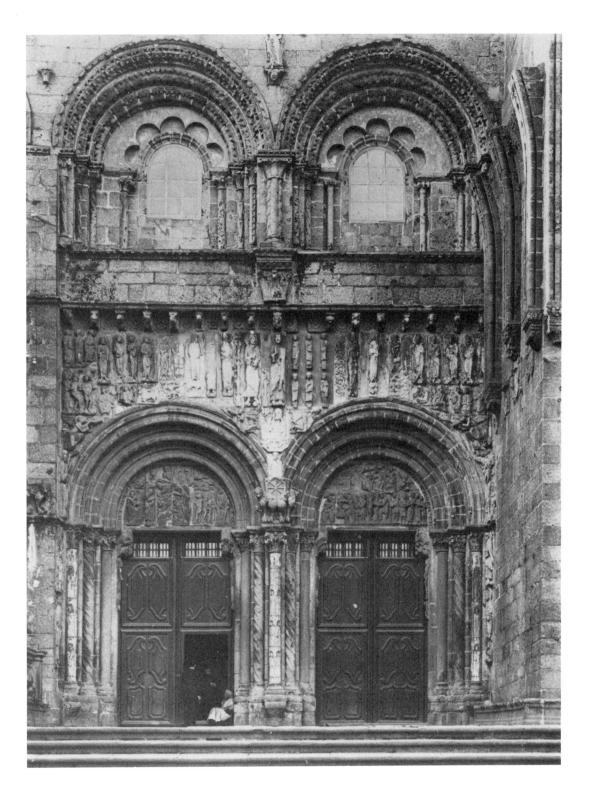

Cathedral of St. James of Compostela, Goldsmiths' Portal, 11th century.

great abbey. From the eleventh century onward, Spain was always present in the mind of the abbots of Cluny. It was for them the outpost of Christianity in the face of the world of Islam, the rampart continuously menaced that was to be defended at all costs. It was the abbots of Cluny who organized the pilgrimage to St. James of Compostela and who brought about the emergence, on the highways of France and Spain, of those Cluniac priories that were a shelter for travellers. Those men in their thousands, among whom were to be found the most seasoned fighting men of France, were easily transformed into Christ's champions against Islam. The Spanish crusade was one of the greatest accomplishments of Cluny. We are not sufficiently aware that during the whole of the eleventh century the barons of France, and in particular the barons of Burgundy, urged on from Cluny, continuously took the road toward Spain. These were not random bands of mercenaries who crossed the Pyrenees; these were entire armies, "armies worthy of a king," as abbot Suger called them. The Spaniards were not alone in their fight against the Moors, and France played her part in the "*reconquista.*" The proof for that is written in the Peninsular dynasties: it was a Burgundian knight who, after seventeen victories over the Moors, became king of Portugal, while another Burgundian mounted the throne of Castile. The *Gesta Dei per Francos* began a century before the capture of Jerusalem.

Cluny was the soul of that Spanish crusade; hence the kings of Spain were deeply grateful to her. Ferdinand sent a considerable sum each year to Cluny but Alfonso VI, the friend of saintly abbot Hugh, was even more generous; he doubled that thankful tribute. The peoples of Christendom had for a long time, moreover, been in the habit of offering evidence of their affection and respect to the holy church at Cluny. Henry II, emperor of Germany, made her the gift of his imperial crown, his scepter, and his mantle. William the Conqueror, king of England, presented her with a splendid cloak sewn with pearls, and his wife, Queen Matilda, with a great seven-branched bronze candelabrum recalling the one in the temple at Jerusalem. The republics of Pisa and Genoa, after their victories over the Muslims in Sardinia, sent to Cluny all the gold taken as booty and abbot Hugh had a ciborium for the high altar made from it. The whole of the eleventh century was instinctively aware that the noble thought that shaped Christianity dwelt at Cluny; that within its sanctuary the lamp of the church was kept alight. And indeed the great popes of the eleventh century were all Cluniacs or had adopted the ideology of Cluny.

In associating himself with the the building of the new church whose remains we admire, Alfonso VI also wished to show his gratitude to Cluny. In 1085 he had just taken Toledo. This momentous event, which must have thrilled all of Christendom and filled Saint Hugh with joy, was probably not unrelated to the laying of the church's foundations. They were begun three years later, in 1088, and Alfonso VI's subsidies came, one can hardly doubt, from the spoils of his victory. For it is clear that Spain left its mark on this church which was so particularly dear to it. Perhaps the architect of Cluny had accompanied Saint Hugh on one of the two voyages that he made to that country; perhaps he was

among those Cluniac monks whom Alfonso VI summoned to Toledo after the capture of the city. Moreover, French monks had for a long while been numerous in the Cluniac priories of Spain, at St. John de la Pena, at Burgos, at Carrion, and at Sahagun. The architect of Cluny could have seen some of those splendid mosques that were later destroyed by the Christians. The Arab motif with which he decorated the triforium of his church is proof of contact with the art of Islam. And it is not the only one. Today, we no longer know the abbey doorway at Cluny except through a few inferior engravings. Among these, the one that seems the least unreliable shows us a surprising detail. The great half-circle of the portal is enclosed within a rectangular border that is framed by a decorative frieze. It is difficult not to think immediately of the rectangle within which all the doorways of the monumental Arab buildings are set. That setting, which Muslim architects called the *arrabâ*, is like the hallmark of Islam; it encloses the broken arch of the buildings at Isfahan as it does the horseshoe arch of the mosque at Cordoba and the vast stilted archway of the gates of Fez. Surrounded by these straight lines, the half-circle of an arch not only appears more majestic, it creates a mysterious impression of serenity and repose. The *arrabâ* is occasionally to be found in the churches of Spain but never in those of France. The portal at Cluny is the only clearly defined example that I know of in this country; as in the monuments of Islam, the horizontal band of the frame is exactly tangential to the half-circle of the doorway.

To be sure, this multifoil triforium and framed doorway (for these are all that Muslim art gave to Cluny) are little enough to go on; nonetheless, those designs, when one knows their history, cause one to reflect for a long while. How strange it is, at Cluny, to come upon these reminders of distant Arab Spain! What avenues open for the imagination! So the great abbots of Cluny, those champions of Christendom against Islam, who directed the Spanish crusade and prepared the crusade to Palestine, borrowed the ornamentation of the mosque for their church? Peter the Venerable did not find it shocking, although it was he who had the Koran translated (the better to war against it) and then refuted it in a book of which the greater part has been lost. Those beautiful shapes seemed to him inoffensive, and he did not associate them, as we do today, with another religion and another race.

The wish to imitate the church at Cluny may perhaps explain the appearance of those decorative scallops on the tall windows of the robust tower that rises at the transept crossing of the church at Tournus. Tournus, indeed, is one of the oldest Cluniac priories in Burgundy, and the borrowing of a motif from the mother-church would indicate nothing unexpected there. Nonetheless, one is obliged to remember that Peter, prior of Tournus, made the journey to Spain in 1080 to negotiate the marriage of Constance of Burgundy with the king of Castile and Leon, Alfonso VI. For it was Peter who began the building of the transept at Tournus that we see today. The bell tower that dominates it may have been completed at the time of his death in 1107; the plans for it, at least, must have existed. Here, once again, we come upon Spain.

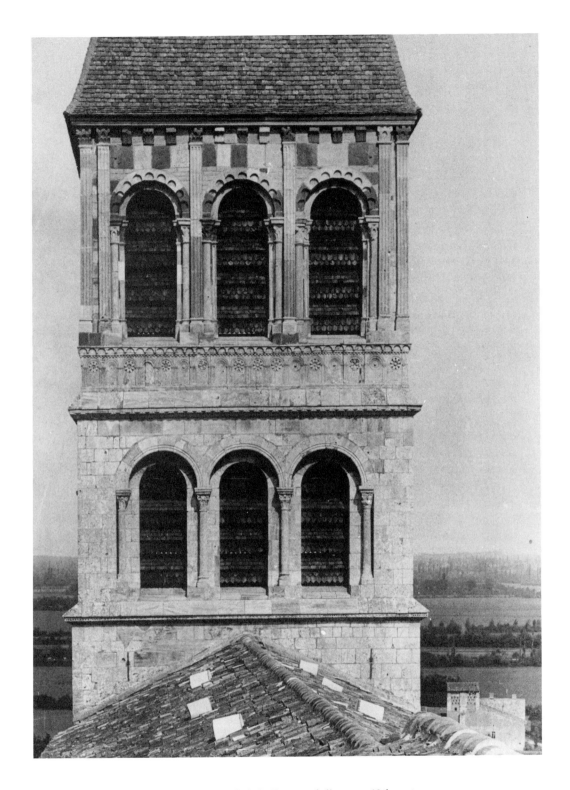

Saint-Philibert de Tournus (Saône-et-Loire). Transept bell-tower, 12th century.

II

WHEN I SAW the Tour Hassan in Rabat, I admired with what skill the architect, leaving that sturdy minaret entirely bare at its base, had clothed its summit with a covering of Arab lace. It was the same principle followed by the old French Romanesque and Gothic masters, who believed that a belfry should give an impression of strength in its lower portions and of delicacy and richness at its summit. As I studied the faces of the monument in turn, I noticed half-way up on one side an elegant arcade made up of three scalloped arches set into the wall and carried on colonettes. At once, I thought of the square bell tower that rises in front of the half-ruined nave of the church at La Charité-sur-Loire. One sees there, in effect, an identical set of arches at the same place.

These arches at La Charité are decorated according to the same principles as those at Cluny, but with a difference. The small ornamental semi-circles are no longer carved in the stone that surrounds the arch, leaving its curve untouched. Now the arch itself is made up of a series of contiguous half-circles; the arch seems like lacework that stands out in space. Properly, it is what is called a multifoil, or polylobate, arch, whereas the arch of the triforium at Cluny is an ordinary one *surrounded* by a multifoil setting; both of these designs, the one and the other, are of Arab origin.

The multifoil arch, like so many other elements of Muslim design, comes from Persia. Sassanid architects occasionally imitated, in the depths of a recess, the beautiful design of the *pecten,* the shell that was picked up along the shores of the Persian Gulf. Its flutings formed the decoration at the back of the niche and the toothed edges of the shell easily became a multifoil arch. The fluting later disappeared, but the lobed arch persisted. This multifoil arch was a motif in Arab architecture at the time of the Abbasid caliphs. Ancient Baghdad exists no longer and, with its disappearance, has taken away the secret of the origins of Muslim art. A few years ago, however, a ruined mosque was discovered in the wastes extending north of Baghdad among which Samarra stands, that is contemporaneous with the ninth-century caliphs. And its windows are polylobate. These polylobate arches reappear in North Africa, where they advanced along with the conquerors; one sees them in the *mihrab* of the Kairouan mosque in Tunisia. Morocco offers us many examples; there, the multifoil arch still remains, after so many centuries, one of the elements of the Muslim architecture of today. For in Morocco the architecture of Islam has not died out, and craftsmen may still be found there who could build Alhambras. Sometimes the arch, rather than polylobate, is simply trilobate; it then appears as an elegant three-leaved trefoil.

It is one of the curiosities of that great half-ruined church at La Charité-sur-Loire, that it should present us everywhere with the multifoil arches of Islamic art. We see them at every level of the bell tower on the façade; we find them again on the octagonal tower that rises at the transept crossing; they surround the chevet. If one enters the church, one has the surprise of recognizing them in the triforium of the nave and the choir.

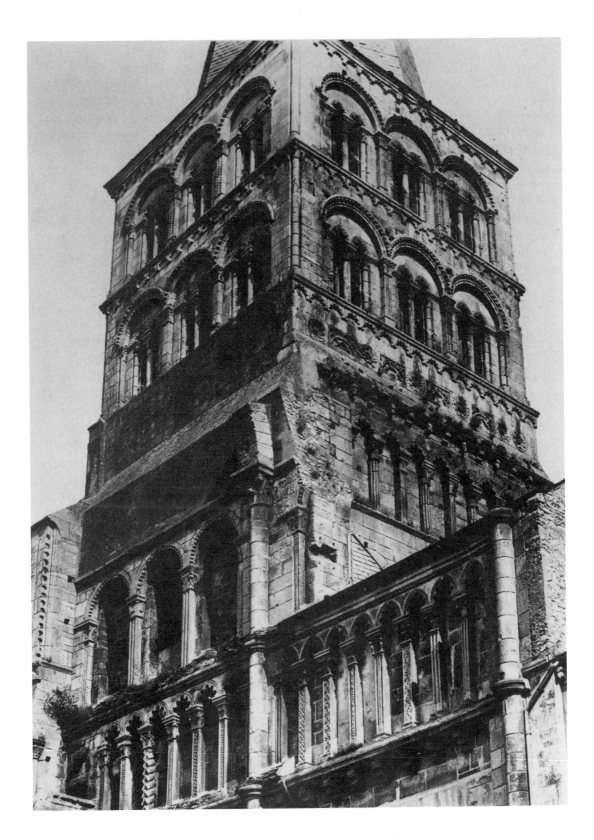

La Charité-sur-Loire (Nièvre). Belltower of the old abbey church, 12th century.

This strange likeness between the decoration of the minaret at Rabat and that on the church at La Charité-sur-Loire—contemporary monuments—would remain an insoluble mystery if one did not immediately think of Spain. Spain was the intermediary between La Charité and Rabat. It is enough to have seen Toledo, to revisit in memory bell towers and church apses decorated with polylobate arches that resemble at one and the same time those in Rabat and those at La Charité. If one has been inside that famous synagogue in Toledo which became a church and was called Santa Maria la Blanca, one has seen a multifoil triforium like the one at La Charité. There is no city in Spain where the multifoil Arab arch appears more often than Toledo, for there are few cities in Spain where the arts of Islam were practiced for so long a time. When Alfonso VI made himself master of Toledo, not only did he not drive out the Moors, but he allowed them to practice their religion, to observe their laws, and to follow all their trades. These conquered Moors were known as Mudejars. The victors had great need of their new subjects, since the pure-blooded Spaniards were arrogantly content for a long while to be priests, soldiers, or laborers; they were not artists, they barely consented to be craftsmen. Therefore they were happy to find perfectly organized Islamic guilds, where art was taught and crafts were practiced. After the conquest there were no other masons, no other designers, and no other architects in Toledo except the Mudejars. It was these infidels who built the first Christian churches and decorated them like mosques. In the thirteenth, fourteenth and fifteenth centuries, the Mudejars were no longer the only artisans in Toledo, but their influence remained profound. In Spain an architect is today still known as an *alarife*, as the head of an Islamic guild was once called, and a mason bears the old Moorish name, somewhat corrupted, of *albañil*. But it was their taste above all that impressed itself upon their conquerors. Mudejar art is one of the delights of Spain. There is nothing more enchanting than these Moorish designs grafted onto the monuments of Christianity. Sometimes an endless chain of interwoven polygons seems to cover an entire wall with a rich Oriental fabric; sometimes, on the savage nakedness of brick walls, a series of multifoil arcades is enough to stir the memory of the East. In the fifteenth century, Mudejar art had set its stamp so strongly on the Spanish imagination that when the Christian artists were designing flamboyant tracery, they gave it the richness of Arab decoration. In the Spanish art of the Middle Ages, it is rare that close study does not reveal some Mudejar element. And when it does not show itself, we are aware, at the very least, of a way of feeling that is not that of our French artists. The art transported from the North is caught up here in another current. The charm of Spain lies in its being the meeting-place of East and West; they fought fiercely against one another but their arts came together in love, as did the Christian kings with their beautiful Moorish captives.

Thus one frequently finds multifoil arcades in Toledo that resemble those at La Charité-sur-Loire. Many of them are from a later date, which is of little consequence, for all bear witness to a lengthy tradition. We know very little of the history of the monastery at La Charité; we do, however, know that Henry of

Toledo. Church of Santo Cristo de la Luz; trefoil arch beneath the cupola.

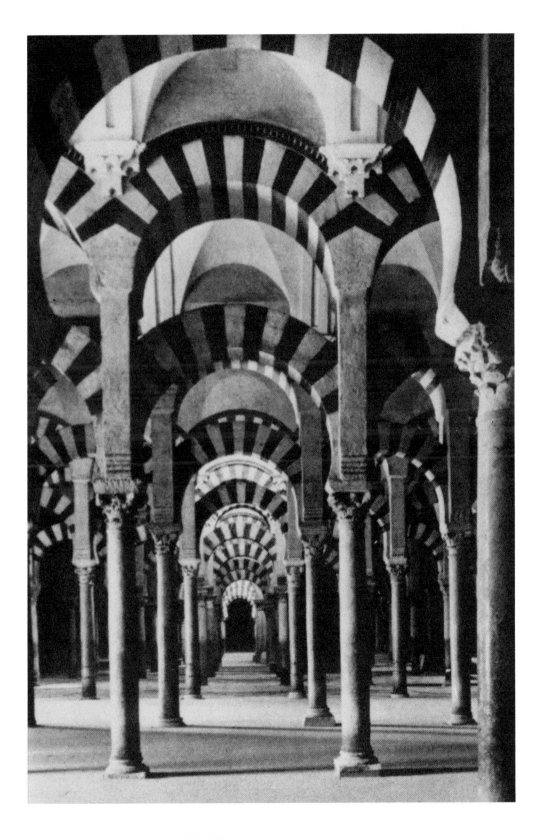

Arches in the mosque at Cordoba, 8th century.

Burgundy, king of Portugal, gave to the monastery at La Charité a priory in the neighborhood of Braga, retaken only lately from the Muslims. But it is enough to recall that La Charité was one of the major Cluniac priories for its relationship with Spain to become clear. It has been shown that the builder of the church at La Charité had crossed the Pyrenees and it is very probable that he had seen Toledo. The church at La Charité, built in the eleventh century, was extensively altered in the first half of the twelfth; at that time, it received its Moorish arcades. Toledo, which even today recalls the cities of the Maghreb, must twenty years after the conquest have retained an appearance that was wholly Muslim. It still had its souks, its mosques, its minarets, the white *koubas* of its cemeteries. The Great Mosque, the Aljama, contemporaneous with the mosque at Cordoba and burnished by the centuries, must have been magnificent. The Christians availed themselves of it on the morrow of the conquest and hung bells in its minaret. They preserved it for over a century and only pulled it down in order to build the cathedral. Historians still tell us of the two resplendent mosques called Adabejin and Djebel Berida. Lesser mosques were everywhere; one known as Bib-al-Mardom still exists and has become the church of Santo Cristo de la Luz. It was saved by a legend. Men said that one of the walls of the mosque was that of a church going back to the time of the Visigoths. When it was captured by the Christians, they discovered in a recess, hidden by a coating of plaster, an image of Christ and a lighted lamp before the image, still burning after 370 years.

The two palaces built by the Muslim rulers were still standing then in all their enchantment. In this Toledo, parched as the desert, they had known how to create gardens with the reflecting pools of Persia. At the center of one of these lakes there stood a pavilion of crystal and gold where the sultan spent the nights of summer. The water of the Tagus, lifted by water-wheels, was brought to rustle in a cascade over the dome of that pavilion and surround it with a veil of freshness.

This celebrated city, where the Northerner met the shock of Africa, where the dust carried the scent of the desert, must have touched the sensibility of an artist deeply. The French were then numerous in Toledo, so numerous that a whole quarter had been set aside for them. A Frenchman, Bernard, a monk from the Cluniac monastery of St. Orens at Auch, became the first bishop of the reconquered city. The monks of Cluny, summoned from France, established themselves outside the walls in the castle of San Servando, as if on the outpost of Christianity. Is it surprising that the future architect of La Charité-sur-Loire, monk or layman, could thus have seen the monuments of Toledo? What is clear is that all the Arab motifs of La Charité can be found in Toledo. The multifoil arch is everywhere; as for the trefoil arch which is visible on the two upper stories of the belfry at La Charité, it is this which one sees beneath the dome of the former mosque, Santo Cristo de la Luz; it is the same, as well, as that which decorated its exterior walls. Thus that tall belfry at La Charité, whose silhouette from the distance is entirely French, reveals as one draws nearer its kinship with the ancient minarets of Toledo. This is the art of the Mudejars of Spain, interpreted by a Frenchman.

III

LET US LEAVE Burgundy and the realm of Cluny for the Auvergne. Certainly one is hardly thinking of Arab art, when one enters the church of Notre-Dame-du-Port. One can stroll entirely through it without noticing anything that turns the thoughts toward the world of Islam. If, however, one returns to the nave to look more closely at the galleries, one realizes that some of the arches by which they are pierced are semi-circular but that others are trilobate. That detail comes as a surprise. Why, in this austere church, where the semi-circular arch can be seen everywhere, these trefoil arches, which are Arab arches? Is it not odd to meet arches in Auvergne like those decorating the entrance to the *mihrab* in the Cordoba mosque? Note that the trefoil arches at Cordoba are earlier by four hundred years than those of Notre-Dame-du-Port. Surprise grows when, leaving the church, one examines the picturesque chevet. The cornice of the apse and the chapels rests upon unusual modillions, known as "wood-shaving" modillions (as described in the previous chapter). Seen from the front, this modillion resembles a sort of Pan's-pipe, whose horizontal cylinders are held together at the center by a sharply outlined cord. Seen in profile, this modillion, hollowed into a half-circle, is made up of a series of superimposed spirals, like the shavings that spring up under a carpenter's plane. But identical modillions decorate the springing line of the horseshoe arches in the Cordoba mosque. This was a decoration familiar to Arab architects in the ninth century, for it can also be found in the great court of the Kairouan mosque.

Beginning in the tenth century, the Christians of Spain borrowed the wood-shaving modillion from the Arabs. It appeared in the very oldest churches of Castile and the kingdom of Leon, as a recent study tells us.[2] Often in these very old churches, some of which go back to before the year one thousand, one recognizes a detail lifted from the Cordoba mosque. But the wood-shaving modillions that decorate Santiago de Peñalba, San Millan de la Cogolla, and the square chapel of San Miguel de Celanova that is like an Arab tent—these elegant and bizarre modillions take great liberties with their models. Here the wood shavings become circles studded with stars. Oddly enough, the modillions of the church at Clermont exactly reproduce those of the Cordoba mosque, while those on the churches of Spain are debased copies. Must one conclude from this that the Auvergne artist had seen, not the Spanish churches, but the mosque at Cordoba itself? One hesitates before the implications and does not know what to answer, when a detail, suddenly glimpsed, brings certainty. Beneath the cornice of Notre-Dame-du-Port, between the wood-shaving modillions, are carved small domes in a charming shape: it is that of an open flower with eight petals. Now an identical flower decorates the dome of the small chapel that opens off the *mihrab* in the Cordoba mosque. The juxtaposition of this appealing flower with a modillion of the purest Arab type proves that the French architect was familiar with Cordoba.

[2]Gomez Moreno, *Iglesias Mozarabes* (Madrid, 1919).

But another idea at once comes to mind. At Clermont, immediately below these wood-shaving modillions, a band of mosaic decorates the half-dome of the apse, decks it in the most seductive beauty: it is composed of eight-pointed black stars set within circles of white. Viollet-le-Duc believed that he saw here "an oriental fantasy." I believe that one must be more specific and find there an imitation of Arab diaper work. More than once, in the narrow streets of Fez, where there spring up minarets that are clothed at their summits with a mosaic of stars, I thought of the apse of Notre-Dame-du-Port. The mosaic work of these minarets (made up of faience that is green, blue, black, or dusky) captures more luminosity than the lava and the white and yellow stone of Auvergne, but the decorative principle is analogous and the design almost the same. Therefore it is likely that the architect who borrowed from Islam the trefoil arch, the wood-shaving modillion, and the cupola in the form of a flower, also took from it the idea of mosaic tiles. Was it on the summit of the minaret at Cordoba that he admired this design of star-studded faience? We cannot tell, for the fabled minaret, celebrated by Muslim writers, was replaced in the sixteenth century by a Spanish belfry. Edrisi tells us, it is true, that "it was covered from base to summit with the most beautiful decoration that various arts knew how to create, such as gilding, calligraphy, and painting," but we do not know if it was already crowned with mosaics, as later minarets were. One has asked oneself if the Arabs decorated their monuments with mosaic work of faience in those very early times. It can be answered that, if the faience inlay of the *mihrab* at Kairouan actually dates from the ninth century, there is no reason not to assume so. Moreover, recent excavations at Medina Azahara—that palace more celebrated than all others, that fantasy which the caliph Abd al-Rahman, like a magician, made rise up from the earth outside of Cordoba to beguile a favorite sultana—have disclosed mosaics made of glazed tiles that go back to the tenth century. This charming style of glazed facings has, as we see in the Maghreb and in Muslim Spain, very remote origins. It is therefore not impossible that the builder of Clermont copied the mosaics of Cordoba. What confirmed my belief that the decorative frieze of Notre-Dame-du-Port is indeed Muslim in its origin, was that I have seen one very like it in Sicily, within the apse of the dome at Monreale. Beneath the cornice there extends a band of inlay made up of white stars against a black ground. Now, this apse at Monreale, built at a time when Sicily was still three-quarters Muslim, is in its decoration wholly Arab.

We know that the beautiful chevet of Notre-Dame-du-Port, with its mosaics and its wood-shaving modillions, reappeared all over Auvergne; at Issoire, at Saint-Nectaire, and as far as Brioude. Should we conclude from this that Notre-Dame-du-Port was the model so often imitated in the twelfth century? Excavations made a few years ago in the cathedral at Clermont allow us to identify an earlier source. In effect, a crypt has been discovered there whose plan proves that the original cathedral had possessed, before Notre-Dame-du-Port, an ambulatory with radiating chapels. Some of the remains of the chevet have led to the belief that it went back in the eleventh century. Therefore it is probable that the

Romanesque cathedral at Clermont, the one known to Urban II, and before which he called France to a holy war, was the very earliest of these beautiful Auvergne churches; Notre-Dame-du-Port, built in the following century, was in all likelihood only a copy of it. Thus these imitations of Arab art, which most probably must already have characterized the original, would have come down to us from the eleventh century.

As we know, in the eleventh century France was drawn toward Spain. But for what reason does Hispano-Arab art thus leave such a strong imprint on the churches of Auvergne? We can only reply that Clermont stood at the meeting-place of three ancient roads that went on to join with the major highways to St. James of Compostela. The first of these was the Roman road that led to Limoges by way of Ahun and La Creuse; the second, the Roman way that ran to Périgueux through Ussel (where one can see the Roman eagles still) and Brive; the third, the Roman road that followed the Allier as far as Vieille-Brioude and went on to Puy. A host of pilgrims from central and eastern France could only join up with the major routes to Santiago by passing through Clermont. Clermont was thus a way station for travellers on their journey toward Spain, or as they returned from it. One can assume that the artisan who gave the old cathedral at Clermont its Arab decoration came by the pilgrims' road and had seen not only Christian Spain but Muslim Spain as well.

However beautiful these Auvergne churches may be, one must have the courage to point out that they are not indigenous and that we will seek among them in vain for an expression of the native genius of Auvergne. We know that the churches of Saint-Martial at Limoges (today destroyed), of Sainte-Foy at Conques, Saint-Sauveur at Figeac, Saint-Sernin at Toulouse, and St. James of Compostela resemble, or resembled, the churches of Auvergne and we have sought to infer from this that the Clermont school radiated an immense influence. It is a futile effort. Those great churches that stand along the highway to St. James are the daughters of the oldest and most splendid of all the pilgrimage churches in France, Saint-Martin of Tours, which was destroyed during the Revolution. An existing plan of it and a drawing leave no room for doubt on this subject. It is that illustrious model which the Clermont churches together imitate. They represent it for us with different proportions, but those proportions are so felicitous, the chevet is so harmoniously dominated by the crossing tower, that one wonders if the original, in all its vastness, could have been equally without flaw. Lastly came the ornamentation of Islam, to render them yet more beautiful with the suggestion of the East.

IV

IT IS AT Puy, in the heart of the mountains of Velay, that those monuments may be found that bear witness more clearly than anything else in France to Muslim influence. The strange polychrome façade of the cathedral evokes, before any conscious reflection, a confused impression of the East. But in the superb cloister,

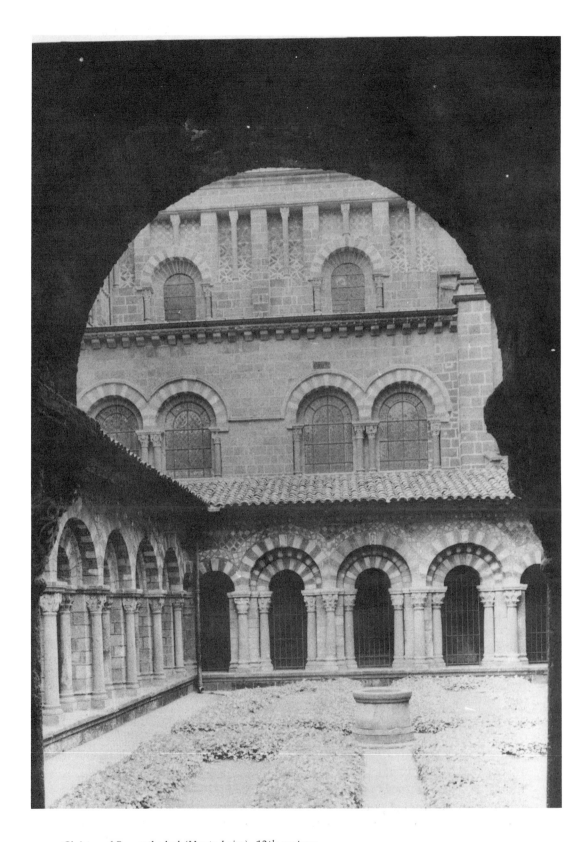

Cloister of Puy cathedral (Haute-Loire), 12th century.

one of the most beautiful in Christian Europe, that indistinct impression becomes a specific thought. The arcades with their voussoirs, that are in turn black and white, bring to mind the white and red arches of the Cordoba mosque; the colors are different, but the effect of magnificence is the same.

If one then returns before the façade to study it in detail, one discovers there an Arab theme that was at first not apparent. The trefoil arch appears on almost every level, and the multifoil arch shows itself at the summit; both the one and the other are set against the wall as ornamental relief and do not open into any interior space. On the lower level of Puy cathedral, three great arcades lead into the porch; with astonishment, one now realizes that the outer arcades describe the Arab horseshoe arch, and that those arches, with their voussoirs in two colors, are like those in the Cordoba mosque. But within the porch, one's surprise increases. There one sees two ancient doors of carved wood that close the entrances to two chapels. Those doors tell the story of the childhood and Passion of Jesus Christ. But nothing could be stranger than these carvings; the figures are simply shallow reliefs cut out against the background. One thinks immediately of the flat designs of the Arab sculptors and it happens that this first impression is confirmed by a magnificent border of Kufic characters which frames one of the doors. One seems to read there an invocation to Allah. Islam makes its presence known here, and if one was uncertain of it at first, one is so no longer.

One then grows more daring. There is, at the entrance to the cathedral's south transept, an unusual porch. It opens out on both sides through two great archways that exhibit the peculiar feature, unique in French art, of being made of two superimposed arches that not only do not touch one another, but which leave a wide space between them. The sunlight plays between these two arches and, at certain times of the day, throws upon the wall a circle of light between two circles of shadow. How is one not to see, in this baffling fantasy, an echo of the two superimposed arches which, ceaselessly repeating themselves, open up endless perspectives in the mosque at Cordoba and lend an airy lightness to that dream-like interior? But at Puy necessity has restrained the free play of the fantasy which at Cordoba is unhindered. To carry the weight of a high wall, it has been necessary to join the two arches by three small pilasters. Over and over, this portion of the south transept at Puy awakens the memory of Moorish art. The door that leads into the church has a great arch surrounded by Arab lobes that one would not be surprised to see at the entrance to a mosque. The wall of the transept itself is decorated on its upper reaches with a black and white mosaic, strongly reminiscent in its design of the tiles that cover the walls of Moorish apartments. Lastly, the free-standing bell tower nearby shows us, like the minarets, trefoil openings.

The East reappears not only in the cathedral; of all the cities of France, it is in Puy that the designs of Muslim art most frequently present themselves to us. Near the basalt piers that support the church dedicated to St. Michael, there stands a small building still elegant in its dilapidation. At one time it was known as the temple of Diana. Octagonal, of the same date as the cathedral, it was in all likelihood the chapel of some early hospital. Its charm stems from its agreeable

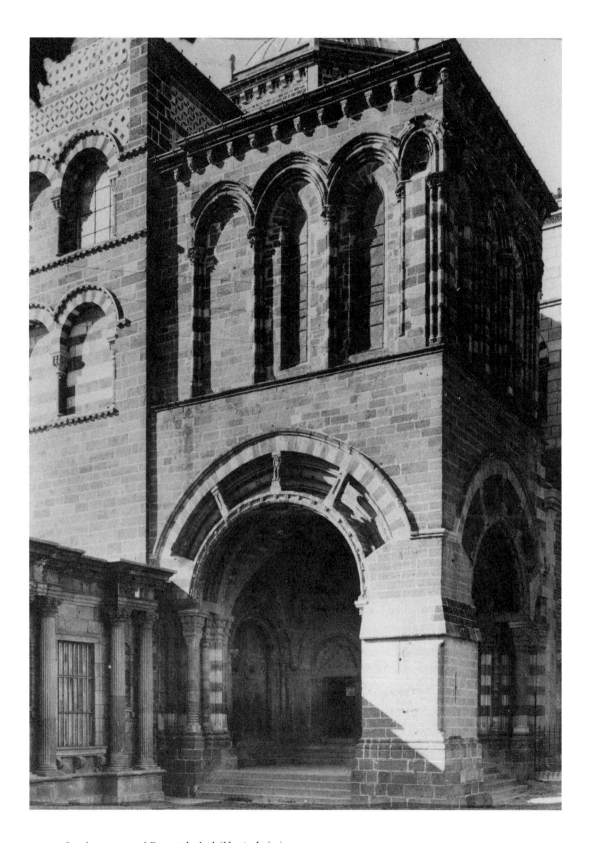

South transept of Puy cathedral (Haute-Loire).

Le Puy (Haute-Loire). Chapel of Saint-Clair.

proportions, as well as from several graceful details. The voussoirs of the arches on each side are white and black, and some of those arches are polylobate; a shallow mosaic design of stone in two colors holds them all within a frame. All of these motifs, which one encounters again in the cathedral, are of Arab origin, but here they seem perhaps yet more striking. If the dome that covers the building had not been concealed by roofing, it would be difficult not to be reminded of an elegant *kouba.*

The chapel of Saint-Michel d'Aiguilhe, poised miraculously at the summit of its gigantic volcanic pedestal, was sure to remind the pilgrim who passed by of Normandy's Mont-Saint-Michel. The building, constructed in the tenth century and originally quite small, was somewhat enlarged in the eleventh century and enriched with a fine façade in the twelfth. The last of this series of architects was no stranger to the art of Muslim Spain, as is shown by his unusual trilobate doorway with its flat foliage sprays. Strong moldings create a rectangular frame for this doorway, which is filled in with a mosaic in white and red. There falls across this façade a glimmer of the light of the South.

Puy is thus the French city where, even today, Moorish influence is most visible; there are cities in Spain where it is less apparent. How is one to explain this remarkable phenomenon?

It must first be remembered that Puy was the starting-point of one of the four great highways that led to St. James of Compostela: explicit instructions in the *Guide* written for pilgrims in the twelfth century leave no doubt on this point.* As a result, this city, which seems to us today forgotten among its mountains, stood at that time astride one of the great thoroughfares of Europe. A constant stream of travellers, coming and going, kept it in daily communication with Spain. Some years ago, a hoard of Arab coins was found in Spain in which some French coins were intermixed; among these was a piece struck in Puy in the tenth century. It had been bored through with a hole; that is, it had been hung like a jewel from the necklace of some Muslim woman.

A remarkable text dating from the end of the thirteenth century opens an astonishing perspective for us on the exchanges between Puy and Islam. It occurs in the *Mirror of Morality,* the great compilation which sums up the *Speculum majus* of Vincent of Beauvais, but was written by an unknown theologian after the author's death. One reads there a curious conversation between an archbishop of Lyons, who is not identified, and a preaching friar. The preaching friar is astonished to see that lightning sometimes strikes sacred monuments and the archbishop explains to him that since lightning is a chastisement, it must be assumed that these monuments have been contaminated by some unknown sacrilege. For this reason, the archbishop himself has seen the ancient stone before the cathedral at Puy, where the sick come to offer prayers, marked by lightning. Not long afterward, a holy saint, gifted with second sight, revealed that a crime had been committed upon that stone. Thus Puy cathedral itself was not

*See J. Vielliard, *Le Guide du pèlerin de Saint-Jacques de Compostelle,* 3rd ed. (Macon, 1963).

Le Puy (Haute-Loire). Doorway to the chapel of Saint-Michel-d'Aiguilhe, 11th–12th century.

sheltered from the fire from heaven and nevertheless, he adds, "The Saracens of the West, according to what one has heard told, offer gifts to Our Lady of Puy so that she will protect them and their fields from lightning and tempest."[3] Thus, something which it is hard to believe: the Arabs of Spain were in the habit of making offerings to the Virgin of Puy.

Ought we to reject this text from the *Mirror of Morality* as implausible? We certainly have no right to do so. We do not know what association of ideas may have taken place in the heads of those Muslims of the West who lived side by side with Christians. It is not impossible that they had special veneration for the Virgin, for the Koran speaks of her with the greatest respect. It proclaims her virginity. There are verses in the Koran that might be verses from the Gospels. "The angels say to Mary, 'God has chosen thee, he has kept thee from all stain, he has exalted thee among all women in the universe.' " (*Koran*, III, 37) Elsewhere,

[3]*Speculum Morale*, in the chapter entitled "De Sacrilegio locali," dict. 21.

God himself addresses the Prophet and says to him: " 'Bethink you of her who retained her virginity and into whom We breathed Our spirit; We created her together with her son as a sign unto the universe' " (*Koran*, XXI, 9).

Such words could only predispose the Muslims to respect. In Jerusalem, at the tomb of the Virgin, an ancient *mihrab* proves that Muslims prayed side by side with Greeks and Armenians in the sanctuary of the mother of Christ.

If Arabs travelled to Puy, it is not unlikely that there were Christians who journeyed to Cordoba. One cannot account for the unusual decoration of the churches of Auvergne and those in Puy except by admitting that the architects of those monuments had seen the mosque at Cordoba. That distant Cordoba, which seems to us a forbidden world, was not an inaccessible city; Christians were living there and openly following the practices of their religion. Some of those Frenchmen who so frequently crossed the Pyrenees surely penetrated that far. It was probably not very difficult to gain entrance to the mosque, for the builders of the Spanish churches imitated many of its details in their turn. French artists, for all that they were good Christians, could not resist the enchantment of that marvellous mosque, like a grove of palm trees in some desert oasis. Its details captivated them and were carried away in their memory: the shape of an arch, or a bracket, or a little dome chiselled out of the marble; the alternation of colors, the fantasy of the arches standing one upon the other; and they later took pleasure in making their churches beautiful with what they remembered.

All of these historic churches in Auvergne and Velay are the work of French architects; nowhere does the hand of a Muslim artist appear. Only the wooden doors of the cathedral at Puy could raise some doubt: that shallow carving, framing an Arab inscription, where the Latin letters themselves become a part of the design, seems to be the work of some Christian raised in a Muslim setting, of a Mozarab of Spain. If the hypothesis is not absolutely necessary, it is at least not an unlikely one.

We understand now why the monuments of Puy have such an astonishingly strange air. There is perhaps no more extraordinary church in France than Puy cathedral. The nave, covered not by a vault but by a series of domes on squinches, stirs the memory of Sassanid Persia. Arab Spain can be glimpsed on the façade and in the cloister. We know that the famous black Virgin worshipped in the sanctuary was said to have been brought back from Egypt. Everything here suggests the East, that timeless East which fascinated the Middle Ages and retains all its seductiveness for us today. In the cathedral at Puy we sense a nostalgic longing for the countries of the sun. That African décor, that yearning for the South, lend an irresistible charm to this strange cathedral. The great memories that it calls up add their own poetry. Every year, as the fifteenth of August drew near, the pilgrims of the Midi ascended in throngs along the old Roman roads, the Bolène way and the Régordane way, toward Velay. They came to worship the Virgin in her sanctuary, and one saw arriving there, along with the illustrious barons, the most famous poets of the *langue d'oc*. There was a height from which one caught sight of the holy city, and which was called, like the hill from which

one first glimpsed Rome, *Mons Gaudii,* the Mountain of Joy. This festival at Puy on the fifteenth of August was the great festival of southern France; one gave battle in the lists; one was dubbed a knight; one listened to the verses of the troubadours. There was nothing that could compare with those gatherings that took place at the foot of the cathedral, in the setting of great volcanic rocks. Worship of the Virgin, knighthood, chivalry, lyric poetry, all that was noblest in the soul of the Middle Ages made its appearance on this extraordinary spot, which seemed to have been prepared for some great event. All this today has vanished, and the strange cathedral appears as an enigma to the passing traveller.

In passing through this picturesque Velay, one comes more than once upon some of the Arab decorations from the cathedral of Puy. The abbey church of Monastier, standing amid the solitudes that herald Mezenc, also has a polychrome façade. The voussoirs of the portal are white and black; those of the tall window towering above it are red, white, and black; the mosaics of stone and lava, scattered with naïve art here and there, awaken the memory of Muslim design almost as vividly as at Puy. That reflection of Islam is particularly surprising in this place, when one considers that St. Chaffre, the patron of the church, was murdered here in the eighth century by Arab invaders before the battle of Poitiers. It is clear that the decorative arts of the twelfth century were indifferent to history.

In the capital of the Velaunians, Puy's forerunner, ancient Revessio (which is today Saint-Paulien), there is a Romanesque church those original appearance is poorly preserved; nonetheless, the exterior of the absidal chapels still displays mosaics in two colors, above windows whose voussoirs are white and black.

More than one village church in Velay perpetuates those Eastern traditions. One is even surprised not to meet more often with the colored mosaics and the alternating stone wedges, for this country of volcanoes, with its black lava and its red volcanic agglomerate, seemed designed for polychrome architecture.

But there are other elements of Arab decoration in the Velay churches: often they are entered through a polylobate portal similar to the one in the south transept of Puy cathedral. At times, they simply borrow a trefoil arcade from their model. These churches make up a great circle around Puy. They can be met to the south at Arlempdes and at Landos, as one follows the Loire back toward its source. They may be found along the roads that lead to the valley of the Allier, at Bains, at Chaspuzac, and on the very banks of the Allier itself, at the melancholy monastery of Chanteuges, on its Plutonian rock. One finds them to the north, near those gorges where the Loire has valiantly hewn itself a passage between the lava and the granite, at Saint-Vincent and at Chamalières. That beautiful and primitive abbey church at Chamalières, the best preserved of all, shows us along the flanks of its nave the trefoil embrasures of the cathedral at Puy.

These imitations should not surprise us in Velay. It was entirely natural that the artisans who had worked on the cathedral would borrow from it when they built in the villages of the diocese. But there is a phenomenon that does surprise: far from Velay, on the banks of the Rhone at Valence and at Vienne, we find once more the Arab motifs of Puy cathedral.

The Romanesque cathedral at Valence is an astonishing thing to find in the Rhone valley. Its ambulatory with radiating chapels brings to mind the churches of Auvergne, but the trilobate arches that decorate the exterior of the transept, the black and white voussoirs of the windows, summon up the memory of Puy cathedral. This influence from Puy was much more in evidence when the old bell tower, which was destroyed in 1838, was still standing. One could see polylobate arches there, and in particular trilobate arches, that were absolutely identical with those in the belfry at Puy; it was, without any doubt, the model that the architect at Valence had chosen to follow. A number of churches in the Valence region recall Velay by their multifoil arches. The elegant portal of the church at Étoile is a cousin of the portal with its Arab lobes in the transept at Puy.

If one ascends the Rhone, one finds a reminder of Puy once more at Vienne. The Merovingian basilica of Saint-Pierre, which is perhaps the oldest church still standing in France, has before it a Romanesque belfry erected in the twelfth century. On its second level, three trefoil arches exactly reproduce those in the belfry at Puy. Those Arab arches lend this square bell tower, which lacks a spire, the appearance of a minaret.

It is remarkable that Vienne and Valence, two cities exposed to all the influences of Burgundy and Provence, should have gone to Puy, from which everything seems to divide them, to find their models. The harsh mountains of the Vivarais, which plunge from their peaks straight down to the Rhone, seem to present an insurmountable barrier. But this is only an illusion. There has been a road that leads from the Rhone to Revessio, the capital of the Velaunians, since Roman times. Before it reaches Tournon, one sees the mountains opening into a wide gap; this is the beautiful valley of the Doux, which the ancient road followed. It began at a little port on the Rhone, where the Gallo-Roman sailors had raised a statue to the Emperor Hadrian, "the best of princes, the protector of the Gauls." It climbed toward Disania (Desaignes), where there was a temple to Diana, and on to Chinacum, which later became Saint-Agrève. Thence, across vast wastes, it continued to Revessio. During the Middle Ages, this road was constantly followed by pilgrims, by traders, and by travellers. In the seventh century, Bishop Agrippanus (St. Agrève) was assassinated by pagan peasants at Chinacum, which preserved his relics and took his name, as he returned from Rome. The popes often followed this road across the high plateaus. In 1095, when Pope Urban II came to France to preach the crusade, he halted at Valence where, on the fifth of August, he issued a bull; on August fifteenth, he was at Puy and officiated at the feast of the Virgin. Pope Paschal II in 1107 and Pope Gelasius II in 1118 travelled by the same route from Puy to Valence. Puy was thus linked by a direct road to the valley of the Rhone. One can now easily understand the similarities of detail that are so apparent between the historic churches of Valence and Vienne and the cathedral at Puy. One understands, as well, how the cusped doorway of Puy cathedral could reappear in the department of the Drôme.

But this is not all. The road from Puy came to join up near Caesar's old bridge, north of Tournon, with the highway along the right bank of the Rhone. This, too,

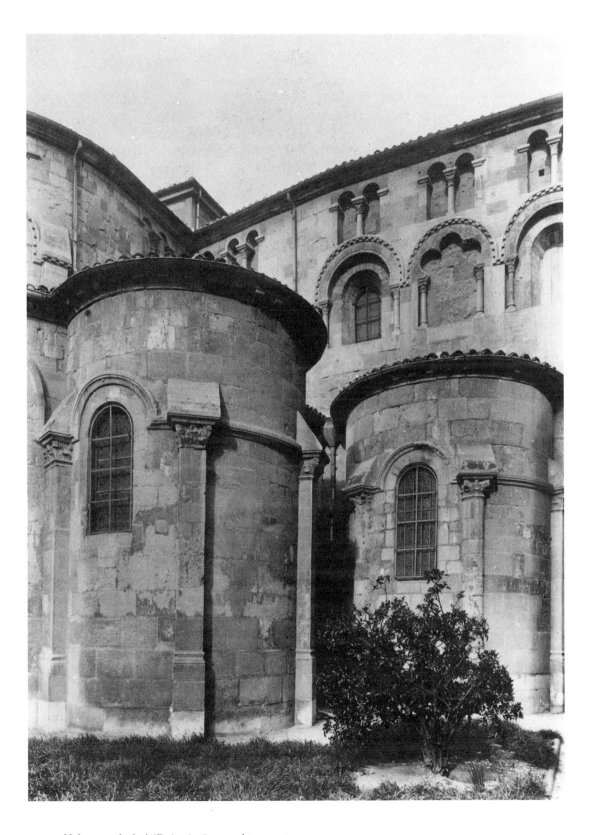

Valence cathedral (Drôme). Apse and transept.

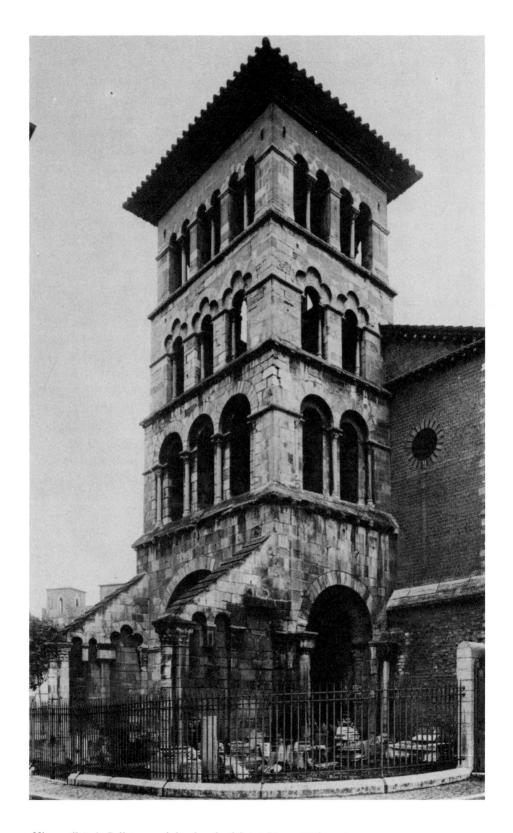

Vienne (Isère). Bell tower of the church of Saint-Pierre, 12th century.

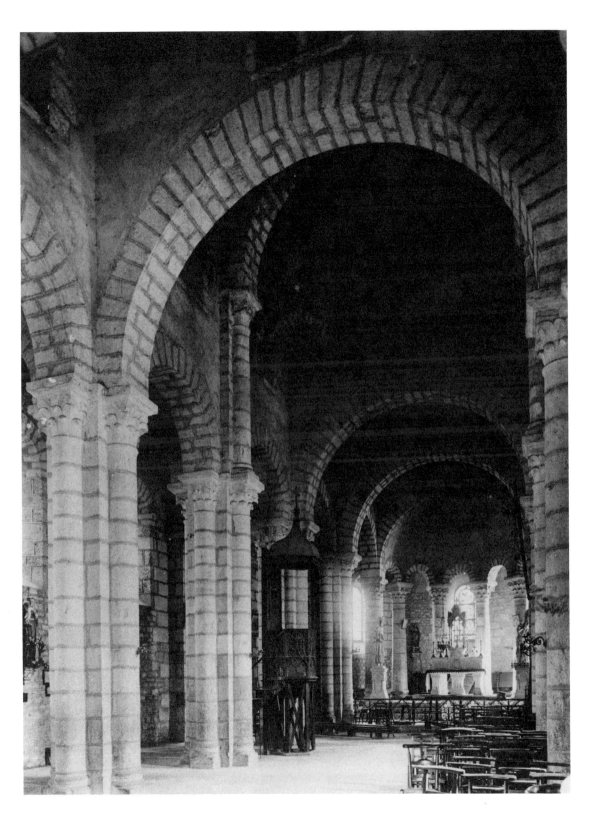

Nave of the church at Champagne (Ardèche).

was an ancient Roman road, marked off by milestones, funerary stelae, Mithraic bas-reliefs, and Christian ruins. Near Bourg-Saint-Andéol, one saw the triumphal column erected on the site of Andeolus' martyrdom. Now there are at least two churches along this road where one again finds reminders of Puy. Travelling southward, one comes upon the ancient church of Cruas, not far from a Roman milestone on which the name of the Emperor Antonius can be read. A belfry rises before its façade, and that belfry is pierced by a multifoil Arab bay whose original is at Puy. As one goes northward, another church appears that astonishes one by its oddness; built partially of Roman fragments, it is the one at Champagne. Its nave, like that of Puy cathedral, is roofed with domes on squinches; the imitation is obvious, crude as it may be. But it would seem that the architect was not only familiar with Puy but also with Clermont, for the galleries at Champagne open, like those of Notre-Dame-du-Port, through trefoil Arab bays. That road along the right bank of the Rhone, which ran parallel to the famous one on the left bank, explains how the decorative motifs of Velay were able to spread as far as Lyons. For it seems to me certain that the mosaic in colored stones that can be seen on the façade of Saint-Martin at Ainay is a last reminder of the cathedral, already so remote, at Puy.[4]

<p style="text-align:center">V</p>

THE OLD *Guide* to St. James of Compostela, written at the beginning of the twelfth century, tells us that four great highways brought the pilgrims from France toward Spain. The first ran from Arles to Toulouse and crossed the Pyrenees by the Somport Pass; the second from Puy to Moissac; the third, from Vézelay to Limoges and Périgueux; the fourth, from Orléans to Bordeaux via Tours, Poitiers, and Saintes. The last three, after crossing Gascony, came together at the foot of the mountains, at Ostabat; thenceforth, they made up a single road, which climbed toward the pass of Roncevaux. These roads, and others that led into them, were the highways by which the components of Arab design made their way into France; it is along these roads, or near them, that we will discover those components.

It is curious that the regions closest to Spain are those in which the themes borrowed from Muslim art are the rarest. It is true that Gascony, which is still little known, has not yet yielded up all its secrets. It is nonetheless true that up to the present time those themes appear above all in central and western France. It was with the Romanesque architecture of Saintonge, of Limousin, of Berri, of Auvergne, and of Velay, that the art of Islam merged most harmoniously. This commingling lends great charm to some of the churches in those regions.

If these borrowed elements are rarely to be found in Gascony and Béarn, they are however not wholly unknown there. One even comes upon one of the most extraordinary examples of the influence of Cordoba. Between Navarreins and

[4]The squinches of the dome at Ainay, with their double colonettes, are like those of Puy cathedral.

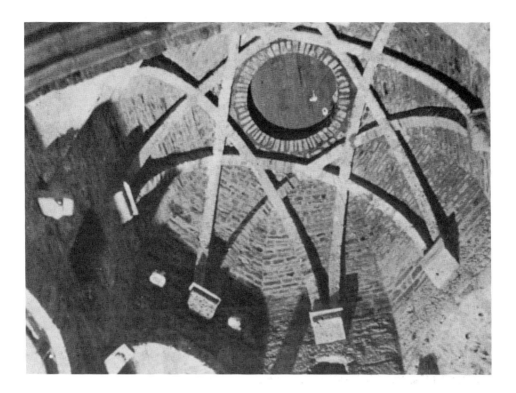

Hospital of Saint-Blaise (Basse-Pyrenees). Ribbed dome of the central crossing.

Mauléon, not far from the road that brought pilgrims from Puy and Moissac to Ostabat, stands an ancient church which the guidebooks do not even mention and which is one of the oddest in Béarn; it is that at the Hôpital-Saint-Blaise. Its cruciform plan is one of extreme simplicity, but at the meeting of nave and transept rises a truly extraordinary dome. It is supported by pronounced ribs which describe in outline an elegant eight-pointed star. Such a dome is purely Arab, and in the *mihrab* at the Cordoba mosque there exists one like it in every way. Had the architect of Saint-Blaise seen Cordoba? One would be tempted to think so, if one did not know that a ribbed dome of the same design can still be seen today at Toledo, in the former mosque of Bib-al-Mardom, now the church of Santo Cristo de la Luz. The dome at Toledo is furthermore nothing else than a copy of the one in Cordoba. It is thus possible that the architect of the Hôpital-Saint-Blaise did not journey any further than Toledo. Whether from Toledo or Cordoba, he brought back several practices of Muslim art that are easily recognized; he closed his windows with those stone slabs pierced with geometrical designs that one sees in the mosques, and he framed the bays of his bell tower with trefoil or multifoil arches, like those on the openings of minarets. This church at the Hôpital-Saint-Blaise is one of the most striking examples that can be given of the Arab infiltration along the pilgrims' roads.

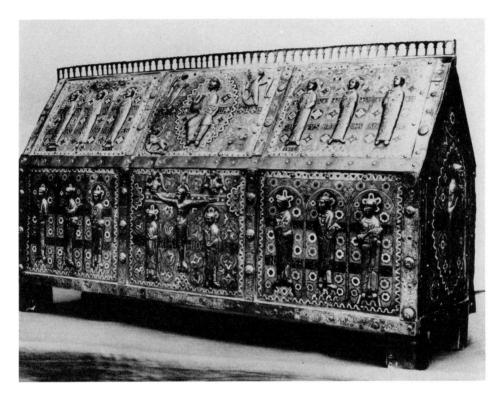

Church at Mozac (Puy-de-Dôme). Limoges coffer from Saint-Calmin. Enamelled copper, late 12th or early 13th century.

Let us return along one of the routes that the twelfth-century *Guide* indicates for us, the one which, starting at Vézelay, goes by way of Limoges and Périgueux. The influence of Arab Spain already begins to make its appearance at Périgueux. The old belfry of Saint-Front is more ancient than its companion, the famous domed church; the former goes back to the eleventh century. But before the restoration that rejuvenated it, one saw wood-shaving modillions beneath its cornice in the purest Arab style, older than those at Clermont; one will come upon some of them in the museum at Périgueux. Beside these modillions were others made up of a series of horizontal half-cylinders. Their models can still be found in Muslim Spain, for one sees ones that are similar in the oldest sections of the Cordoba mosque. These valuable fragments remind us that Périgueux was one of the principal way stations on the road to Spain.

Limoges has kept none of its Romanesque churches and we cannot say if the art of Islam had left its mark on them. One is inclined to think so, when one carefully examines the designs of the Limoges enamels. In the twelfth and thirteenth centuries, motifs borrowed from the decorative script of the Muslims are indeed more than once to be found there. In the beautiful enamel in the Cluny Museum, the Adoration of the Magi is set beneath a great multifoil arch that resembles the arcade of a mosque. But the Limoges coffer from Saint-Calmin that

is preserved in the church at Mozac (Puy-de-Dome) furnishes us with proof: behind the figures, there runs an inscription in Arab lettering. A similar inscription, but in a much more beautiful design, decorates the rim of the Louvre's splendid ciborium, the work of Alpaïs, enamel worker of Limoges. These examples are not the only ones that could be cited. In all these inscriptions, the letters are put together at random and have been chosen solely for the beauty of their arabesques. Limoges thus seems to us one of the cities of France where the charm of Muslim design was sensed most vividly.

From Limoges the highroad led the pilgrim on to Saint-Léonard, where he worshipped at the tomb of that famous hermit to whom captives prayed for their deliverance. From Saint-Léonard, the *Guide* tells us only that the road led to Vézelay. But by what route? That is not difficult to guess, for we are familiar with the traces of the Roman way that crossed the provinces of Marche and Berri: it ran by way of Argenton, Châteauroux, Issodun, and Bourges. It is along this road that the multifoil portals will begin to show themselves. Those that we have seen earlier, at Puy or in its neighborhood, are of one particular type; the lobes are blind, that is to say, they describe their scalloping around the arch of the doorway but do not open into the interior. Here, on the contrary, the arch itself is cusped; it is made up of a chain of small contiguous semi-circles that create a luminous lacework against a background of shadow. One scarcely needs add that these portals would not have possessed tympana, since their whole charm comes from this lace-like edging to the bay. The Arab mosques never made use of entrances of this kind, but what one does not find without, one discovers within. In the Cordoba mosque, a splendid multifoil arch leads into the private chapel, or *maqsura*, of the caliph. From time to time, the interior arcades of the mosque have this cusped outline. The grand mosque at Tlemcen has arcading of this kind. Among the wild gorges of the Atlas, at Tinmel in Morocco, near the track from Marrakech to Taroudant, one comes upon a ruined mosque dating from the twelfth century that was erected by the Almohads on the very spot where their ancestors dwelt. Its arcades are scalloped, and those arcades with their pointed outlines resemble certain Romanesque portals in central France. The genius of French architects lay in realizing that these designs, which lost something of their beauty in the obscurity of the mosque, took on their true value in full light, and they adopted the multifoil arch for their portals. [5]

Leaving Saint-Léonard, the pilgrim hastened to rejoin the great Roman road running from Limoges to Bourges. It passed within a short distance of Bénévent-l'Abbaye, and it is probable that this monastery, at that time rich and famous, offered shelter for the traveller. He found there a reliquary to adore, for in earlier times pilgrims returning from the Holy Land through southern Italy brought from Benevento the relics of St. Bartholomew the Apostle; it was then that the abbey took the name of the Italian city. Its fine Romanesque church is entered through a

[5]It should be added that there are certain differences of outline. The Romanesque multifoil arch is an adaptation, and not a literal copy, of the Arab multifoil arch.

multifoil portal that throws, over its rough granite façade, a glimmer of the East.

A little further along, the road reaches the Gallo-Roman outpost of Bridiers, whose place was taken in the Middle Ages by the little town of La Souterraine, situated at a short distance. The church at La Souterraine is also entered through a multifoil portal; its pierced arch, instead of being semi-circular, is a pointed arch and recalls the arcades of the Tinmel mosque.

The abbey of Déols, at the gates of Châteauroux, was without question one of the principal halts on the Bourges road. Little remains of its church today, which, if one judges by the bell tower that still stands, was one of the most splendid in central France. The great doorway was destroyed along with the entire façade, but a small portal that led into the cloister still exists; this doorway is itself polylobate and the voussoirs surrounding it are of the same design.

The Romanesque churches of Bourges, as we realize, have vanished. Did they have multifoil portals? I believe that we may assume that they did, for that design was carried over into the following century and reappears on the façade of the cathedral. The central portal, divided by a mullion, opens through two semicircular multifoil bays. These bays are more richly decorated than those of Romanesque doorways, but derive from them. One would search in vain for a similar doorway in other thirteenth-century cathedrals. The architect of Bourges was therefore surely inspired by a Romanesque model that was before his eyes. This curious reminder of the past proves to us that in the twelfth century the cusped arch of the Arabs was known in Bourges. It was probably from Bourges that multifoil portals spread into the neighboring countryside. They occur frequently in the southern part of the former diocese and, curiously enough, the principal ones are strung out along the Roman road that ran from Bourges to Clermont by way of Néris; we meet them, indeed, at Saint-Symphorien, at Saint-Amand, at Ainay-le-Vieil, at Malicorne, at Colombier, and at Charroux. For a long time there still existed another witness to Bourges' links with the Muslim world. A bas-relief that was still in existence around 1840 showed an unidentified figure surrounded by a border made up of Arab lettering. In the opinion of Longpérier, who published a drawing of it, it was one of the panels of a Romanesque portal. One senses that Bourges also lay on the pilgrims' route to Spain.

By what road could the traveller go on from Bourges to Vézelay? The Roman way, whose track we know, led in an almost straight line toward Sancerre, where it crossed the Loire. Thence, one could continue on to Clamecy and Vézelay. But it is likely that in the twelfth century many pilgrims, as they set out from Bourges, followed another road that brought them to La Charité. From the twelfth century onward, in fact, there was a bridge across the Loire at La Charité—a bridge that posits the existence of a road leading toward Bourges. Early in the thirteenth century, a church was built at La Charité in honor of St. James. A church under that patronage indicates that pilgrims continually passed by, for sanctuaries dedicated to St. James sprang up along all the roads to Compostela. It was natural that travellers seeking shelter for the night would come to this rich abbey of La Charité, which had earned a glorious name for its hospitality. Like Vézelay, La

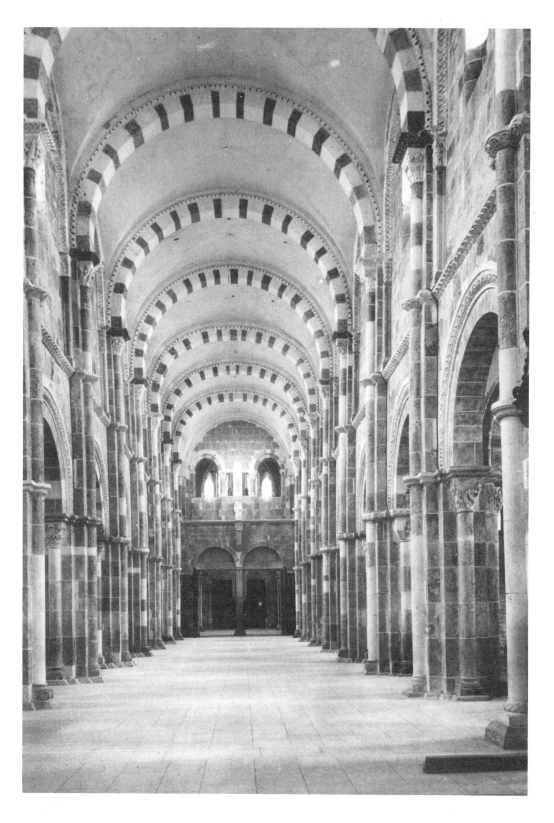

Vézelay (Yonne). Basilica of the Madeleine: nave seen from the choir, early 12th century.

Charité was one of the most celebrated of the Cluniac priories, and it would indeed have been surprising if the route to Compostela, laid out by the monks of Cluny themselves, had not directed pilgrims from Vézelay to La Charité. In the twelfth century, the church at La Charité, where we have seen such striking reproductions of Muslim art, was thus in all likelihood situated on one of the roads from Spain.

Lastly, at Vézelay, at the end of the journey, will we again find some souvenir of Arab Spain? The exterior of the great abbey church will not reveal anything that suggests the art of Islam; we will not find there that East for which we seek. The portals have no cusped arches, even though this type of arch had been carried on by architect-travellers a little beyond Vézelay; one sees it again, decorating the portal of the church at Montréal and the belfry of Saint-Eusèbe d'Auxerre, after which it appears no more. But if we enter the church at Vézelay, after an initial shock of admiration that arrests the critical faculties, we realize with surprise that the voussoirs of the pronounced vaulting ribs are in turn white and dark grey. To be sure, these arches were reconstructed by Viollet-le-Duc, but he did not invent them and we may trust him when he refers to this alternation of colors as the work of the twelfth-century architect. Viollet-le-Duc was at that time still a young man; he had much greater respect for the old masters than he was to have later and he did not yet believe himself to be their equal. Thus, at the very end of the road from Spain, we rediscover the arches in two colors of the Cordoba mosque. Nothing in the architecture of Burgundy anticipates this singular fantasy, nothing explains it, it has no past and it had no future. One can only understand it by recalling those pilgrims who, as they returned from Spain, came to kneel in the church at Vézelay.

VI

THERE WERE TWO HIGHWAYS from St. James that crossed, the one, Saintonge, and the other, Angoumois. It is the first to which the twelfth-century *Guide* refers. The pilgrim who was returning from Compostela, after having travelled through the Landes and revisited Bordeaux, followed the old road from Blaye to Saintes and from Saintes to Niort and Poitiers. The great monuments along the way have unfortunately vanished. The church of Saint-Romain at Blaye, where Roland was buried beside the beautiful Aude, no longer exists; it was ruthlessly razed by Vauban. The façade of the church of Saint-Eutrope at Saintes, which was in all probability one of the prototypes of Saintonges façades, was destroyed by the Protestants. The magnificent abbey of Saint-Jean-d'Angély, where the pilgrims halted to venerate the head of John the Baptist, suffered the same fate. Thus we shall never know what traces Arab Spain had left on these great monuments. In place of these archetypal churches, which must have served as their models, there remain along the pilgrims' way, or in its vicinity, a few that are like the imprints left by those generations of travellers. At Saint-André-de-Cubzac one glimpses an Arab arch in the shape of a horseshoe in the bell tower. Near Pons, where there

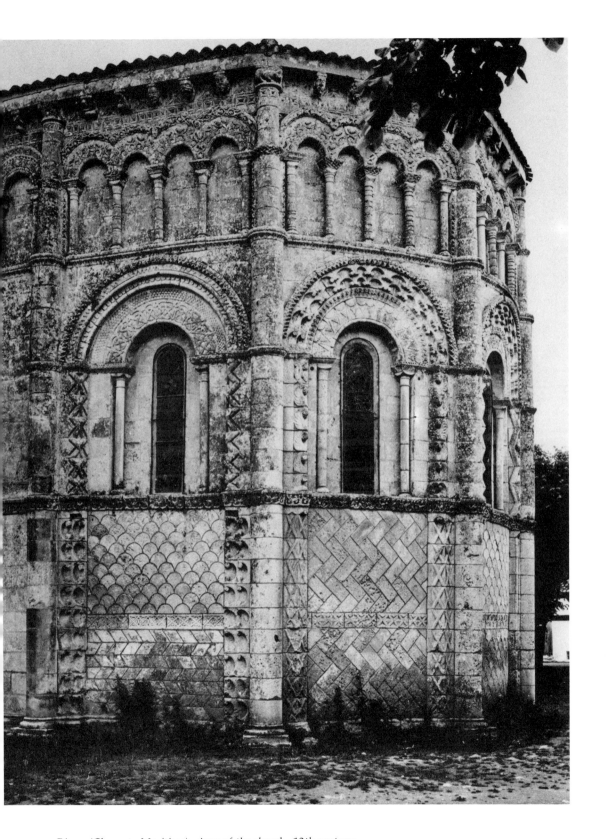

Rioux (Charente-Maritime). Apse of the church, 12th century.

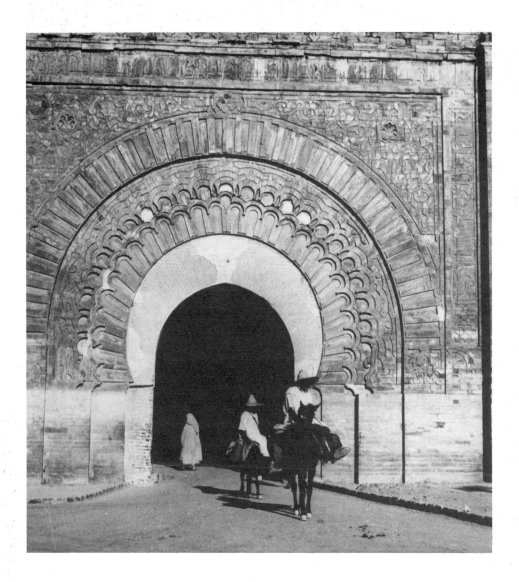

Marrakech. The Bab-Agnaou gate.

was a hospital for pilgrims, arise the churches of Échebrune and Pérignac, which are entered through multifoil portals. Between Pons and Saintes, but at a little distance from the highway, one comes upon the church at Rioux, whose apse is a flawless masterpiece. Several of its windows are surrounded by blind multifoil arches, but these arches are double rather than single, and describe two superimposed festoons. Similar arches appear in Muslim art; the magnificent gateway of Bab-Agnaou in Marrakesh, grandiose like all the works of the Almohads, has that double line of scalloping. There existed, beyond question, similar gateways in Spain and, if one is to believe legend, it was in Andalusia that the Marrakesh

gateway first was raised. It would apparently have been carried away, stone by stone, by the Moors, as a reminder of their lost homeland. Multifoil arches appear again in the neighborhood of Saintes, at Trizais. We find them once more—not at Niort, whose Romanesque buildings have disappeared—but not far from Niort, at Celles-sur-Belle. They reappear beyond Parthenay at Thouars, on the route followed by the pilgrims from Anjou.

The pilgrims' *Guide* makes mention only of the Saintonge road, but there was another no less frequented, by way of Angoumois. It was first mentioned by the monk Aimoin, who in 1003 accompanied St. Abbon from the monastery of Fleury-sur-Loire to the monastery at La Réole.[6] The principal halting-places on the journey were at Poitiers; the monastery of Charroux; Angoulême; Aubeterre; Casseneuil, where the old palace of Charlemagne could still be seen; and finally the abbey of La Réole, defended by its fortress-like walls and towers. The pilgrims from Anjou and Poitou willingly followed this road, and at La Réole rejoined the main highway from Vézelay to Compostela that ran by way of Limoges and Périgueux. Often they turned out of their way a little, to have their wayfarers' staffs blessed by the abbot of Grand Sauve, who was one of the founders of the pilgrimage to St. James. We do not know the exact course that this route followed from La Réole to Angoulême and Charroux; we can see only its general orientation. Beyond La Réole, at Courpiac and at Clairac, we will again meet with wood-shaving modillions; at Puisseguin, a polylobate doorway makes its appearance. At Petit Palais, a façade that is the most delightful of all these charming façades of the South-West offers us five examples of the polylobate art of the Muslims. On the central window, the scalloped arches are superimposed as in some of the doorways of the Maghreb. On either side of the cusped portal, the arcading, with its elongated scalloping, exactly recalls the fenestration of an Arab house in Toledo. A church of this kind, in which Christian art is so closely associated with the designs of Islam, is the French equivalent of the churches built by the Mudejars in Spain. Multifoil doorways appear again at Guitres and at Aubeterre. From Chalais to Montmoreau, from Montmoreau to Blanzac, from Blanzac to Plassac and Moutheirs, the churches decorated with multifoil arches follow each other toward Angoulême.

VII

SHOULD ONE HAVE the opportunity to study all of the routes followed by the pilgrims to St. James with the most scrupulous attention to detail, one would discover along nearly all of them, at the principal way stations, some reminder of that Muslim art which Christians were never able to forget.

At Moissac, for example, where travellers halted before they began the ascent toward Puy, the first thing that strikes us today is the unexpected shape of the pillars of the doorway; they are cusped, rather than being straight—a wholly

[6]*Vita sancti Abbonis, Patrot. lat.*, Migne, vol. 134.

Eastern concept. One next notices that the sculptured figures on either side of the porch have trefoil arches above their heads (that is to say, Arab arches), and these Moissac trefoils are among the most ancient that still exist in France. If one enters the beautiful cloister, one discovers there a number of capitals whose design instantly calls up the memory of Muslim art. Here are interlacing and palmettes done without relief, sharply undercut and standing out like lacework against a dark background. One recognizes the spirit of Arab sculpture, and one thinks of those ivory boxes, netted over with fragile lace, that were carved in Andalusia for the caliphs and the sultans. Then a detail, suddenly glimpsed, transforms our instinct into a certainty: on the abacus of one of these capitals, a series of Kufic characters outlines the most elegant of borders and sets upon the work the seal of Islam. There were artisans therefore at Moissac who had been in contact with the Arab world: this explains the motifs that had surprised us on the doorway; this also explains why, on yet another capital in the cloister, St. Peter's prison opens through a multifoil arch like the arcade of a mosque.

Not far from Moissac, at Saint-Antonin, we find the trefoil arch again in the campanile of the charming palace built in the twelfth century by the vicomte de Saint-Antonin. But the squares of Arab faience, set in the façade like some exotic rarities, bear witness still more conspicuously to the influence of the East. Surely it was in Spain that these beautiful tiles originated, that were judged so worthy of admiration.

Along the road from Somport toward Toulouse and Arles, traces of Muslim art are rarer. Yet a few of them do exist. The great church of Saint-Sernin at Toulouse, so like that of St. James at Compostela, speaks to us of Christian Spain but seems in no way to recall the Spain of Islam. If one climbs to the tribunes, however, one finds capitals there with flat interlacing, strongly undercut, that might have been incised with a scalpel. These capitals, which are like those at Moissac, testify to the same Muslim influence.

We know from the twelfth-century *Guide* that the road led the pilgrim from Toulouse to Saint-Guilhem-du-Désert. It must surely have passed by Saint-Pons de Thomières, where there was a celebrated Cluniac priory that greeted the traveller. Thence it arrived at the beautiful valley of the Orb, which it followed for several leagues. Beside this road there stands, not far from Lamalou, the Romanesque church of Saint-Pierre de Reddes. Its doorway is surprising, for the decoration on the lintel consists of one Arabic character, repeated over and over, that creates the impression of an inscription in Kufic lettering. A cross of dark lava, set into the tympanum, reminds us that this unusual construction is not a mosque but a church.

From the valley of the Orb, the pilgrim reached the valley of the Hérault. There in a narrow gorge, among jagged rocks, beneath the glare of an African sun, appeared a church gilded by the centuries. It stands over the tomb of a hero of epic, canonized by the church, William of Aquitaine, whom the poets called William of the Short Nose. This church of Saint-Guilhem-du-Désert copies, on its exterior, the decoration of the churches of Lombardy. But the capitals that enrich

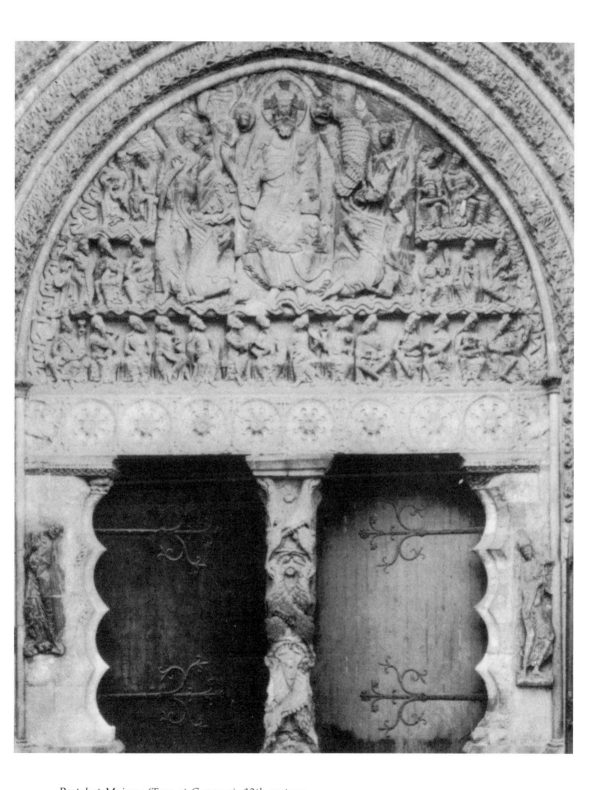

Portal at Moissac (Tarn-et-Garonne), 12th century.

the windows of the apse have an unusual appearance. These are capitals in the shape of a cube that abruptly diminishes and becomes circular, like the column that carries it; a network of palmettes and flat tracery surrounds it. What we have here are neither Lombard capitals nor French capitals, but Arab-inspired capitals. One finds others that are almost identical, two hundred years later, in the Court of the Lions in the Alhambra at Granada, or at Fez, in the Attarine *madrasa*. Thus William, the legendary champion of Christianity against Islam, had Arab capitals to surround his tomb. If he could have known of it in advance, it is likely that he would not have been at all offended, for the poets assure us that he had married a beautiful Muslim captive.[7]

These, then, were the gifts of Arab Spain to the Romanesque art of France. They consist, as we see, only of a few decorative elements. The Arabs, whose mosques were not vaulted, did not have major lessons to teach our twelfth-century architects, who were already so skilled. But the Arabs possessed a talent for decoration, and they knew how to lend an irresistible charm to their graceful fantasies. France borrowed from them some of their supple linear designs. The traveller who has seen the world of Islam recognizes those adaptations with delight; they cast a gleam of the ardent light of the South over our sober Romanesque churches. But the historian is moved even more deeply than the artist, for those shapes bring before his eyes pages of French history that are half-obliterated. That great age of the pilgrimage to Santiago and the struggle against the Moors exists not only in the *Song of Roland;* it is written across the brow of the old churches along the road to Spain; it is written on the transept of Cluny, on the bell tower at La-Charité-sur-Loire, on the façade of Notre-Dame-du-Puy. Those superb monuments, which we have been admiring, thereby will become not only more beautiful in our eyes, but even more to be venerated.

[7]Let us again briefly point out some imitations of Arab art along the pilgrimage routes. The Roman way that brought pilgrims to St. James from Clermont to Périgueux shows us along its course or in its neighborhood multifoil portals and arcades at Meymac, Palisse, Rosiers-d'Égletons, and at Tulle. At Brive, which is on the same route, the capitals in the porch of the church of Saint-Martin, as Viollet-le-Duc has already pointed out, suggest Arab capitals. Another road from Limousin to Cahors and Moissac led those pilgrims to St. James who wished to make a halt at the sanctuary of Rocamadour. This route is also bordered with churches whose portals are polylobate: Lubersac, Vigeois, Allassac, and Noailles. The cathedral at Cahors shows us the trefoil arch as well.

R ODIN'S BOOK on the cathedrals of France* is not a book in any conventional sense: these are trembling notes, noble reflections, beautiful metaphors, which it is difficult to bind together into a wreath. Do not seek the history of the cathedrals here, nor the laws of their equilibrium, nor an explanation of these encyclopedias of stone. The practical spirit that demands exact information from what it reads, solid facts to carry about on its travels, has no business here. Rodin provides very few explanations, and those which he does provide seem primarily intended for himself. It is as a sculptor that he looks at architecture. If one asks him why the cathedrals are beautiful, he replies that they are kneaded out of light and shadow. In the cathedral, as in the human body, each element enacts its own function, and it is light and shadow which reveal these harmonies. Each passing hour unveils some new beauty. The artists of today have lost the secret of design, of profundity, of eloquent shadows; that is why their work is shallow, arid, without a soul. When they meddle with the monuments of the past, their restorations are little more than crimes. Such is approximately Rodin's whole message.

But is it necessary for Rodin to furnish us with reasons? That he admires is enough. When a man who has created masterpieces tells us that the cathedrals are sublime, that we should gaze at them with tears of joy, one ought to take him at his word.

Does one ask a visionary or a prophet for his reasons? One listens and feels the heart kindle within one's breast.

Rodin's role is to bear witness. Inspired, like his own St. John the Baptist, he preaches the fundamentals and begs us to believe in them. Listen to his texts:

"The imagination that created the Parthenon is the same as that which created the Gothic cathedrals."

"A bas-relief like this one at Amiens is as fine as a Greek stele from the classical period."

"The artists who have done this have cast a glimmer of the divine over the world."

"The French temperament achieved perfection and then drew a veil of humility over it."

"The Parthenon was the defender of Greece. . . . The nation cannot perish as long as the cathedrals endure. They are our Muses; they are our mothers."

"Why do you disdain happiness? Come and receive true life from those who are no more, but who have left us such magnificent witnesses to their soul."

To express what he feels, Rodin finds metaphors that rival in beauty the

*Auguste Rodin, *Les Cathédrales de France* (Paris: Armand Colin, 1914). One volume in quarto, with one hundred untitled plates following the text. [Available in English, translated by Elisabeth C. Geissbuhler, with titled plates, from Black Swan Books Ltd.]

things he wishes to describe. He sees flying buttresses thus:

"The cathedral is surrounded by faithful and valiant friends who sustain her in her attitude of prayer, as the Hebrews sustained the arms of Moses, lifted toward God." The undulation of Gothic moldings is linked in his imagination with the movement of the sea. "Gothic moldings," he says, "are sometimes inspired by a tempest. They move like the sea, in surges." The beauty of an arch above a portal comes to him in a rush: "I understand the profound eloquence of the arch. It appears to me like the orbit about a star."

Do not protest, "These are nothing but metaphors." Beautiful metaphors prove a great deal, for only beautiful objects can give birth to beautiful images. At times, his metaphors partake of the visionary, almost the ecstatic. "Two pillars, near the choir, seem to me like two angels. They represent two great witnesses to the strength and purity that have their sanctuary here. . . . Suddenly, gazing upon them with increasing love, I grow, I participate in their being, an influx of purity and strength flows to me from them. The youthfulness of my spirit revives." How splendid! In this artist who seems to be wholly occupied with form, appearance resolves itself nearly always into spirit, is transformed into symbols, reaches a climax of lofty moral thought. The foliage of a capital thrills him, but see to what depths that emotion reaches: "This leaf breaking forth . . . the same impulse that formed heroes and martyrs has formed this leaf as well." And elsewhere, "Before the cathedral I feel myself elevated, transfigured by the awareness of justice. Justness of form, which mirrors and corresponds to moral justice." Who has better sensed the harmonies of the soul? And has he not the right to say that there is no art that is not religious?

I have no doubt that Rodin's book will make the cathedrals beloved, but it will also make Rodin better understood. One will marvel over this inner paroxysm, this enthusiasm that grows over the years; one will be struck by this nobility of thought and at times astonished by sudden insights. This book is a witness; it proves that great artists are only great in terms of the soul. Rodin belongs by right among the most sensitive temperaments of the nineteenth century. Often he is moved to respond like Chateaubriand, like Michelet, like Ruskin. In *René*, there occurs a phrase full of beauty and mystery: "How beautiful they are," says Chateaubriand, "those sounds which we hear echoing inside a dome!" What was he trying to express? In all likelihood, no one has understood, but now a phrase of Rodin's suddenly sheds light on Chateaubriand's phrase. "Within the majesty in which the cathedral wraps itself like some vast cloak, the sounds of the world— footsteps, the rumble of a carriage, a closing door—reverberate. *The solitude orchestrates them according to a harmonious sense of the proportions.*"

Rodin belongs as well among the poets. At times, his phrases begin like the *Méditations*. "Entering that ancient church, it seems to me that I am entering my own soul . . . ," or again, "Time does not exist within this cathedral, only eternity." He speaks with the religious accents of the lyric poets. "This flower, of the violet that I love, in a window of Notre-Dame, moves me like a memory, now all the more so as we return to God, she and I."

Chartres cathedral. Drawing by Rodin, from a sketchbook in the Loliée Collection, Paris.

But it is when he pictures the beauty of women that he rivals the most sensitive of the poets. "That corner of the mouth, that line, narrow to begin with, which diverges and spreads: the dolphin of antiquity. . . . The words that stir as they emerge from the lips are shaped by them, by their delicious movements." Has Sully Prudhomme written any brief lyric about a young girl that is more tender and chaste than this:

"A little French girl glimpsed in church, a little lily of the valley blossoming in a new dress. Sensuality is still alien to that adolescent form. What modest grace! . . . From my place behind her, I see only the simple outline of her figure and the rose velvet of her child-woman's cheek. But she raises her head, turns away for an instant from her little book, and the profile of a young angel appears. Here is the young girl of the French countryside in all her charm: simple, honest, tender, intelligent, and smiling with that calm of true innocence that expands like a gentle contagion and pours its peace into the most troubled hearts."

Like all true poets, he senses mystery everywhere. Victor Hugo can only speak of sculpture with a sort of terror; that changeless form, it seems to him, is born of some enchantment. Rodin, who has created statues with his own hands, is close to sharing this belief in magic. "Reality of the soul," he calls it, "that one can capture in stone, that one can imprison for centuries." And those statues which he visualizes in the night seem to him "as if they waited upon some vast event."

The great artists have no need of our books; for them, the study of nature, meditation, reverie, are better teachers. Rodin has arrived at that hour of which Virgil speaks, when dreams become realities. His "new friend, old age" has brought him certainty. This he shares with us: we can be, we must be, happy. "What a paradise this earth is! Let us only try to exhaust the share of abundance, of happiness, that has been allotted to us; we will never come to the end of it, for it is infinite." How does one achieve happiness? By the labor that leads to admiration. "Begin by studying a plant and you will discard all the childishness of vanity." "Let us reduce everything to admiration and not search so far afield for beauty." Beauty is everywhere; you will find it by observing the flower by the roadside or the faces about you. "Look at your parents, your friends; admire the touching beauty of those dear faces through which glimmer souls that sacrifice themselves in silence. See your friends as Rembrandt saw his. Were there only living master-pieces, then, around that great man?" Admiration is inseparable from love. A man cannot lift himself higher. "To admire is to live in the presence of God." Does Rodin not reveal here for us—at the same time as the secret of happiness—the secret of the eternal seduction of masterpieces? Men recognize that the great artist was all admiration, all love; they are aware that he was happy. And it is with that happiness that they long so avidly to be associated.

The labor of solitary imagination, the passage of the years, carries Rodin on from idea to idea, leads him to the very doorstep of the mystery. He muses on the religious instinct: "Art, for the artists of earlier times, was one of the wings of love; religion was the other. Art and religion provide humanity with all the certainties

that it needs." A mass that he hears in Limoges cathedral stirs up a storm within his soul. Architecture, music, liturgy, all combine their forces to tear passionate exclamations from him.

"The church is no longer terrible, as it was before the office began. . . . Love answers, *Credo.* Ah! all is love here!

"What submissiveness in that long-drawn-out *Amen*!

"The vault lifts even higher now, immense.

"*Crescendo.* A pure voice, ultra-celestial.

"Ah, yes, what a triumph to submit our spirit to the discipline that can re-forge it!"

And he concludes, "Faith civilized the barbarians that we once were; in rejecting it, we have become barbarians once more."

As I read this book of Rodin's, I thought of those that Viollet-le-Duc, himself an artist, wrote on the cathedrals. Both men call upon us to admire, but has there ever been such a contrast? From the one, intuitions, metaphors, outbursts of admiration; from the other, dispassionate enlightenment and a geometrician's logic. His thought is as acute as the fine point with which he sketches, but in that gifted Viollet-le-Duc, who is all intellect, one thing is lacking: the dream. His cathedral holds no mystery; it seems to be lit by windows of clear glass. What has happened? It is that when Viollet-le-Duc created, he produced work that may satisfy logic but which freezes the emotions. The cold light of undiluted reason falls upon his moldings. Not so Rodin. After reading his book, after sharing his raptures before the cathedrals, after the surprise of that constant inner exaltation, one understands why there is not an inch of skin on his statues that does not quiver. And one understands his aphorism, "The intelligence designs, but it is the heart which molds."

It is thus not by reason alone that one creates a work of art; nor is it by reason alone that one understands it. The Greeks knew this. They have told us that the Muses of inspiration were the daughters of Zeus, the god of reason and clarity; but also that their mother, Mnemosyne, was a goddess from the race of Titans, a child of Earth and Sky and sister to the Ocean.

J UST AFTER LEAVING Limoges, whose beautiful cathedral is a daughter of those in the North, I arrived in the charming small town of Martel on the borders of Quercy. There, the tall houses of the Middle Ages have preserved their emblazoned turrets; an old palace still displays its fourteenth-century windows, and the narrow streets lose themselves beneath stone vaulting or under arching trellises of vine. From a distance, the church resembled a fortress; I entered it and felt that I was entering a different France. It consisted of a single nave, without columns and without aisles; a great hall covered with rib vaulting where the entire community could gather together; where the words of the priest reached all the faithful, and where the voices were raised together in song. Gothic art has been reduced to its most fundamental expression here. Since a nave without aisles has no need of flying buttresses, simple piers were enough to counter the thrust of the vault; but, so that no space should be lost, lateral chapels had been opened on the two sides of the nave between those piers. Nothing remained of the Gothic system but the essentials.

It was the art of the Midi that I encountered here for the first time, coming from the North. In it another spirit began to show itself. This interior held no exuberance, only calm. Like the men of antiquity, the architect had sensed the beauty of vast open spaces and had sacrificed height for amplitude. A few narrow windows lent this church, deprived of the poetry of columns, something of the mystery of twilight.

As I went on my way southward, I continued to come upon churches like that at Martel; I saw them at Gourdon and at Cahors; at Moissac, Toulouse, Albi, Carcassonne, and at Perpignan. I saw those that were entirely similar in the small towns of Languedoc and the hamlets of Gascony; in those new towns of the South-West, founded in such great numbers at the end of the thirteenth century or the beginning of the fourteenth. If I had journeyed into the Midi by way of Auvergne, I would have met these meridional churches much earlier, for Notre-Dame du Marthuret at Riom is already of this kind and, at the gates of Clermont, the church at Montferrand. On the other hand, for the traveller who descends the valley of the Rhone, they scarcely appear before Avignon.

Thus, the majority of France's southern provinces—Auvergne, Quercy, Gascony, Languedoc, Provence, and Roussillon—show us a stylized type of church, where the Gothic is not only made simpler but filled as well with a different spirit. This meridional Gothic did not halt at the Pyrenees; Catalonia made it welcome at an early date, and churches with a single nave (which is relieved only by the chapels that open between the pier buttresses) are almost as frequent there as in Languedoc. We become aware of an affinity of culture and taste between mediev-

Revue des Deux Mondes (February 15, 1926).

Church at Martel (Lot). View from the north-east.

al Catalonia and France's southern provinces.

The origin and spread of this architecture of the Midi are curious phenomena; they have frequently been mentioned but perhaps never studied with the attention that they deserve. This fine subject would require a whole book in itself; here we will outline it only briefly.

I

THOSE GOTHIC CHURCHES with a single nave that are so surprisingly apparent to the Frenchman from the North as soon as he has plunged into the central plateau— were they really a new departure for the Midi?

Let us return to the age of the Romanesque; let us think back over the great meridional churches of the twelfth century, and we will be surprised to find them equally as simple as the Gothic churches that we have just described. The Romanesque cathedrals of the Midi—Angoulême, Bordeaux, Périgueux, Cahors, Agde, Maguelone, Cavaillon, Digne—have but a single nave. The cathedrals of Avignon and of Aix, so disfigured today, were originally churches with a single nave. The cathedral of Toulouse, begun in the first years of the thirteenth century, is a magnificent hall, without interior divisions, that has the grandeur of an ancient monument. The more modest churches, those charming Romanesque churches of the Midi that one finds upon entering Auvergne and Velay, are very often churches without aisles. Anyone who has journeyed through Provence will recall those enclosed spaces that are so uncluttered, yet so happy in their proportions, so poetically full of shadows, that make up the churches of Saint-Gabriel, near Tarascon, and the Saintes-Maries-de-la-Mer, on the desolate strand of the Camargue. Churches of the same kind are scattered across ancient Acquitaine. The Midi seems from the first to have had a genius for simplification that turned it from the basilical plan. The aisled churches that one does find there are predominantly pilgrimage churches, like Conques and Saint-Sernin at Toulouse, which remained faithful to a hallowed model, or monastic churches which, like the churches of the Cistercians, copied the mother-churches of Burgundy.

The single naves of these Romanesque churches of the Midi are covered over either with a barrel vault or with a series of domes, as in Quercy and Périgord. The dome has lent a splendid character to these single-naved churches of the Midi. Few historic buildings have moved me as deeply as the old abbey church at Souillac. I saw it, no doubt, at one of those fugitive moments when it seems as if the beauty of objects reveals itself to us. What grandeur there was in that nave crowned with the ageless cupolas of Asia! What an intake of breath, a murmur from the world of the antique! The choir, opening wide into a magnificent semi-circle, has kept the nobility of the apse in which the Roman magistrate was seated. The soul of the monk expanded freely in these vast spaces. Such a church, the child of the southern temperament, opposes with all its being the dramatic church, mysterious and filled with yearning, of northern France; all here is calm, harmonious, grand, but with a grandeur measured on a human scale.

II

IT WAS ONLY in the opening years of the thirteenth century that the southern architects began to launch vaults above their single naves that were carried by strong ribs intersecting at right angles, that is to say, by Gothic vaulting. The old nave of Toulouse cathedral offers us one of the earliest examples of this new technique. These reinforcements at right angles, known as "rib vaulting," had already for a considerable time produced magnificent architecture in northern France about which the France of the Midi appeared to be unaware.

How did the ribbed vault make its way into France's southern provinces? Who were the architects who brought it there? It is an interesting problem that no one has yet thought to examine. Entire books have been written on the spread of French architecture across Europe; nothing has been said about the conquest of the Midi by the art of the North.

It would seem that the Cistercian monks of Burgundy, those great missionaries of Gothic art all through Christendom, were the first to make rib vaulting known in the land of the *langue d'oc.* Beginning in the twelfth century, they built two abbeys in Rouergue, Silvanès and Loc-Dieu, in which rib vaulting appears. In Gascony and Languedoc they built a number of others, of which only a few examples remain: at Flaran, in Gers, the ribbed vault appears in the chapter house and at Fontfroide, near Narbonne, in the transept of the church. This rib vaulting, still very primitive, is rounded and in cross-section presents a semi-circle. It seems that this new technique, which was to prove so fruitful, was for a fairly long while restricted to the monasteries of the Order of Cîteaux. There is, nevertheless, in the porch of the Benedictine church of Saint-Guilhem-du-Désert in Hérault, a semi-circular ribbed vault that dates from the twelfth century; it proves that the Cistercian vault was not entirely unknown to meridional architects. But in the Midi one finds rib vaulting of an altogether different kind. The ribs are square, rather than being round, and they form, beneath the vault that they support, a cross whose large arms have an archaic appearance. Such vaulting is not to be found in the Cistercian order and one must look for its origins elsewhere.

Where does it come from? Kingsley Porter, an American archaeologist who has spent many years studying the architecture of the eleventh and twelfth centuries in Lombardy, looking at the square-ribbed vaulting of Fréjus cathedral, does not hesitate to state that it is Lombard in origin, for these are the characteristics of Italian vaulting. According to him, it was in Lombardy that rib vaulting originated, even before the middle of the eleventh century, and from there it spread into France and to England. We will not go along with him to that extent. It is possible that rib vaulting, anticipated by the Romans, was first used by the Lombards, but this is as yet only a hypothesis, and the early dating that Porter assigns to the oldest Lombard rib vaulting is far from being established with complete certainty. On the other hand, it cannot be questioned that Lombardy was familiar with rib vaulting in the twelfth century. The Lombards did not recognize in it the principles of a new architecture, nor guess at its future, but they made use of it and it is even probable that they exported it. In the twelfth century,

Lombard stonemasons often emigrated into southern France. They entered by the old Roman road across the Alps that ran from Turin to Arles by way of the Mont Genèvre pass and the valley of the Durance, passing by Briançon, Embrun, Sisteron, Apt, and Cavaillon. They left more than one mark of their passing along the highway itself or in its immediate neighborhood. The cathedral at Embrun still shows us, like Verona's Saint Zeno, a porch whose columns are supported by lions. Moustiers has a campanile like those of northern Italy. The chapel of Saint-Victor at Castellane is decorated on its exterior with Lombard banding; moreover there are, over the single nave of this chapel, two vaults with square ribs very much like those of the churches of Lombardy, with the result that everything leads us to suppose that this Gothic vaulting is the work of Italian artisans.

Another route, longer but less taxing, was open to the itinerant masons of Lombardy, the dazzling road along the Corniche that was the ancient Aurelian Way. It followed the sea from Genoa to Fréjus, left it to arrive at Aix, and returned to it at Marseilles. Now, one finds along this road, or in its immediate vicinity, a number of churches whose vaults are supported by square ribs of the Lombard type. They exist at Grasse, at Fréjus, at Hyères, and, finally, in the porch of Saint-Victor at Marseilles.

Nor is this all. The two roads from Italy came together at Arles; henceforth, they formed only one, which was the highway to Toulouse and Bordeaux via Nîmes, Maguelone, and Narbonne. The Lombards followed this route, as the external decoration of several churches in lower Languedoc testifies. It is thus not rash to attribute to them the square rib vaulting that was raised toward 1178 over the transepts of the old cathedral of Maguelone. They went on even further, for it is most probably to Lombard techniques that one must attribute the large square-ribbed vault whose appearance is so archaic in the porch at Moissac and the less ancient ribbed vaulting of the church at Saint-Gaudens.

Thus these occasional ribbed vaults of the Midi, which were astonishing to archaeologists, become simple to explain when one notes that they are scattered along the routes followed by the Lombards. One cannot study these old roads across France too often, for they disclose some of history's secrets to us.

Those first ribbed vaults, imported by the Lombards, do not seem to have impressed the architects of the Midi very deeply. They saw in them nothing more than a means of building a vault; they did not discover there the principles of a new art, something that the North had realized for a long while. In the Ile-de-France, Gothic architecture developed like a beautiful theorem; in the Midi, the ribbed vault, employed haphazardly, remained a masons' expedient.

It is in the cathedral of Toulouse that the true nature of the Gothic vault seems to have been understood for the first time. The problem was that of raising a vault over a nave without aisles, more than nineteen meters across; a truly daring attempt that would have dismayed the old Romanesque architects. The architect of Toulouse resolved the problem boldly: across the three vast spans of the nave he launched three ribbed vaults. He therefore understood what could be risked by means of the new invention. But, curiously enough, these audacious ribbed

Nave of the cathedral of Saint-Étienne in Toulouse (Haute-Garonne).

vaults still retain the square profile of the Lombard rib. The traditions of the Italian masons thus persisted in these localities. Nevertheless, I do not think that one should look for the hand of a Lombard artisan here, for the keystones that appear at the meeting of the ribs lend a French aspect to the work. Indeed the Italian ribbed vaults have no keystones at their point of intersection. This splendid nave was not yet completed in the spring of 1211, when Simon de Montfort attempted unsuccessfully to seize Toulouse. The vaults that were under construction could not have been abandoned without endangering the fabric of the whole; hence, Count Raymond VI commanded that the work be continued throughout the entire duration of the siege.

The nave of Toulouse is the only Gothic monument of major significance that was built in the South-West before the French conquest. From that time onward, it was the men of the North who were to bring their art into the Midi.

This same cathedral of Toulouse offers us one of the most moving witnesses to the conquest of Languedoc by the art of the North. Toward the year 1230, after the treaty that assured the transfer of the county of Toulouse to the king of France in the near future, it was embellished with a great rose window that is an almost exact reproduction of the one in the façade of Notre-Dame of Paris, then newly completed. The royal house of France in this way set its stamp on the work of Raymond VI. It is true that one could see, on one of the keystones of the nave vaulting, the cross with twelve pearls of the counts of Toulouse, but the rose window that filled the façade, that first caught the attention, was the rose of the royal cathedral. For us that rose is a symbol; it tells us that an era had come to an end, and that this ingenious Languedoc, this kingdom of poetry and art, would henceforth be nothing more than a province of France. One finds it difficult to believe that, forty years ago, it was proposed to demolish this nave, on the pretext that it was out of alignment with the choir; a modern restoration, in the style of the late thirteenth century, would have replaced it. The plans were drawn up and only a lack of funds held back the wreckers. Happily, today no more is said about dismantling those magnificent vaults and obliterating those touching reminders of French history.

<div align="center">III</div>

THE CATHEDRAL of Bayonne is not, as was long supposed, the earliest cathedral in the Midi to be built in the Northern style, but it is in a class by itself—which can be explained by the mysterious influences of the road to St. James of Compostela. The architect who built its oldest sections—that is, the undercroft of the choir and the ambulatory with its radiating chapels—derives from Rheims and Soissons. In the year 1258, when the first stone of Bayonne cathedral was set in place, the interiors of Rheims and Soissons were almost complete. One must therefore assume that the architect of Bayonne had passed his early apprenticeship under the advanced direction of those two masters and knew their works intimately, for he imitated them. One rediscovers at Bayonne the interior gallery which passes

before the windows of the chapels in Rheims cathedral—one even rediscovers the design of those windows; but one also finds the distinctive vaulting of Soissons, which joins the ambulatory to each of the radiating chapels by the same rib vaulting. It was probably a chance journey to St. James of Compostela that has given us the wholly northern cathedral at Bayonne. Detained along his way by the bishop, who was considering the rebuilding of his church, the pilgrim-architect put forward a plan whose novelty was irresistible. Bayonne cathedral grew slowly, remaining faithful to the art of the North; nonetheless, a close examination brings to light some southern characteristics in its upper regions.[1] They show us that, among the masters of the work, there was one who spoke the artistic tongue of Champagne and the Ile-de-France with a faint accent of the Midi.

The art of the North truly began the conquest of the Midi shortly before the middle of the thirteenth century. One after the other, we see arise the cathedrals of Clermont and Limoges; and then those at Narbonne, Toulouse, and Rodez. Now, when one examines these five churches, when one compares them with each other, one realizes with surprise that they make up a whole and cannot be analyzed in isolation. All five seem to be dominated by the genius of one master workman, whose name has not yet acquired the reputation that it deserves: Jean des Champs.

Hugh de la Tour, Bishop of Clermont and friend of Saint Louis, had been present in 1248 at the consecration of Sainte-Chapelle. He had compared that ethereal jewel-box, shaped out of light, with his somber Romanesque cathedral, and resolved to summon to Auvergne one of the masters who knew how to create such things. The young architect, whose name was once engraved in Clermont cathedral, was Jean des Champs. He lived until 1295;[2] one can consequently suppose that in 1248 he was in his thirties, for it was difficult to become a master-builder before that age. Years of apprenticeship were needed to acquire the encyclopaedic knowledge of those multi-talented artists. Born around 1218, he came after the heroic generation of the great architects, those men who built Chartres, Amiens, Rheims, Soissons, and the nave of Saint-Denis. During his youth, Gothic art had attained its perfection, and it seemed as if he were fated to imitate rather than create. To be sure, he did imitate a great deal, and from those imitations we can guess where he had learned his craft. One can assume, it seems to me, that he passed in succession through the workshops of Amiens, Saint-Denis, and Soissons.

Begun in 1248, the cathedral of Clermont is a beautiful and somewhat severe structure. The dusky lava of the Auvergne volcanoes lends a touch of austerity to its exterior, but the graceful effect of the interior, as one enters, awakens the memory of Amiens cathedral. The proportions of that original have been reduced,

[1] Flat roofs over the chapels, tall windows in the choir that do not take up the entire width of the bay, buttresses joined by arches, as in the church of the Jacobins in Toulouse.

[2] On this subject, *see* Abbé P. Sigal, "Contribution à l'histoire de la cathédrale Saint-Just de Narbonne," *Bulletin de la Commission archéologique de Narbonne* (1922), p. 73.

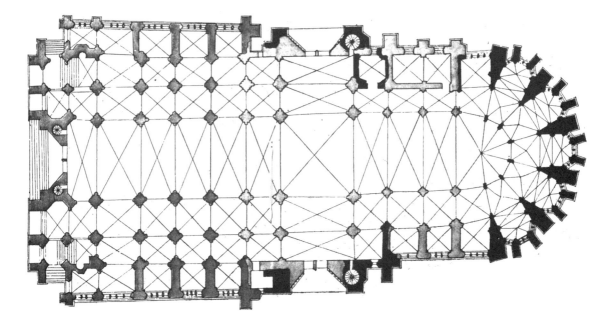

Plan of the cathedral of Clermont-Ferrand (Puy-de-Dôme).

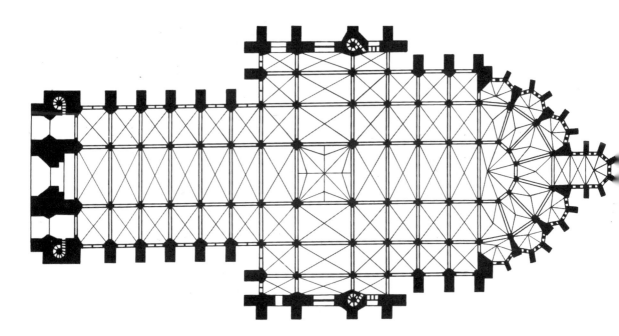

Plan of Amiens cathedral (Somme).

but the relationships between the different elements are almost identical: the height is nearly three times the width, and the aisles rise almost to the mid-point of the nave. Numbers, which are the hidden music of architecture, respond to one another, and the two resonant strings sound the same note. It is evident that the young master of Clermont had been taken into the confidence of the master of Amiens. The two choirs have the same plan, the same number of bays, and would be altogether identical were not two of the radiating chapels at Clermont square rather than polygonal. This Amiens choir, which was being reproduced at that same moment at Beauvais and Cologne, was thought (within that little world of experts who knew what a masterpiece should be) to be a model that could not be surpassed. When Jean des Champs drew up the plans for his cathedral, Amiens was thus constantly in his mind's eye. He even copied its dark triforium, although he could have seen at Saint-Denis an open triforium that brought more illumination into the church and greater lightness. Nonetheless, he could not be indifferent to the splendid nave and the vast transept that Pierre de Montereau had just raised up at Saint-Denis. We find their traces in his work. The nave of Saint-Denis, in effect, represented a new type of Gothic nave, one that foreshadowed the future. At Chartres, at Rheims, and at Amiens, the colonettes that descend from the vault all terminate in the strong capital of the pillar—save one that continues down to the pavement. At Saint-Denis, the forceful capital that went back to the early years of the thirteenth century disappeared, and all of the colonettes, with nothing henceforth to interrupt them, descend to the floor. A nave of this kind diminishes the effect of force, but, by its vertical lines, expresses greater vivacity. Such is the case in the choir and nave of Clermont; there the pier appears as a cluster of colonettes, as at Saint-Denis. In addition, Saint-Denis gave to Clermont the great rose window that flowers in the north arm of the transept; Jean des Champs was content to augment its circumference with an extra ring of circles and to multiply the stars that pierce this wheel of fire.[3] On the other hand, the rose in the southern façade is clearly an imitation of Jean de Chelles' rose in the south transept of Notre-Dame of Paris. That famous rose of Paris, which was reproduced all over France, was created a little after 1258. Jean des Champs was therefore not permanently confined at Clermont after 1248; he knew what the Parisian masters were doing and he doubtless revisited Paris while he was building his cathedral.

Lastly, Soissons cathedral gave him the design for his triforium. It is very evident, indeed, that the elegant arcades, crowned with a "gable" (*i.e.*, a triangle), that make up the triforium at Clermont are exactly those of the arcaded gallery on the façade of Soissons.

Derivation thus abounds in the work of Jean des Champs; nevertheless, he is in no way merely an imitator. Indeed, there are certain features of Clermont

[3] The two arms of the transept of Clermont may have been built after the death of Jean des Champs by Pierre des Champs, who was probably his son, but the second architect was no doubt content to carry out the plans of the first.

Cathedral of Clermont-Ferrand (Puy-de-Dôme). Exterior view of the aisle at the triforium level.

cathedral that can only be attributed to him. These are worth indicating, for they represent the hallmark of the architect.

When we study the pentagonal chapels that radiate from the choir, we see that each of them, in contrast to what one observes at Amiens, opens out of the bay of a vault—an ingenious device that lends them greater depth and creates more intimate and smaller sanctuaries.

But it is above all on the exterior that these innovations become apparent. To begin with, we see that the triforium gallery, rather than passing through the piers (as was the custom), is carried around them, in order not to diminish their mass. This displacement of the triforium creates, over the aisles, a series of little turrets. We next notice that the balustrade which crowns the chapels, instead of breaking off at each of the buttresses, passes around them and creates a graceful continuous balcony all the way around the church. Finally, we remark certain details that seem to be concessions to southern tradition: the aisles are not covered with a sloping roof but by a simple terrace, and windows that in the North never seem large enough—that absorb the wall space between the buttresses—here do not fill the whole width of the bay.

Curious as these innovations are, there are two which are even more unusual, but they must be sought out, for they are not immediately apparent. The columns that make up the circuit of the choir are divided in front into three small colonettes; now, this cluster of colonettes is joined to the column by a curve and a counter-curve, that is, by a sort of "S." This sinuous line, which we encounter here for the first time, is nothing else than the principle of Flamboyant art itself. This opposition of an inward to an outward curve, this movement as of a flame, will lend Gothic architecture, after the end of the fourteenth century, its tortuous appearance. It represents a revolution much like that which erupted in the eighteenth century, for the Rococo style and the Flamboyant were born, the one like the other, from the curve united to the counter-curve. It is for this reason that a beautiful screen of the time of Louis XV persists in such harmony with a fifteenth-century church. Nothing is more intriguing than to discover at Clermont, beginning in the mid-thirteenth century, the first attempts at a new art form.

But one discovers something else as well. Looking closely at the ribs in the vaulting of the choir, one realizes that some of them do not continue down to the abacus of the capitals but merge into the wall and disappear there. This represents a technique with which the architects of the great classic period were not familiar; in their work, each of the components of the vault has its point of arrival on the capital. The "penetration" of the rib moldings is, together with the union of the curve and counter-curve, one of the principles of Flamboyant architecture. One senses wholly the originality of these attempts, as well as the appeal that Clermont cathedral presents for the art historian. Here Jean des Champs appears before us as an innovator.

The cathedral of Limoges was begun a considerable time after that of Clermont. It was a rich prelate, Aimeric de La Serre (whose bishopric lasted from 1246 until 1272), who decided to replace his old Romanesque church with a Gothic one.

At the time of his death, the work had not yet been begun, but the plans had been drawn up, perhaps for some time already. Beginning in 1273, his successor had those plans put into effect.

Upon entering Limoges cathedral, one receives an impression identical to that made by the cathedral of Clermont. Here are the same proportions, the same harmony; the same cluster of colonettes descending from the vault to the base of the piers; the same blind triforium that creates a band of shadow beneath the light-filled windows; the same windows, somewhat reduced in size, that do not entirely fill the width of the bay; lastly, the same decorative restraint, for the granite of Limoges is no easier to work than the lava of Clermont. From the first glance, we deduce a close kinship between the two buildings. But what was a suspicion within becomes a certainty without, for here again we find the terraces over the aisles, the triforium's sweep around the piers, the uninterrupted balustrade that encloses even the buttresses. It is clear to us on the basis of the evidence that Limoges cathedral had its inspiration at Clermont.

If, carrying our examination further, we bring together the plans for the two, drawn to the same scale, we are no longer speaking of suggestion but of literal replication. The two choirs, with their radiating chapels and their ambulatories, could almost be superimposed. One finds again at Limoges, as at Clermont, the bay before each of the chapels, a characteristic that is only to be found in these two churches. Lastly, that precocious penetration of the rib moldings, which we have seen at Clermont vanishing into the walls, can also be remarked at Limoges. The conclusion is inescapable, for historic buildings sometimes speak as clearly as documents can; it was from Jean des Champs that the bishop of Limoges ordered the plans for his new cathedral, and it was Jean des Champs himself, however busy he may have been at Clermont, who oversaw their execution. A pupil would not have reproduced, with such fidelity, details, some of which were still tentative for the artist.

Jean des Champs nevertheless did not copy himself as slavishly as we may appear to suggest; the mullions of his windows, the arcades of his triforium, are of a somewhat different design, and, on the exterior, his beautiful radiating chapels, so pure in their outline, are enriched with those triangles of dressed stone, those "gables," whose models could at that time be found at Notre-Dame of Paris and on the chevet of Amiens cathedral.

In 1273, at the moment when work began on the cathedral of Limoges, another cathedral was being erected in the Midi, at Narbonne. It had been begun in the previous year, but the work went forward slowly, and came to a halt when the choir was completed, never to be resumed. This choir without a nave, this incomplete masterpiece, suggests some beautiful mutilated piece of antique statuary. The choir at Narbonne is the finest architectural fragment in the Midi. It does not have the calculated and deliberately reduced proportions of that at Clermont, whose height does not exceed twenty-nine meters; it possesses inspiration, ardor, energy, and rises over forty meters in a single bound. Here is the dense forest of the North breaking forth in that unshaded Midi; here is the genius of the *un-*

Cathedral of Saint-Just, Narbonne (Aude). View from the south.

bounded appearing on the shores of that Mediterranean which had known only the *measured*. Its emotional effect is all the more vivid.

To whom do we owe this magnificent choir? Clearly, in this disproportionate cathedral the name of Jean des Champs, the disciplined architect of Clermont and Limoges, does not immediately come to mind. But if, instead of taking haphazard enjoyment in the impression of grandeur, we analyze each of the elements of the building, that examination discloses, to our immense surprise, traits with which we are already familiar. The roof over the aisles is in the form of a terrace; the triforium is unlighted and skirts the piers; the windows, deliberately narrow, do not fill the entire width of the bay and disclose the triple division of the windows at Clermont; finally, as at Clermont and Limoges, two of the choir chapels are closed off by a wall and were from the first destined to serve as a sacristy. Viollet-le-Duc, who worked for a long time at Clermont (as well as at Narbonne) and was wholly familiar with both of them, was greatly impressed by these similarities. He did not hesitate to identify the hand of the same artist in the two historic constructions. Audacious as the hypothesis might be, it was generally accepted by archaeologists—but remained a hypothesis. A very recent discovery (1922), made by the Abbé Sigal in the archives at Narbonne, has just transformed it into a certainty.[4] A document there spells out the name of Jean des Champs and tells us that he was, in 1286, the master in charge of Narbonne cathedral. From another document it appears that the levelling of the site and the laying of the foundations for the cathedral required more than twelve years, with the result that Jean des Champs arrived in Narbonne at the very moment when the building was about to arise from the earth. Did he draw up its plans only at that date? It is difficult to think so, for the foundations could not have been laid out without a plan.

His work presents interesting innovations, of which these are the principal ones. The penetration of the moldings, which is only suggested at Clermont (as it is at Limoges) and which one barely notices, becomes wholly apparent at Narbonne. One observes it on the archivolts, as well as on the pillars at the entrances to the absidal chapels constructed by Jean des Champs before 1295; here a number of the components of the archivolt disappear into the piers; only a few moldings descend to their bases. Already one anticipates the fifteenth-century pillar, that type of robust vegetable stalk out of which emerge, little by little, the leaves of the plant. But the cathedral of Narbonne holds another surprise for us. The chapels that preside over both sides of the choir, rather than being square as was customary, are pentagonal. They resemble the radiating chapels that open into the ambulatory. This is one innovation, but we remark another that has infinitely more appeal. Before each of those chapels that parallel the choir—on the north side—stand two columns that form a type of portico. Between the chapels and the columns extends a continuous passageway, which forms a narrow aisle of studied elegance.

Is this charming fantasy a new departure or a recollection of something seen?

[4] Abbé Sigal, p. 69.

It is difficult, before this beautiful gem that is Narbonne, not to think of the marvellous choir of Saint-Nazaire at Carcassonne. Indeed, it is conceived after the same manner, for before each of the chapels (which here are square) stands the identical portico of tall columns and the same presiding aisle. Work was begun on the choir of Saint-Nazaire in 1269, as soon as Saint Louis had granted to the canons of the upper town the parcel of land for which they had asked him. It required more than thirty years to carve out this delicate piece of jewelers' work, a setting for the precious stones of the windows. But the choir of Saint-Nazaire existed in drawings upon parchment from 1269. Jean des Champs, who in all likelihood came to Narbonne soon after 1272—at the moment when the decision was taken for the new cathedral—must have seen the preliminary work on Saint-Nazaire at Carcassonne, and could have conferred with the master of the work and studied its plans. The old pilgrims' road to St. James, which ran from Clermont to Puy and from Puy to Conques and Moissac, brought him quite naturally to Narbonne by way of Toulouse and Carcassonne. A great artist responds deeply to the appeal of a happy innovation; he is intrigued by it and makes use of its inspiration at his first opportunity.

But can this graceful imitation actually be attributed to Jean des Champs? It can be questioned, since the double left aisle, together with its chapels, was only built between 1295 and 1320 by Jean des Champs' two successors, Dominique and Jacques de Fauran. But one must remember that the plans of the original master builder, approved by the chapter and kept in the offices, were generally followed by his successors. Normally they altered nothing but the details. After 1272, when Jean des Champs sketched the cathedral of Narbonne on parchment, the double aisle on the right side must have been planned. What seems to prove it is that this double aisle exists in the cathedral of Toulouse as well, where we also recognize—we think—the hand of Jean des Champs.

At that time, there was in Toulouse a magnificent bishop, Bertrand de l'Isle Jourdain, of a great ducal family, who maintained friendly relations with Maurin, Archbishop of Narbonne. He was familiar with the latter's projects and determined that he too would build a new cathedral in the style of the monuments of the North. He had it begun in 1275, and it strangely resembles the one at Narbonne. Indeed, at Toulouse one finds the pentagonal chapels preceded by a portico of columns along the choir aisles. An uninterrupted passage once extended before these chapels, but partitioning erected at a much later date today interrupts it. One senses that the plan of Toulouse cathedral is later than that of the cathedral at Narbonne, for what was only experimental at Narbonne has become systematized at Toulouse. All of the choir chapels, even the radiating chapels, are preceded by two columns and a narrow aisle.

Have we here another work by Jean des Champs? One is strongly tempted to think so, for Bertrand de l'Isle would have sent to Archbishop Maurin for his master builder. One is aware at Toulouse of the logical development of an idea. It is true that the two monuments produce vastly different impressions today, as a result of Toulouse cathedral's having remained unfinished for several centuries.

In 1286, at the death of Bertrand de l'Isle, the seventeen chapels and all of the lower part of the choir were completed; but after that great effort, sustained by the generosity of the bishop, the work came to an abrupt halt. It was not until the fifteenth century that the triforium was added, and the seventeenth that the vaulting was launched over the choir. That vaulting, instead of reaching forty meters as at Narbonne, rises only to twenty-eight. As for the nave, it was not even begun, a happy circumstance that has had the result of preserving for us, out of alignment, Raymond VI's three magnificent bays, of which we have spoken.

Toulouse is thus inseparable from Narbonne, but there is a third historic building that, without Toulouse and Narbonne, could not be accounted for: the cathedral of Rodez. It was begun in 1277, at the time when all these great northern churches were arising in the Midi. The eye habituated to the concepts that were so new at Narbonne and Toulouse recognizes them without difficulty at Rodez. The chapels that flank the two sides of the choir are pentagonal;[5] in the ambulatory, the components of the arcading disappear into the pillars; those pillars themselves exhibit in cross-section a perfectly described curve and counter-curve. The archaeologist who comes from the North and has not yet seen the two great cathedrals of Languedoc will not fail to believe, in the face of these innovations, that the date of 1277 which his *Guide* gives him, is a printer's error. That choir, where the Flamboyant style appears with such distinctness, seems younger to him by a century. How could he admit that a monument could thus give the lie to accepted principles? Nevertheless, no doubt can be possible; when Raymond de Calmont, the bishop who laid the first stone of the cathedral, died in 1298, the radiating chapels, the ambulatory, and the first two bays of the choir were already complete, and it was in the midst of that choir that the founder was interred.

Rodez cathedral thus cannot be studied in isolation. By itself, it appears incomprehensible; brought together with Narbonne and Toulouse, it ceases to be an enigma.

Was I once more to attribute to Jean des Champs the cathedral of Rodez? I dared not do so. This did not make it, in my opinion, any less certain that the architect of Rodez had passed through the workshops of Narbonne and Toulouse. The flat roofs of the aisles, the somber triforium that is carried around the piers, the narrow windows, the capitals reduced to the dimensions of a band, offer their evidence as to the background of the master of the work at Rodez.

Today proof has been established: a recently discovered document proves that Jean des Champs was indeed the architect of Rodez cathedral. His last cathedral is one of great beauty, and the relationship between its components is so happily calculated that in the nave, which rises to only thirty meters, the impression of height is almost as strong as at Amiens. It was not until the sixteenth century that the two splendid architectural features were added that give the

[5] One does not find, at Rodez, the portico of columns and the passageway before each chapel that we saw at Narbonne and Toulouse, but, as at Narbonne and Toulouse, these chapels are of the same height as the aisles.

cathedral of Rodez its character: the bell tower and the façade. The austerity of the lower parts of the bell tower is transformed on the upper into a dazzling richness. As for the façade, it creates a sort of strong-point in the ramparts and plays a part in their defense; hence, those vast expanses of a savage nakedness. The citizen of the Midi responded, like the Roman, to the beauty and the commanding aspect of a great wall of stone. This tall ruddy fortress that, on high, opens into a splendid rose and is completed by a façade with classical lines, is one of the grandest achievements of French architecture.

The cathedrals of the Midi—Clermont, Limoges, Narbonne, Toulouse, Rodez—thus form a single unit. All are the work of Jean des Champs and all spring from his genius. This great man, who has been almost forgotten, must regain his place in history. A pupil of the masters of the Ile-de-France and Picardy, at Clermont and Limoges he follows them, but one already sees the ideas dawning in his work from which the art of the future will be born. At Narbonne and at Toulouse, surer of himself and believing that a great architect should not imitate but initiate, he gives free rein to his mathematical genius and, beginning in the thirteenth century, creates Flamboyant art.[6] A simplification of form achieved by the penetration of the moldings; a diminution of the capitals; a use of the curve and of the counter-curve; these are the new principles that he introduced into architecture. They are the ones that will triumph in the fifteenth century and which he already practiced in the thirteenth. Jean des Champs belongs to the race of creators; he belonged as well to those great generations of thirteenth-century artists who never built a church without carrying onward the progress of architecture—a magnificent age, in which art developed with all the majesty of science.

<div align="center">IV</div>

THE CATHEDRALS of the Midi were built by bishops who were the friends of the king of France and had seen the great constructions of the North. But these magnificent churches, so different from everything around them, apparently did not awaken the enthusiasm of the people of the South. Indeed, nearly all of them remained incomplete. The naves of Clermont and Limoges did not receive their final bays until the end of the nineteenth century. Narbonne is only a splendid choir closed off by a wall; a few enormous pillars standing in an abandoned building-yard bear witness to the inability of the succeeding centuries to carry on the work undertaken. Toulouse waited more than three hundred years for its vaulting and is still awaiting its nave. The cathedral of Rodez alone was completed, in the sixteenth century, by two prelates who loved art, François d'Estaing and Georges d'Armagnac.

Not only did the cities of the Midi lack the upsurge of faith and generosity of

[6] Or at least the chief constituents of Flamboyant art. There are others to which Enlart has assigned an English origin.

those in the North, they sometimes presented an obstacle for their bishops and canons. Recently published (1921) documents[7] tell us that from the fourteenth century onward, the magistrates of Narbonne showed themselves hostile to the completion of the cathedral. According to them, such a cathedral was un-necessary; it was, they said, a veritable citadel capable of posing a threat to the town, a fortress bristling with crenellations and towers. The canons were obliged to explain to them that those apparent towers were only buttresses required for the stability of the construction, and those crenellations were merely ornamental. The canons added, in vain, that the achievement of such a splendid cathedral would make the names of the magistrates resound through all the nations; their persuasion was not effective, since shortly thereafter the work came to a halt.

Thus the great art of the North was understood in the Midi only by a sophisticated few. It was too knowledgeable, too complicated for those men of the *langue d'oc*, accustomed to the austerity of their great halls. It reflected neither their customs nor their tastes. The workmen themselves were trained in other traditions and ill-prepared to deal with the thousand *minutiae* of Gothic art. Jean des Champs was no doubt obliged to summon a number of skilled stonemasons from the Ile-de-France to serve as supervisors and set up the workshops.

Therefore one is not surprised to see an architecture emerge in the Southwest, after the conquest, that was wholly different and genuinely meridional. It was at this time that there multiplied, in Languedoc and the neighboring regions, those churches with a single nave and chapels opening between the buttresses which, coming from the North, we met for the first time at Martel.

Two German archaeologists, Dehio and von Bezold, have put forward the idea that this meridional architecture was perhaps a form of protest made by the vanquished against the art of the conquerors. In certain cities, indeed, the contrast between the two types of architecture is so striking that the hypothesis at first appears reasonable. While the king of France's architect was setting up the delicate columns of the choir of Saint-Nazaire in the citadel at Carcassonne, the sons of the revolutionaries, of those men whom Saint Louis had driven from their homes, were building the great meridional naves of Saint-Michel and Saint-Vincent in the lower town. It seemed as if they wished to ignore what the French from the Ile-de-France were doing in the upper town. The contrast is striking; must one believe that it was deliberate? Does the architecture of Languedoc express, in its own way, the moving struggle of the Midi against the North in the years that followed the conquest? It was the period, one must remember, when a demented Franciscan, Bernard Délicieux, attempted to raise up Carcassonne against the French, and when the leading citizens of the lower town were put to death, on the orders of Philip the Fair, for having appealed to the prince of Majorca against the king of France.

These ideas, which transform architecture into drama, may appeal to the imagination, but a closer study of the buildings and their history causes them to

[7] By the Abbé Sigal, in the *Bulletin de la Commission Archéologique de Narbonne* (1921).

evaporate. At Carcassonne, the architects of the lower town were so far from rejecting what took place in the upper that they copied at Saint-Michel the rose window from Saint-Nazaire. More than that, on the portal of Saint-Vincent can be seen a statue of Saint Louis, wearing the Crown of Thorns. It belongs, from its style, to the first quarter of the fourteenth century. Thus, a few years after Bernard Délicieux's final effort, the Midi, forgetting the past, paid tribute to that Saint Louis who had been responsible for the razing of the outskirts of Carcassonne after the revolt of the Vicomte Trencavel. The cathedral of Lavaur, begun in 1255 at a time when Languedoc was still imperfectly subdued, is a purely meridional church. Yet documentary evidence tells us that the Inquisition itself had ordered it to be built with the fines imposed upon the heretics. Can one suppose that the architect of any such monument wished to express the hostility of the Midi toward the North? The most magnificent of the meridional churches, the cathedral of Albi, was raised up by Bishop Bernard de Castenet, the dedicated opponent of the remaining heretics and of all tentative resistance in Languedoc. Would he have tolerated a work in which he could detect a rebellious theme?

But there is still a more convincing argument: the Order of Preaching Friars, which St. Dominic founded in Languedoc to combat the Albigensian heresy, adopted meridional architecture. It even appears that the Dominicans were the first to build those vast naves out of which chapels open. They borrowed this idea from the strictest of all the orders, the Cistercians, who like themselves professed the love of poverty. Already at Fontenay in Burgundy, near Montbard, the monks of Cîteaux had built a church in which the aisles were, in fact, replaced by chapels opening one into the next; the vaulting of these chapels is perpendicular to, and not parallel with, that of the nave. This architectural model could be found everywhere in the twelfth century. We discover it in Rouergue, in the Cistercian abbey of Silvanès, which was begun in 1169. But here the meridional traditions have substantially modified the appearance and the proportions of the Burgundian models. The nave is wide rather than narrow, and the false aisles of Fontenay are replaced by a series of chapels with transverse vaulting, set in between the buttresses and with no interconnection. Thus, from the twelfth century onward, the Cistercians of the Languedoc had already created the church that we call meridional. All that will remain is to apply rib moldings to all the vaults. When one thinks of the influence that the architecture of the monks of Cîteaux had upon that of the mendicant orders, when one remembers that in Italy the Franciscans imitated it throughout the entire thirteenth century, one is ready to admit that from their foundation, the Dominicans could have been inspired by the same models.

One of the oldest Dominican churches still in existence today, if I am to believe the archaeologists of Catalonia, is the one in Barcelona that is dedicated to St. Catherine. It was begun in 1223 and, however slow the work upon it may subsequently have been, its plans go back no later than this date. Yet it presents us with a wide nave out of which chapels open between the buttresses. In this, it is a purely southern church. But here the chapels communicate with each other by a

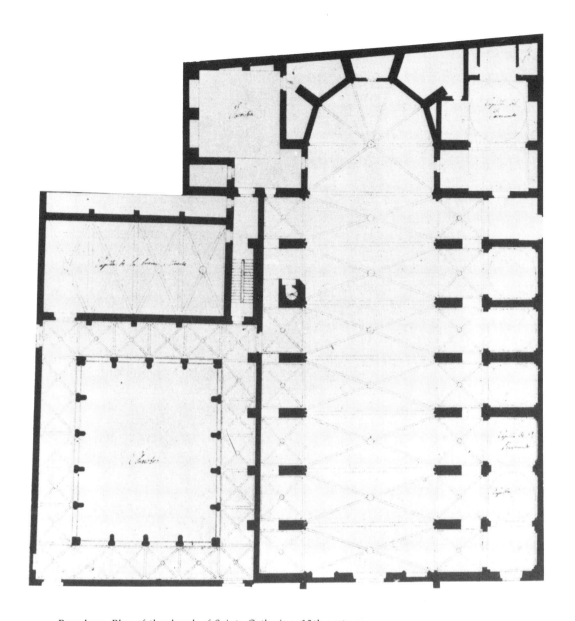

Barcelona. Plan of the church of Sainte-Catherine, 13th century.

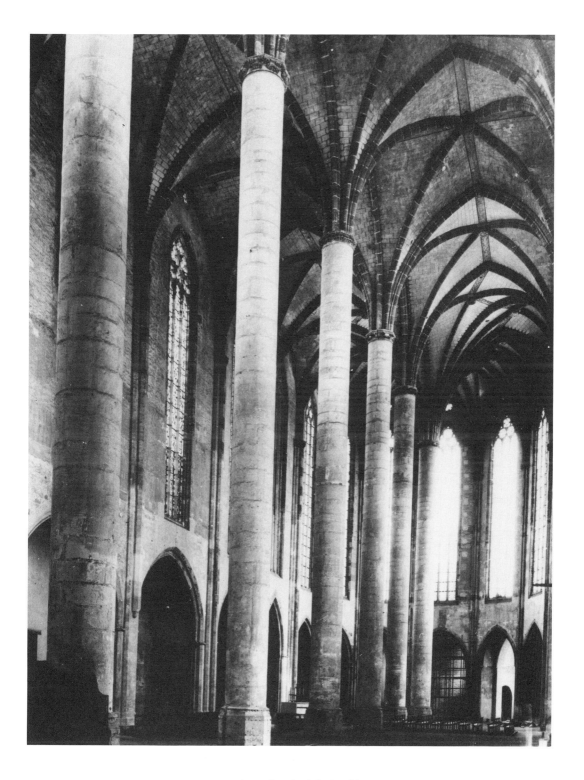

Toulouse (Haute-Garonne). Interior of the church of the Jacobins.

sort of false aisle and this characteristic, which can be observed at Fontenay, seems to point to the Cistercian origin of Dominican architecture. In meridional France, there were Dominican churches older than the one in Barcelona. One may suppose that they were of the same kind, for the Order built in this style all through the thirteenth and the fourteenth centuries. The convent church at Cahors, whose ruins still exist, is dated from 1263; it was a church of the purest meridional type.

The Preaching Friars thus adopted and disseminated, throughout the Midi, the church that had a single nave and chapels between the buttresses, which seems to have originated in the twelfth century with the Cistercians of Languedoc. It is true that a little later we see the Dominicans hesitate between this type of church and another. They asked themselves whether a church with a double nave were not better adapted to preaching. One half, in effect, was reserved for the clergy, the other for the people, those townspeople whom they wished to transform by the Word. As a result, they arrived at some exceedingly strange churches, divided in two by a row of columns that seem to march in procession from the entrance to the choir. Of this kind are those at the convents at Agen and Toulouse; also the one in the convent of the Jacobins in Paris. The church at Toulouse, the mother church of the order, in which St. Thomas Aquinas was entombed, is a veritable miracle. One cannot imagine anything more splendidly poetic than the seven giant pillars that divide this tall nave in half. Contemporaneous with Dante, this church partakes of his genius; it has his energy, his winged swiftness. Man is here aware of his own spiritual being. Like music, this architecture seems to reveal our true nature to us. Outside, tall walls in a dark red brick that the evening sun transforms into violet suggest an idea of grandeur that is almost Roman, while a polygonal tower with delicate colonettes of white marble enchants one in its grace. Does Toulouse suspect that it possesses one of architecture's masterpieces? A few years ago, I saw this fine church abandoned, unpaved, windowless, traversed by the flight of birds. Intelligent restoration must give it back its beauty, return this tattered queen to her rightful place.[8]

Beautiful as these churches with double naves were, within the Dominican Order they did not prevail over the churches with only a single nave, which were equally well suited to preaching and permitted a better view of the altar. Within that Order, the churches with double naves were always less common.

One is aware that it is wholly impossible to associate any idea of rebellion with those great meridional naves, since the Dominicans, the champions of orthodoxy, adopted them; an example that was soon followed by the Franciscans, the Augustinians, and the Carmelites. The architects and masons of the Midi simply went about doing what they knew how to do. They had neither the inclination nor the training for the complications of Gothic art. Moreover, the brick of Languedoc (where it seems clear that this architecture had its birth) directed them toward extreme simplicity, obliged them to appeal to the emotions only through strong

[8] I understand that this restoration has recently been begun.

masses and vast space.

In 1282, the school of the Midi began work on its masterpiece, the cathedral of Albi. Bishop Bernard de Castanet determined upon its construction on the day of his arrival, "even before," a document tells us, "sitting down to table with his canons." This fiery bishop was less a man of words than one of action, a soldier dispatched to a town that was still unruly, to bring about the destruction of the heresy within it. His harshness provoked violent hatred. In 1301, as he returned to Albi after a journey to Toulouse, he was greeted by a menacing crowd that shouted threats of death along his way. To join the rebels in Albi came others from Cordes and Carcassonne; they took possession of the bishop's estates, broke into the judicial chambers of the Holy Office, and drove the Dominicans, who acted as inquisitors, out from the churches of the town. They destroyed the images of St. Dominic and St. Peter of Verona, who was celebrated for his martyrdom at the hands of the Italian heretics, on the portal of Albi. In their places, to the right and left of Christ on the Cross, were represented the two royal commissioners sent by Philip the Fair to oversee the bishop and the inquisitors. They were grateful to these two for having caused the royal standard to be flown above the episcopal palace. On several occasions they broke into the cloister of the Dominican convent and mistreated members of the clergy. For nearly six years, they were the masters of the town and the friars scarcely dared to emerge from their monastery, much less to preach in the churches.

When one is aware of the facts, of which a document preserved by the sheerest accident has left us an account,[9] one better comprehends the character of the cathedral of Albi and understands its military appearance. It is a fortress of red brick dominated by a strong keep. The walls of that citadel are flanked by semicircular buttresses that resemble towers, and its base is extended out into a talus from which projectiles launched from above would rebound; the narrow windows open at a great height, out of reach of the enemy. Never since the Assyrians and the Romans have walls of brick created such an impression of might. This cathedral is terrifying. To soften that impression of terror, to reassure the faithful on the threshold of the temple, a sixteenth-century bishop, Louis of Amboise, had a stone baldaquin erected before the door, a sort of tall flowering shrub, where the art of the declining Middle Ages has set its mildness. In the fourteenth century, a church like this was an impregnable refuge for the bishop; connected with the episcopal palace, which was a second fortress, it defied the uprisings and seemed to defy the town.

Today, when one enters this fierce cathedral, one's initial impression is that of astonishment. Here is an effect of contrast such as the Arabs loved to create, when they concealed enchanted palaces behind great blank walls. The enormous enclosure of the choir, which fills half of the nave, confounds the imagination. When the doors are opened, sunlight lends it the colors of old ivory. The statues of prophets and apostles, the stalls crowned with angels, the bristling canopies, the

[9] *See* Compayré, *Étude historique sur l'Albigeois,* p. 237.

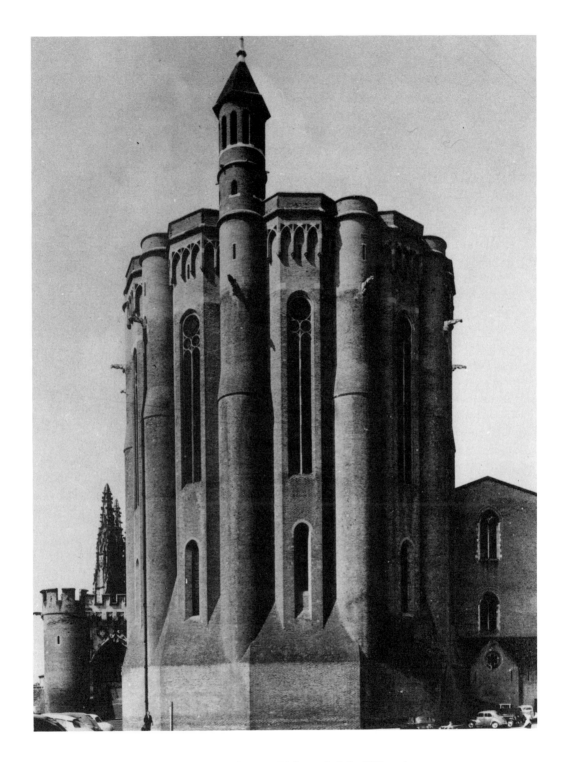

Albi (Tarn). Chevet of the cathedral of Sainte-Cécile, end of the 13th century.

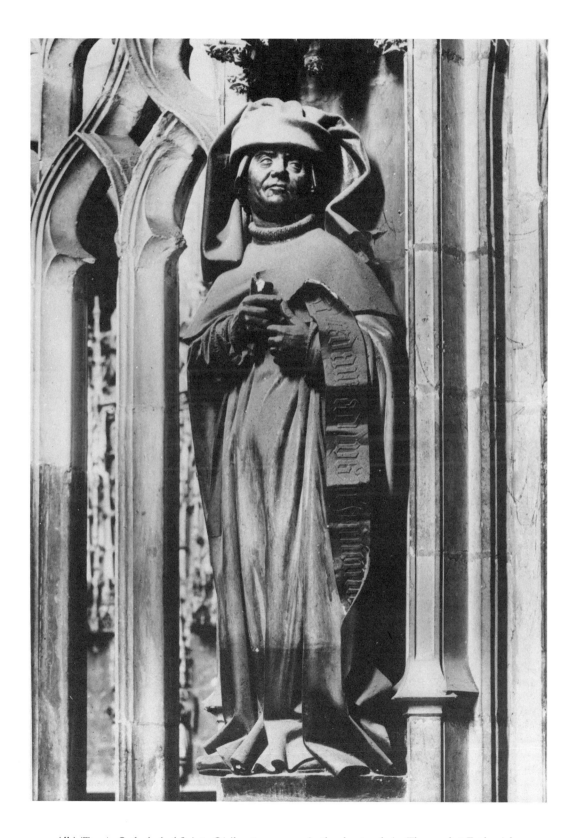

Albi (Tarn). Cathedral of Sainte-Cécile: stone screen in the chapter choir. The prophet Zephaniah.

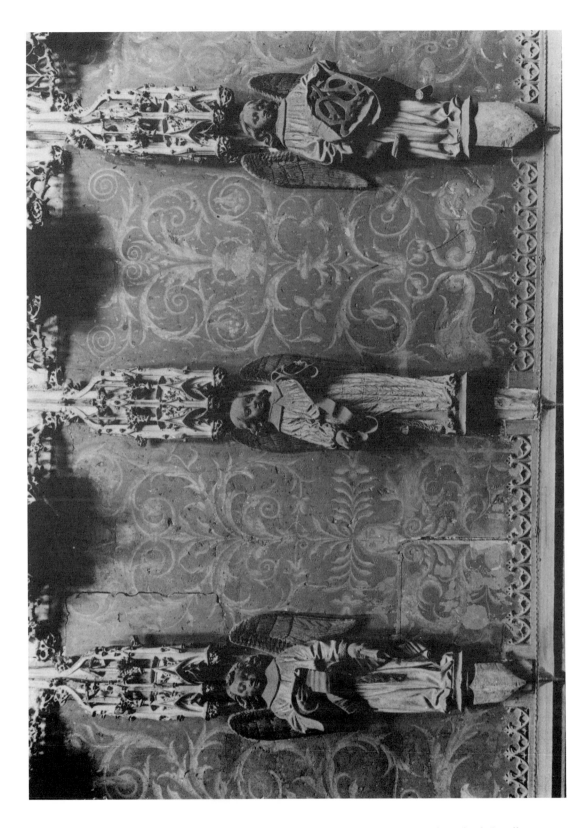

Albi (Tarn). Cathedral of Sainte-Cécile: screen in the chapter choir, lower section above the choirstalls.

garlands of foliage, are carved with a resolute patience that would be incomprehensible if one did not sense in it a kind of prayer, an homage that the artist wishes to render to God. Above this ravishing forest arches the blue and gold sky of the vaulting, illuminated like an Italian Renaissance missal by painters brought from Bologna. It was these again who decorated the chapels of the choir with charming frescoes that carry over into the sixteenth century the traditions of the *quattrocento*. Beside the short and stocky prophets on the periphery of the choir, vigorous like all the works of Burgundian sculpture but deriving from the people, the elegant Italian figures are enchanting in their aristocratic grace. Inscriptions in gilded lettering that imitates antique calligraphy stand out as noble and pure as those on the triumphal arches. This choir at Albi with its Burgundian statuary and its Italian frescoes is one of the glories of France.

But all of this magnificence dates only from the close of the Middle Ages and the dawn of the Renaissance; it was born out of the determination of two bishops who cared passionately about art, Louis I and Louis II of Amboise. This was not the cathedral visualized by Bernard de Castanet, which appeared in its splendid nakedness and only acted upon the soul by the beauty of its proportions. The vast enclosed choir of Louis I of Amboise, who made two churches from one; the arcades and balustrades that cut off the chapels at mid-height and the diapered ornamentation decorating them, all of these additions from the fifteenth and sixteenth centuries take away from that interior something of its majesty. The enclosed choir, a work of Northern art, was wholly contradictory to the meridional spirit that loved only open spaces. Nothing could be grander and more audacious than this solitary nave, whose vault, suspended thirty meters in the air, is nineteen meters in width. The chapels opening between the buttresses, originally without interruption, rise almost as high as the nave. It is not vigor and yearning that dominate here, but the awareness of vast enclosed space. One senses an equilibrium that is in contrast to the energetic art of the North. Indeed, the width of the nave, if one adds to it that of the chapels opening on either side, is equal to its height; the thirty meters of the elevation of the vault. These are the proportions of antiquity, which the Midi had retained by instinct; the width of the Pantheon at Rome, in fact, is equal to its height. Almost those identical proportions can be found in the old nave of Toulouse cathedral; there they are even more apparent, since that nave has no chapels between its buttresses.

At Albi, thanks to the ribbed vault, the Midi realized what it had dreamed of for so long: a great nave where nothing interrupts the vision nor the spoken word, a church without decoration but awe-inspiring in its proportions and sacred in its dim lighting; as simple without as within, with no flying buttresses, with no pinnacles, with a simple terrace for a roof, all on a grand scale. The architecture of the Midi was henceforth determined, and it predominated in that region until the sixteenth century. In 1304, the cathedral of Albi was far from complete, and already the one at Saint-Bertrand-de-Comminges was rising in its image. If Saint-Bertrand-de-Comminges had been finished, it would be, with a few exceptions, a diminished version of Albi. All of the cathedrals that arose in the Midi

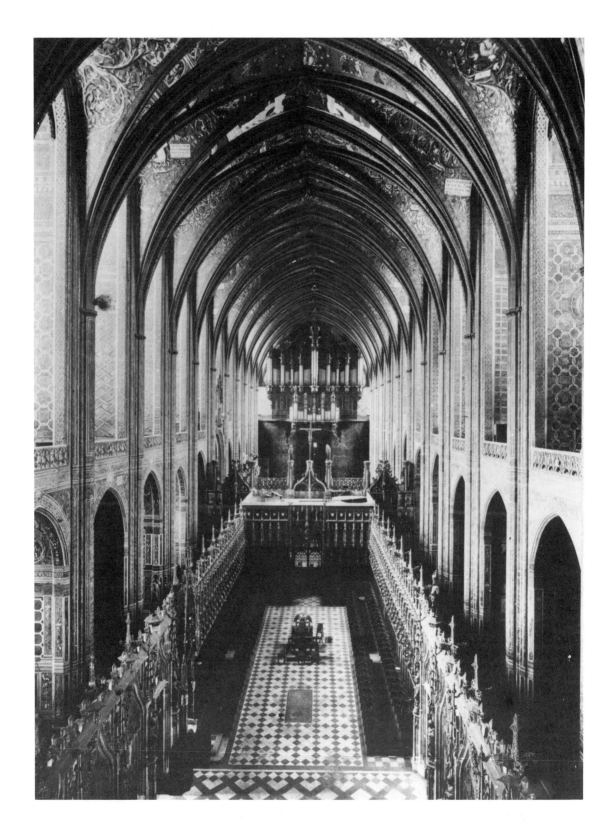

Albi (Tarn). Cathedral of Sainte-Cécile: nave viewed from a tribune near the chapter choir.

in the fourteenth century—Pamiers, Mirepoix, Perpignan—followed a model henceforth sacrosanct. Travelling through the Midi, one finds in the towns and villages a host of churches with reduced dimensions but of an identical type.

The vaulting of the cathedral of Albi, like that in the old cathedral at Toulouse, is nineteen meters across. These dimensions, already enormous, have been surpassed several times. The vaulting of Saint-Vincent at Carcassonne is twenty meters in width; that at Mirepoix, twenty-one meters; that at Gerona, twenty-three. The choir at Gerona, which has an ambulatory and radiating chapels, was built after the plan of the one in the cathedral at Narbonne, but with different proportions. In 1416, work had not yet been begun on the nave; a council of twelve master-builders was brought together to decide whether that nave should have aisles or if it would stand unaccompanied. Five voices spoke for the single nave, seven for the nave with aisles. The partisans of the single nave argued not only that it would be less costly, but that it would be more impressive, *solemnior;* valuable testimony that shows us what the men of the Midi experienced within their great naves. The chapter agreed with the minority. That is why the cathedral of Gerona consists today of a choir whose origin is Picard and a nave from Languedoc; it is a rare example of the union of the architecture of the North with that of the Midi. This beautiful vault, twenty-three meters in its span, one of the most daring that was ever built, exceeds the width of the vaulting in the basilica of Constantine in the Forum, which is only twenty meters in width and yet astonishes us by its majesty. It is only surpassed, in its turn, by the vault of St. Peter's in Rome, which is twenty-four meters across in the apse and twenty-seven and a half in the nave—dimensions that seem to mark the limits of man's effort, for the gigantic vault of the palace of Chosroes at Ctesiphon was also only twenty-seven meters in its width.

Thus the Midi, left to follow its instincts, shared the ambitions of the Renaissance architects: it rediscovered the proportions of antiquity. Amplitude, unfettered space, these seemed to it to be the height of grandeur. The dream of the southern architect was to enclose a kind of forum and bring the city together within it. In the nave at Toulouse, where the genius of the Midi reveals itself more clearly than in any other place, the width is equal to the height. If one contrasts these dimensions with those of the cathedral of Amiens, one will see that the nave there is three times higher than it is wide; it is a rocket soaring upward. For the Northerner, beauty lies in the vertical line, carried to the farthest limit of the possible. These two standards, so dissimilar, reveal for us profound differences of character. It would seem that the old Pythagorean dream, which interprets not only the world but also the spirit in terms of numbers, here becomes an actuality. Contrary to what one often supposes, imagination belongs to the North, not the Midi. In the North, the Gothic cathedral, with its infinite complexity, its mysterious perspective, its light and its shadows, its surge toward the sky, its forest of flying buttresses, its myriad statues; in the Midi, the unadorned church, spurning decoration, beautiful in its proportions alone, calm, with no longing after the infinite, the daughter of a race attached to the realities of this world. It is

an astonishing contrast, making us think of the two great figures that Raphael placed at the center of his *School of Athens*—Plato, who points with his finger at the heavens, and Aristotle, who with his open hand seems to grasp the earth.

<div style="text-align:center">V</div>

THE CHURCHES of Languedoc adhere so closely to the classical spirit that the Italian churches of the sixteenth century are their images. I have frequently been struck, in Rome, while studying those numerous churches that the traveller does not usually enter, by their likeness to those in the French Midi. The concept is an identical one: a wide, vaulted nave without collateral aisles and, on both sides, chapels opening between the buttresses. We must not be misled by the rounded arches, the pilasters attached to the walls, and the entablatures; this antique décor disguises a structure similar in every way to what we have just been studying. It would be simple to transform one of our Languedoc churches into a Roman one. That is what was done at least once, with the cathedral of Pamiers. It was necessary only to round off the broken arches opening into the chapels and to substitute classical pillars for the colonettes that descend from the vaults, to transform the church from Languedoc into an Italian sanctuary. Only the ribbing of the vaults and the window mullions today recall the original cathedral.

How is one to explain why the churches of Rome are to such a degree like those of the French Midi? Must we believe that the southern genius rediscovered, in sixteenth-century Italy, what that same genius had created in France three hundred years earlier? Or must we recognize that the architects of the Renaissance were familiar with the work of the master builders of Languedoc? The problem is a difficult one, but one perhaps not impossible to solve; we will attempt to propose a convincing answer to it.

For centuries, Rome scarcely knew anything but the basilica; that is, the church whose nave is flanked by aisles on either side. Even in the fifteenth century, the churches begun in Rome—Santa Maria del Popolo, built on the site of Nero's tomb; Sant' Agostino, erected near the baths of Alexander Severus; St. James, built on the site of the circus of Domitian; San Giovanni dei Fiorentini, near the end of the Campo di Marte on the bank of the Tiber—are basilical churches. The oldest vaulted church with a single nave that one can point to in Rome is Santa Maria in Monserrato, which the Catalans had built by Antonio da San Gallo the Elder, beginning in 1495. It was there that Alexander VI Borgia, who for so long had no monument, was buried; today, a modest sarcophagus surmounted by a papal tiara marks his resting place. The austere façade of the church is decorated with an unusual bas-relief: the Virgin holds upon her knees the Child who, armed with a saw, seems to be opening a breach in the rock. It is a naïve way of referring to the sierra, the jagged mountains of Catalonia, where the famous shrine of Our Lady stood. The interior is that of a church of the French Midi; one again finds here the single nave, flanked by chapels set between the buttresses, terminating in an apse. But the decoration is wholly classical: entablature, strong cornice with

modillions, Corinthian pilasters. As for the vaulting, it is no longer the ribbed Gothic vault but the barrel vault of antiquity. The resemblance between such a church and those of the French Midi is arresting, all the more because it, as well, is built of brick.

Should one be unduly surprised? For fifteenth-century Catalans, the church with a single nave was indeed their national shrine. At an early date, as we have indicated, they had adopted the church of Languedoc and carried it all over Catalonia. Is it surprising that their countrymen in Rome wished to pray in a church like those of their native land? The memory of one's country, together with that of one's childhood, is all-powerful within man's heart. One is prone to assume that the artists of the Renaissance had rigid standards, a highly developed aesthetic; one supposes that they would disdainfully have rejected the proposals of a guild's honest representatives. A very striking example gives proof of the contrary. Santa Maria dell'Anima, built in 1500 near the Piazza Navona for the German colony in Rome is, in spite of its classical decoration, a truly German medieval church. Its three naves of an equal height are those of the *Hallenkirchen*, the hall churches that could then be found all throughout Germany and Austria. We do not know the name of the architect employed by the Germans in Rome, but it is certain that, whoever he may have been, he was obliged to comply with the wishes of these foreigners. Renaissance Rome, therefore, was not entirely closed to Gothic influence. It will thus not seem at all impossible—it will even appear probable—that the Catalans asked Antonio da San Gallo for a church like those of their own country. To make him appreciate its economy was not difficult. All the same, it seems that the architect did not entirely accept the idea of this single nave, bordered with chapels; in an early sketch preserved in the Uffizi Museum in Florence, he has indicated a communicating passage between the chapels and created the illusion of aisles. But this proposal was not put into execution; another of San Gallo's drawings in the Uffizi shows us, in effect, the church as it is today, with its single nave and its chapels separated by solid walls. The Catalans thus had in Rome a Catalonian church, but one attired in an antique décor.

It is likely that St. Ignatius Loyola, who once scaled the mountains of Catalonia to hang up his arms in the shrine of the Virgin of Montserrat, came often to pray in the Roman church that bore her name. St. Francis Borgia as well, who came from Gandia and for a long time lived in Barcelona, must have frequented the church of the Catalans in Rome faithfully. He could have persuaded himself that the church with a single nave, less beautiful than the basilica, was more practical; each one of the faithful could see the priest at the altar and hear his words. Formerly, in the centuries of profound belief, one might see nothing and hear nothing and it was of little concern; to be within the church at the moment of the sacrifice, to be one of the members of the Mystical Body of Christ, was enough. But in the century of Luther and Calvin, every man needed to be one with the priest at the altar, to hear his words, to strengthen his faith. The Jesuits in particular had a need for spacious churches. Since they intended to appeal to the senses, in order to win over the whole man, they made a magnificent spectacle out of their services.

Therefore one should not be surprised that St. Francis Borgia, on becoming
Superior General of the Jesuits, had the order's great church, the Gesù, con-
structed on the model of the Roman church of Montserrat and the churches of
Catalonia. The Gesù is indeed a vast nave bordered with chapels, a meridional
church. Vignola, who was its architect, was not left at liberty to build it after his
own fashion. The plan of this celebrated church, which was to serve as a model for
so many others, must have been deliberated at length by the superior of an order
that left nothing to the whim of the individual. A document kept in the archives at
Naples furnishes us with proof of this; it is a letter from Cardinal Alexander
Farnese to the architect Vignola, then absent from Rome.[10] The cardinal, who was
having the Company's church raised at his own expense, took a very particular
interest in it. "Father Polenta," he writes to Vignola, "has been here, sent by the
Superior General of the Jesuits, and has expressed various ideas concerning the
construction of the church. As you were away, I wish to acquaint you with the
essentials; you will, in any case, find there what you already know. You must bear
well in mind the total figure of the expenses, which is twenty-five thousand *écus*.
Your plan must be such that, without exceeding this sum, the length, the breadth,
and the height of the edifice conform to the approved standards of architecture.
The church is not to have three naves but only one, with chapels on its two sides. One
specification is that the church must be vaulted. One might fear that this design
will be less favorable for preaching because of the echo, which renders the voice
less clear. It is thought that this effect is created more by a vault than by a ceiling,
but the examples with which I am familiar make that opinion unconvincing. . . ."

It is thus evident that Vignola was not free to give rein to his own genius. The
single nave of the Gesù and the chapels bordering it were stipulated for him. The
Jesuits' church at Perugia, built a few years earlier and probably by Vignola
himself, still has a nave accompanied by aisles. At Rome, the Superior General of
the Jesuits intervened, for the ideas expressed by Father Polenta are certainly
those of St. Francis Borgia.

It could not be by chance that the plan of the Gesù resembles in almost every
detail that of San Juan de los Reyes in Toledo or of Santo Domingo in Granada.
These beautiful churches are Languedocian churches that have, at their transept
crossing, a charming Spanish dome, a *cimborio.* It is a fact worth noting that the
first churches built by the Jesuits in Spain, San Esteban in Murcia and San Carlos
in Saragossa, both somewhat earlier than the Gesù in Rome, are in the purest
traditions of Catalonia and Languedoc. They have only a single nave bordered
with chapels set between the buttresses; their ornamentation is classical; only
their lierne vaulting recalls the Middle Ages. It is a church like these that the
Company of Jesus, still so Spanish, had built in Rome.

Everything thus persuades us to see in the plan of the Gesù a tradition
common to both Catalonia and Languedoc.

[10] Cart. Farn., fasc. 700. The document has been published by Willich, *Vignola*, but he has
drawn no conclusions from it.

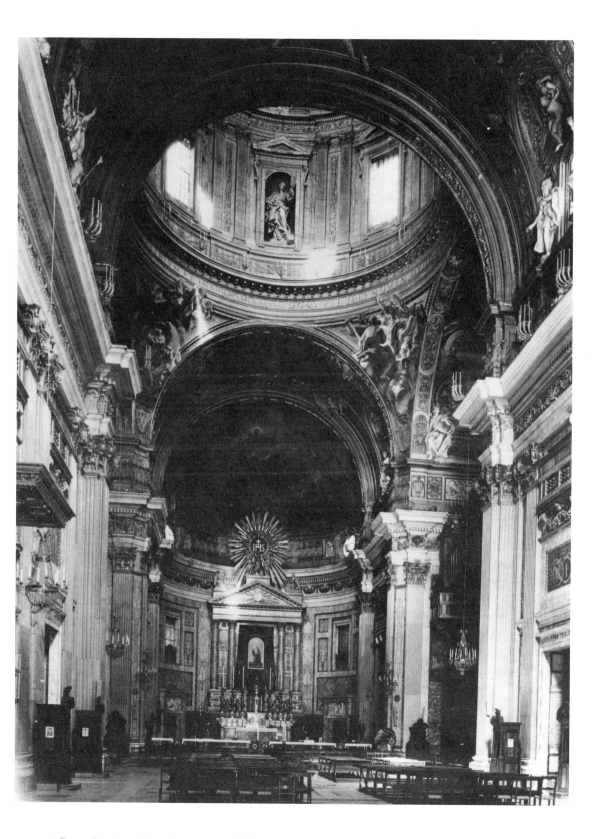

Rome. Interior of the Gesù church, 1568.

In addition, Vignola marked his church profoundly with the stamp of Italy. In 1568, at the moment when work was first begun on the Gesù, St. Peter's, then under construction for more than sixty years, was the school for Italian architects. The beautiful proportions of the Gesù's nave, its pilasters, its dome—that effect of grandeur which the decorative additions of succeeding centuries have somewhat diminished—all draw on the work of Bramante and Michelangelo. Perhaps to those great names we should add that of Alberti. Sant' Andrea at Mantua, for which Alberti drew up the plans and began the work, is, like the Gesù, a church with a single nave and interior chapels. But the placement of these is much more complicated, for the chapels are separated by massive buttressing that contains smaller chapels. It is, however, not impossible that Vignola, required to create a church with a single nave that was bordered by chapels, thought of the work of Alberti. Hence the concept of the Gesù is Spanish, the interpretation Italian.

The influence of the Gesù is well known. From the end of the sixteenth century onward, the single-naved church, flanked by chapels on its two sides, replaced the basilica in Rome. Soon, all of Italy adopted it. The Jesuits certainly contributed to its spread across Europe, although their influence has been exaggerated. They did not insist on imitation of the Gesù as a restriction on the architects of the Company, and they often knew how to make an accommodation to local custom. More than one of their Order's churches, nevertheless, duplicates with greater or less fidelity the famous church at Rome; one recognizes it without difficulty in Naples as at Salamanca, at Montpellier as at Coimbra.

To combat the Protestants, the Counter-Reformation chose the design that the Dominicans of Languedoc had earlier adopted to combat the Albigensians. The same historic architecture answered the same need: these are the churches of the Word.

The meridional architecture of France in its Jesuitical or, more precisely, Roman guise thus achieved the conquest of Europe. The Gothic art of the North, that sublime art that reaches toward the infinite, vanished in its entirety with the Middle Ages; the Gothic art of the Midi, that simple and austere art that ranged itself on the side of the earth rather than of heaven, endured. Caught up by the Renaissance, it reigned for more than two centuries.

R EADING the first of the two volumes that Paul Gout has devoted to Mont-Saint-Michel does not, let us say frankly, create a favorable impression of his work.[1] An interminable history of Mont-Saint-Michel, where everything is given an equal emphasis; singular errors; a labored style; an inordinate number of illustrations that are often irrelevant—everything in this first volume makes the reader's task difficult. It is clear that Gout as a writer and historian is self-taught. If he had been practiced in composition, would he have relegated to the appendix, as something of little value, the finest chapters of his history, those which ought to have been at its heart: the cult of St. Michael, the monastic life at Mont-Saint-Michel, the pilgrimages?

In the second volume, the reader's opinion is modified; after its history, he sets out on a detailed description of the abbey. It is here that Gout reveals his true nature; he is an architect, full of knowledge and of scruple. The happy results of his excavations; his discoveries; his fine restorations; the new names that he has given to rooms whose old identification was sanctified by usage; everything now becomes interesting. And it is not only a savant who is revealed; it is also a man full of enthusiasm, a tireless admirer, whose familiarity has not dulled his zeal. He loves his abbey to the point of hoping for it to become the seat of a French Academy, a rival to the Villa Medici. A worthy ideal, but would the young consent to live between the sea and the sky, between the gale and the lightning, in a solitude where they would have no companionship but that of the elements? Monks did so, for a thousand years, but those were monks; after them, it was necessary to people the abbey with prisoners.

That love of the past for which nothing is without significance, that respect for the smallest stone which is so rare among restorers, awaken not only esteem but sympathy for the author. And if one takes up the first volume anew, after having read the second, one ends by finding that the need to enunciate everything, even the superfluous, that touches on a subject one loves is in its own way moving.

I

THE HISTORY of the cult of St. Michael is one of the most fascinating subjects that a scholar can be offered. Gout has barely touched on it, and one finds it difficult to reproach him, for there is no end to this history. If he had tried to relate it, he would have written a different book.

It is singular that in the cult which sprang up about St. Michael in the distant

Journal des Savants (1911).

[1] Paul Gout, *Le Mont-Saint-Michel*, 2 vol., 470 engravings and 38 plates (Paris: Librairie Armand Colin, 1910).

General view of Mont-Saint-Michel (Manche).

past, the archangel almost always replaced a pagan deity and inherited some of his attributes. Near Hierapolis in Phrygia, where St. Michael had perhaps his oldest sanctuary, he replaced the god of the hot springs. Men said that it was he who caused the springs to gush forth and he who healed the sick there. Near Constantinople, where there was a church from the fourth century onward, he replaced a god-physician who was no doubt Aesclepius. As at Epidaurus, the sick slept in the sanctuary and the archangel revealed to them in a dream the remedy that would heal them. In Gaul, St. Michael appropriated the place of Mercury on the hilltops, as is clearly shown by the name of that hill in the Vendée which is today still called Saint-Michel-Mont-Mercure. In Bavaria, if we are to believe the German scholars, St. Michael would have taken the place of Wotan. The Church thus transferred to St. Michael certain practices to which the peasants were still faithful.

In the West, St. Michael was honored from an early date, but the end of the fifth century marked a decisive moment in the history of his cult. On May 8, 492, the archangel appeared upon Monte Gargano and, from that time on, the mountain cave where the vision was said to have occurred became the most celebrated pilgrimage site in southern Italy. It was from Monte Gargano that the devotion to St. Michael spread across Europe. The Lombards, who in the sixth century had founded the duchy of Benevento, were the first to frequent the famous sanctuary. So great was their devotion to St. Michael that they chose him as their patron. His image appears on their coins and it was to him that they dedicated their most beautiful churches; Pavia counted more than one church of St. Michael.

It is curious to note that the churches thus consecrated to the archangel at times recall the sanctuary on Monte Gargano. In Rome, Pope Boniface[2] built a church dedicated to St. Michael at the summit of Hadrian's mausoleum, at the spot where St. Gregory the Great had once seen the archangel returning his sword to its sheath. Strangely enough, this aerial church was designed in the shape of a crypt (*cryptatim*); it was therefore intended to remind the pilgrims of the sacred cave that they had seen on the summit of the mountain in Apulia.

Above Sorrento, on the peak of Gaurus, from which one looks out over all of southern Italy from the Abruzzi to Calabria, a church arose at an early date in honor of St. Michael. It also possessed, according to the testimony of the monk Bernard, a ninth-century pilgrim, this curious characteristic of having been designed as a crypt.

But the most astonishing of these replications of Monte Gargano is France's Mont-Saint-Michel in Normandy. Everything here is similar. The legends are the same. In a dream, St. Michael announces to St. Aubert, bishop of Avranches, as he had once announced to the archbishop of Siponto, that he wishes to have a shrine upon the mountain. In both accounts, it is a bull that reveals the place where the archangel wishes to be worshipped. Lastly, the two sanctuaries have

[2] Ado (*Martyrolo.*, Sept. 29) does not otherwise identify him. This must have been Boniface III (607) or Boniface IV (608).

Le Puy (Haute-Loire). Chapel of Saint-Michel-d'Aiguilhe.

the same design; since there was no natural grotto at the crest of Mont-Saint-Michel, St. Aubert hollowed out a crypt "which recalled," the text declares, "the shape of the one on Monte Gargano." The source is evident. According to tradition, the dedication of the crypt on Mont-Saint-Michel took place on the sixteenth of October, 709.

The fame of the Mount was soon equal to that of Monte Gargano. It is unquestionably Mont-Saint-Michel that the superior of the cathedral chapter at Puy wished to copy when, in 962, he built a chapel in honor of the archangel at the summit of a basalt rock as abrupt as the mountain in Normandy.

Thus, on all the magnificent heights that dominate the plains or the sea, St. Michael was seen to take up his place, and his worship was henceforth associated with the love of nature.

II

THE GROTTO that St. Aubert had created on the summit of Mont-Saint-Michel was not long in becoming famous. A small shrine arose there; in it, St. Aubert was buried. Canons served the church and exhibited to the pilgrims the marks of St. Michael's fiery touch on the skull of the saintly bishop. Thanks to the throngs of pious visitors, a small town sprang up at the foot of the mountain.

The Scandinavian pirates who were the first dukes of Normandy showed a special reverence for Mont-Saint-Michel. It flattered them to know that the warrior-angel had revealed himself within their domains. They enriched his church by their gifts. In 966, Duke Richard I summoned monks there to found the Benedictine abbey of Mont-Saint-Michel.

"No trace remains of the tenth-century buildings raised up on Mont-Saint-Michel," wrote Corroyer, who began the restoration of the abbey, in 1888.[3] But Gout tells us today that excavation has led him to discover not only the walls of the monastery founded by Duke Richard, but his church as well. This church is of great interest. It lay buried beneath the Romanesque church, where it had to be rediscovered, and it more than probably occupies the very site of the grotto created by St. Aubert. One formerly went down into it by a stair that led from the upper church. It is a small sanctuary with a double nave of an extremely archaic kind; the pillars are of granite but the arches are all of brick. The church was not vaulted; it was covered by a timber-framed roof that burned in 992. It was at that time that the vaulting was raised of which a portion still exists. All these details would lead us to believe that the church already existed in 966 when Duke Richard I founded the abbey. Gout dates it plausibly enough from the beginning of the tenth century. Whatever the date that one assigns to it, it is a new pre-Romanesque construction that these excavations have just disclosed to us.

In 1017, Richard II, Duke of Normandy, was married to Judith of Brittany in the church on Mont-Saint-Michel. The small sanctuary seemed to him unworthy

[3] Edouard Jules Corroyer, *L'architecture romane* (Paris, 1888), p. 186.

of the majesty of the site and he resolved, as of that moment, to have it rebuilt. The rich gifts that he made to the monks in 1022 enabled them to start the work the following year. The builders began with the choir. When they reached the nave, they came up against the old Carolingian sanctuary; rather than demolishing it, they transformed it into a subterranean church and the pillars of the Romanesque church, not without risk, were set up upon its vaults. By 1084 the whole was almost complete. But twenty years later the north side of the nave, whose pillars were in several instances faultily supported, collapsed, and it became necessary to rebuild it on a reinforced foundation.

To what school of architecture does this church belong? Ruprich-Robert asserted, and Corroyer repeated after him, that the eleventh-century choir has all the characteristics of the Norman school; *i.e.*, the aisles are carried forward for two bays beyond the transept, leading into the choir and breaking off abruptly at the beginning of the apse. But until now this was an unproven hypothesis. Gout's excavations have furnished that proof, since he has been able to identify the first bay of the choir aisle in the eleventh-century crypt. It is therefore now certain that the aisles were extended beyond the transept as far as the apse.

In which case, the church at Mont-Saint-Michel finds itself included within the Norman school. But was this plan for the choir, at the opening of the eleventh century, a Norman contribution? To be sure, Normandy and, later, England adopted it, but was it a Norman invention? Was it rather not brought from somewhere else? And when we find it in a Norman church that goes back to the beginning of the eleventh century, should we not for this very reason ask if this church is not the work of an artist from outside the region?

Dehio and von Bezold, in their *Histoire de l'architecture*, have offered an imaginative answer to these questions. According to them, the configuration of the choir that we call Norman was introduced into Normandy from Cluny.*

There were at Cluny three successive churches: the first, built in 906, which has left no trace; the second, built by St. Mayeul[4] and consecrated by him in 981, and, lastly, St. Hugh's enormous church, begun in 1089. It is the second, the church of St. Mayeul, that interests us at present. What was its plan? There exists no document which provides us with an answer. But Dehio and von Bezold reply: it had a nave with accompanying aisles and these aisles extended beyond the transept on both sides of the choir and led into it. How do they propose to prove this? By studying the plan of the Cluniac churches that were built in Europe in the eleventh century.

*Mlle. Gilberte Émile-Mâle is of our opinion that this refers to Georg Gottfried Dehio and G. von Bezold's *Die Kirchliche Baukunst des Abendlands* (Stuttgart, 1884).

[4] The second abbey church at Cluny, a vast edifice built by St. Mayeul and embellished by St. Odilo, should not be confused with a small single-naved church dedicated to St. Mayeul, which existed until the end of the eighteenth century. The *Ordo Farvensis*, in which one finds a description of the abbey of Cluny in the time of St. Odilo, provides us with some very precise details about the great church, but does not give us its floor plan.

In Germany, the Swabian monastery of Hirsau in the eleventh century adopted the rule of Cluny. The two abbey churches that were built after 1060 exist today only as ruins.[5] But the plan of one of them, Saint-Aurélius, has remained perfectly identifiable. It discloses a nave with aisles that extend beyond the transept on both sides of the choir and end abruptly at the beginning of the apse. Hirsau soon became a mother-abbey from which the rule of Cluny spread throughout Germany. In accordance with Cluniac custom, which Germany had not yet learned, there were at Hirsau lay brothers who studied different trades, most of whom were carpenters and masons. It is evidently those workmen who built the abbey churches associated with Hirsau, for they resemble each other. Their ground plan, in particular, is identical. The arrangement of the choir that we have described at Saint-Aurélius is repeated at Halberstadt, Königslutter, Hamersleben, Ierichow, etc.[6] In these examples, however, the side aisles curve into the apse rather than breaking off decisively.

What was the source of this wholly new plan in Germany? Is one to assume that Wilhelm, abbot of Hirsau, who had adopted the rule of Cluny, also copied the church at Cluny? That would not be an impossibility, but further proof is called for.

It appears that France provides us with this. One of the most famous monks at the height of the Middle Ages was the Lombard, William of Volpiano. He entered the monastery at Cluny during the lifetime of St. Mayeul and there so distinguished himself that he was soon named abbot of Saint-Bénigne at Dijon. As his fame spread, he was summoned by Duke Richard II to restore discipline in the monasteries of Normandy. From Fécamp, he ruled several great abbeys from a distance and founded yet another, at Bernay.

The abbey church at Bernay, which must have been begun around 1017, still exists today. Abbot William, who had directed the rebuilding of Saint-Bénigne at Dijon in person, was no stranger to the work on Bernay abbey. It was probably he who suggested its plan: "In locandis fundamentis non modicum praestiterat consilii auxilium," states a text. Now, the plan of the abbey church at Bernay is, aside from a few details, the plan of the church of Saint-Aurélius at Hirsau and the other churches of that school. Aisles that extend beyond the transept flank the choir and open into it. Those aisles, to be sure, rather than breaking off abruptly as in some churches of the Hirsau school, terminate in small apsidal chapels.

This uniformity of plan makes one reflect. Abbot William introduced the reform of Cluny into Normandy, as Abbot Wilhelm introduced it into Swabia; their churches are almost identical. Would not both the one and the other have imitated St. Mayeul's mother-church? The result will seem even more likely, in that a number of the churches built in Burgundy not far from Cluny present us with that particular characteristic of aisles extending beyond the transept. One

[5] One of the two churches at Hirsau was, like Cluny, dedicated to St. Peter and St. Paul.

[6] This school of Hirsau has been studied by C. Baer, *Die Hirsauer Bauschule* (Fribourg and Leipzig, 1897).

finds this configuration both at Anzy-le-Duc and at Semur. Autun cathedral, where the hand of the monks of Cluny is visible everywhere, presents us with the same plan.[7] Lastly, excavations have shown that this was the plan of the old Cluniac church at Romainmotiers in Switzerland.

It is probable, therefore, that all those churches derived from a prototype and that this prototype was the church at Cluny built by St. Mayeul. Respect for the mother-church, whose abbots all were saints, was no doubt the reason behind these imitations, which the rule of Cluny in no way demanded.

One may wonder if, to these examples, one would not be allowed to add the church at Mont-Saint-Michel. What in fact does the *Chronique de Saint-Bénigne* teach us? It states that Richard II, Duke of Normandy, placed under Abbot William's jurisdiction not only Fécamp, but Saint-Ouen in Rouen and *Mont-Saint-Michel*.[8] It is therefore clear that Abbot Hildebert II, under whose administration the church on the Mount began to arise, was not the real director of the community. Behind him, one is aware of the great figure of Abbot William. It is odd that Gout, who has collected so many insignificant details of the history of the abbots of Mont-Saint-Michel, has omitted this major fact. One may consequently ask oneself if Abbot William, who was concerned about his monasteries to the point of directing the work on them in person,[9] did not play a role in the building of the church at Mont-Saint-Michel. Was not the Cluniac plan of Bernay, which arose again on the Mount, specified by him? One must admit that the hypothesis is attractive.

It is evident that, if we have not achieved any certitude in this inquiry into the origins of Norman design, we have at least arrived at a probability. This plan of the choir which will soon be encountered at Jumièges and then, after the Conquest, at Lincoln, at St. Albans, at St. Mary of York, and at Durham, this particular arrangement which becomes one of the characteristics of the Anglo-Norman school, is not Norman. In all probability, it was brought into Normandy by the monks of Cluny. But the Cluniacs were not themselves its inventors. Originating in the East, according to all the evidence, this plan first appeared in the ninth century in Saint-Philibert at Brandlieu. It was adopted, as Lefèvre-Pontalis has shown, by all the Benedictines, for one finds it in the Midi at Saint-Sever, as well as in central France, at Châteaumeillant, or in the West at Saint-Amant-de-Boixe. Must one for this reason reject Dehio's and von Bezold's hypothesis, as Lefèvre-Pontalis has done? I do not think so. If the Cluniacs were not the originators of this plan, if they were not the only ones to make use of it, it nonetheless seems true that they contributed to its spread. Thanks to them, most probably, it expanded throughout Burgundy, entered Normandy, and penetrated into Germany. They

[7] It should be recalled that Lyon cathedral, built in a region that was under the influence of Cluny, presents the same plan.

[8] *Patrologie*, vol. CXLI, col. 865.

[9] *"Referendus abbas magistros conducendo et ipsum opus dictando,"* says the *Chronique* concerning the building of Saint-Bénigne.

may have carried it into yet other regions. To answer with complete certainty, one will have had to study the enormous work of the monks of Cluny in its entirety.[10]

<p style="text-align:center">III</p>

THE MIDDLE AGES produced nothing more overpowering than that formidable group of structures which stands on the northern flank of the abbey of Mont-Saint-Michel and is so rightly called *"La Merveille."* This cyclopean work was accomplished in a relatively short time; begun after the fire of 1203, it was completed toward 1228. However, this complex construction was neither conceived nor executed "at a single stroke," as the archaeologists repeat one after the other. It is one of Gout's virtues to have shown that two distinct constructions are involved here, which are not entirely contemporaneous; it is another to have restored their correct names to the rooms of each of the two buildings. Thus this Merveille, which was assumed to be so familiar, appears now to us in a totally new guise.

The first unit of the apartments, to the east, is made up of three rooms set one above the other: the almshouse, the guest hall, and the refectory.

The architect had conceived of this group as an independent unit, and what clearly demonstrates this is that he had inserted two great windows in the wall at the end of the guest hall. Some years later, however, when a new building was raised by extending the first, it became necessary to block up these windows, whose outlines Gout has retraced. The argument is unanswerable. Consequently, the Merveille does not represent the unified whole that it is usually claimed to be.[11]

In this first unit of the *logis,* Corroyer had identified two rooms by incorrect names and the guides all have repeated, and still repeat, his error. He could recognize, on the lowest level, the almshouse where the poor were given food and where they spent the night on straw bedding, but he did not identify the guest hall that lies above it. It is there that distinguished visitors were welcomed. The hall was so splendid, with its tall columns and its double nave, that Corroyer had seen in it the monks' refectory. But there is no question that the refectory lies above it. It is singular that Corroyer did not identify that refectory by the lectern set within the thickness of the wall; it is the reader's lectern. We know that the Benedictine rule required that a reading be given to the monks throughout the entire duration

[10] I add here, in this new edition (1947), a major note. An American archaeologist, Kenneth J. Conant, who has studied Cluny for a number of years, has made recent excavations in the old church of St. Mayeul and has discovered that the aisles were extended on both sides of the choir. Dehio and von Bezold's hypothesis, with all its attendant consequences, has thus become a reality.

[11] "It is clear," said Corroyer in his *Guide descriptif du Mont-Saint-Michel* (Paris, 1883), "that the two buildings which make up the Merveille were one unit and constructed at the same time" (p. 85).

of the meal. Corroyer would have it that this room was the dormitory and that the reader's niche was the place within which the lamps were placed. The error is all the more surprising in that a kitchen, recognizable by its immense fireplace, lies next to the refectory and leads into it.[12]

The second group of apartments, added as an afterthought to the first and at a slightly lower level, also has three storeys: a cellar, a hall that tradition identifies as the Hall of the Knights, and a cloister.

With its three ranks of columns, the vast Hall of the Knights is one of the most beautiful architectural units within the abbey. What function did it originally serve? For its present name does not apparently go back further than the creation of the Order of the Knights of St. Michael by Louis XI in 1469. If one were to believe Corroyer on this point, it was the hall of general convocation, or Chapter House. But the meticulous study that Gout has devoted to this hall, to its floor plan and its location, has brought him to a different conclusion. According to him, the Knights' Hall was the monks' workplace, by custom called the *chauffoir;* here they devoted themselves to manual labor, here they copied out manuscripts, and here they came to warm themselves on winter days before the great fireplaces. The name that is given it of Hall of the Knights must be relatively recent. Its four naves were so majestic that one could easily imagine the Knights of St. Michael coming together there.

In actuality, it does not seem that the Chapter of the Order ever held its sessions here. Whatever may have been said, Louis XI did not come, after the founding of the Order, to preside in this hall over its first sitting. It is true that he made a journey to Mont-Saint-Michel in 1470; but on September 27, the day fixed for the Chapter's annual meeting, he had already returned to Tours.[13] It was in the little church of Saint-Michel in Paris, standing within the palace courtyard, that the meetings of the Order must have been held; the letters patent of Louis XI allow this to be understood but make no formal statement to that effect. It would nonetheless be wise to leave the hall at Mont-Saint-Michel a name that time has hallowed. That splendid name brings the knight and the monk together in our imagination. On such a spot, that name so filled with poetry calls up all the Middle Ages' powers of sacrifice, and it so happens that our imagination does not play us false, for the abbey has indeed sheltered heroic knights at the same time as its monks. During the Hundred Years' War, one hundred and nineteen Norman nobles, who had not been willing to accept English rule, barricaded themselves within Mont-Saint-Michel and threw back all the assaults against it. Thanks to them, in Normandy the Mount remained French territory. One could read for a long while the names of those heroes inscribed on the wall of the church's south

[12] The monks' dormitory was located on the north side of the nave of the church, in a block of twelfth-century apartments.

[13] Louis XI returned to Mont-Saint-Michel in 1472 to fulfill a vow and to institute a state prison there. No document has been found to indicate that he held a meeting of the Order at that time.

Mont-Saint-Michel: the Hall of the Knights.

transept. Who can say if it was not in their memory that the hall in the Merveille has been called the Hall of the Knights?

Lastly, above the Knights' Hall rises the cloister. Corroyer's restoration has not returned it to us in all its ancient splendor. In the thirteenth century, the monk who paced in meditation beneath these galleries formed by a double row of slender columns arranged in a quincunx had nothing but elegance before his gaze. Within each spandrel unfurled a spray of delicately carved foliage, a theme that renewed itself with each repetition. This rich lacework of foliage was painted and stood out against a colored background. In this beautiful cloister, color existed everywhere: it burst forth on the timberwork of the rafters, on the stone of the galleries, on the glazed tiles of the roof. These fantasies seemed all the more exquisite in that one felt poised beneath the threat of the tempest, between earth and sky. Passing into the northern gallery and looking down through the narrow windows, one could behold nothing but the sea. Before those infinite spaces, the soul would have been seized with dizziness had not the graceful proportions of the cloister restored its sense of harmony.

Nothing creates a stronger impression of that aristocracy which the monastic orders of the Middle Ages represented than the Merveille at Mont-Saint-Michel. The whole seems built for eternity. It is that faith in permanence that creates the greatness of all monastic building. Beside these granite ramparts, our modern construction seems the work of ephemeral beings who do not think of the morrow.

Who was the architect of the Merveille? It remains a mystery upon which Gout has not shed light. He has, however, ventured on a hypothesis. According to him, the Merveille would have had two architects. The older portion, which includes the guest hall, would be the work of an architect from the Ile-de-France; the later part, including the Hall of the Knights and the cloister, is the work of a Norman architect. To me, it seems that if Gout had studied the origins of the Gothic architecture of Normandy, he would not have thought of introducing an architect from the Ile-de-France into the building of the Merveille. Norman Gothic does not differ, to begin with, from that of the Ile-de-France and its neighboring regions; the nave of Lisieux cathedral, which was begun at the end of the twelfth century, curiously resembles that of the cathedral of Laon. Toward the year 1200, the choir of Saint-Étienne at Caen still recalls the choir of Saint-Denis. In 1203, when work was begun on the Merveille, scarcely any of the characteristics that we call "Norman" had begun to appear. Therefore it is not surprising that the guest hall still suggests the art of the Ile-de-France. But what clearly proves that this apartment is the work of a Norman architect, is that the abacus of the capitals is already round in shape. The Norman style is here beginning to make its appearance. Fifteen or twenty years later, the Knights' Hall offers us all the distinctive characteristics of Norman art: not only is the abacus of the capitals round, but the pointed arches have that extreme acuteness that gives such a striking aspect to the cathedrals of Bayeux, Séez, and Coutances. By that date, the variation of the Gothic style which is called Norman Gothic was in full flower. The visible dif-

ferences between the guest hall and the Hall of the Knights thus simply indicate that the first is somewhat earlier than the second. The one offers us the Norman style in the bud; the other, in its full unfolding.

The cloister is one of the most beautiful creations of the Norman Gothic. Although Gout has not attempted to relate it to other works of the same school, it is nonetheless easy to note that the beautiful sprays of foliage that fill the spandrels reappear at Bayeux. The charming doorway that opens beneath the north tower of the cathedral has a delightful decorated tympanum that appears to have been sculpted by the artists of Mont-Saint-Michel. The same can be said of the roses of foliage that decorate the transept and are so characteristic of Norman art. Similar roses reappear in Coutances cathedral. The handsome ambulatory of the church at Norrey in Calvados is adorned with foliage that offers great similarities of design and execution with that at Mont-Saint-Michel. The sculptural decoration of the cloister at the Mount thus does not represent a unique effort; on the contrary, it recalls an entire series of analogous works that bear the mark of Norman taste. At times, it has been said that this cloister is closer to English Gothic than to Norman Gothic. I would have hoped for Gout to offer an opinion on this subject. It is true that the arrangement of the columns in a quincunx, which is fairly unusual in France, appears more than once in England; we see it in the triforium at Worcester and at Beverley. The architect has thereby achieved an effect of perspective and depth. Lincoln cathedral offers us, in the arcades of its transept, a wholly similar device. In addition, the crispness of the colonettes at Mont-Saint-Michel, their round bases, their circular capitals relieved of all ornament, their machine-made appearance, suggest English columns. Had Mont-Saint-Michel's architect been to England before he built his cloister? Or was he summoned there after it was complete? Where was the priority? We do not know. But it is clear that during the early years of the thirteenth century, Norman Gothic and English Gothic offer striking similarities; they represent two schools of architecture that should not be studied separately, as has too often been done up to now.

At other moments in history, a construction like the Merveille would have required a century of effort. It was completed in twenty-five years, and scarcely had it been finished when a magnificent abbot, Robert Turstin, elected in 1236, undertook a work almost equally tremendous. On the other side of the rock he raised up another Merveille; this was to be the abbot's palace, as the Merveille was the palace of the monks. The abbot of Mont-Saint-Michel had become such a great personage, he was now so proud to have the right to wear the miter, the dalmatic, and the ring, that he desired to be lodged in accordance with his rank. The new wing of the *logis* was not unworthy of the old one, whose style it recalled. Above a first floor reserved for the guards there arose, as in a feudal castle, a great hall: it was the abbot's hall of justice. There he exercised his magisterial functions, sitting upon a chair so richly decorated that it gave to the entire construction the name of the "*Belle-Chaise*." Next to the hall of justice, a suite of rooms reserved for the prosecutor and the bailiff charged with the administration of the abbey's vast

holdings in France and England was added. Lastly arose the abbot's lodge, facing almost due south, sheltered from the great northern and western winds that raged about the Merveille and the church. This abbot's lodge, vandalized by the monks of Saint-Maur who reduced the size of all the rooms, and further disfigured and made hideous by the prison administrators, will soon return to its original beauty, thanks to Gout's talents. Here is a project as interesting to pursue as the one which has been undertaken at the Palace of the Popes.

Robert Turstin was not content to labor for himself alone; he wished also to labor for his monks. This extraordinary man undertook to enlarge the Merveille which, in his eyes, could have yet greater majesty. In its extension, he began a building that was to contain the library and the Chapter House. Death interrupted him in 1254, at the moment when the lowest foundations had been laid. No one was found after him to carry on his project and the Merveille has remained incomplete. If Robert Turstin had survived for another ten years, the Merveille would be a work with which nothing could bear comparison.

<div align="center">IV</div>

IN THE FOURTEENTH CENTURY, construction was again begun, but of an entirely different nature. The Hundred Years' War had broken out and it became necessary to fortify the abbey. At the end of the fourteenth century, Abbot Pierre Le Roy had the bastion (whose design is so beautiful) erected to guard the entranceway. This bastion was itself preceded by one of those outer works, called barbicans, that were sometimes planted before the gates. "Pierre Le Roy," says Gout, "did not hesitate to make use of any of the defensive measures employed in the military construction of his day." This is an astonishing statement, for when one studies those defenses, one finds them different to a considerable degree from those that were rising in other parts of France. Machicolation is almost entirely absent here. There are three apertures above the gateway but none are to be found elsewhere; there are none on the towers of the bastion nor at the highest point of the barbican walls. The sole means of defense is the ancient crenelation. Nothing is more surprising when one thinks of the date of this bastion, which was completed in 1393. In the Midi, it had no longer been assumed for fifty years that a wall or a tower could be defended except with machicolation. One need only think of the Palace of the Popes, the ramparts of Avignon, the castle of Beaucaire, and so many other historic buildings in southern France and in Italy. How can it be that at Mont-Saint-Michel there was an apparent resistance to this defensive measure? There is a curious problem here. Must one assume that machicolation, first adopted by the French Midi and by Italy, did not make its way into the North until some later date? One would almost be tempted to think so. But as the history of French military architecture has only just begun to be studied, it would be prudent to make no statements and to wait. What is certain is that the bastion at Mont-Saint-Michel, which can be so precisely dated, will eventually be invaluable evidence for the historian.

Mont-Saint-Michel: the Abbot's lodge and the cistern, 14th–15th centuries.

The girdle of walls that the fourteenth-century abbots had begun to throw around the Mount was extended in the fifteenth century. The new abbot, Robert Jolivet, who foresaw a siege, began his defensive preparations in 1415. Not only did he cause the ramparts to be strengthened, but he also had an immense cistern dug behind the church—which Gout has newly brought to light. The work was in full swing in 1419, when Robert Jolivet learned that the English had taken Rouen. Believing that the French cause was lost, Jolivet without hesitation abandoned the abbey and came to offer his homage to the King of England. His indignant monks replaced him with a vicar general and continued work upon the ramparts. This Jolivet is a sinister figure. He played the role of traitor with a clear conscience. He came in person at the head of the English troops to besiege his own abbey. He showed himself pitiless toward all Frenchmen who would not accept the foreign overlords, and he was one of Joan of Arc's interrogators. He lived long enough to see France triumphant; he died at the moment when he was glibly preparing his rehabilitation with the Pope and among his monks. His tomb could long be seen in the church of Saint-Michel at Rouen.

Jolivet had just quitted Mont-Saint-Michel when a group of valiant Norman knights threw themselves into the breach, resolved to defend it to the last. At first, they had as their leader the Count d'Aumale, and the account of their deeds, spreading as far as Lorraine, came to the ears of Joan of Arc, then still a child. St. Michael thus became for her the true champion of France. Aumale having been killed, a commander of unconquerable spirit, Louis d'Estouteville, took his place. His defense of Mont-Saint-Michel is one of the heroic acts of the Hundred Years' War. Later, in recognition of his deeds and the loyalty of the Mount, Louis XI added to the arms of the abbey, three scallop shells sable on a ground of silver, the ordinary of France with three golden lilies.

At Mont-Saint-Michel, there still exist several pieces of evidence testifying to the energy of Louis d'Estouteville. He set up a barbican before the gate into the town and rebuilt several of the towers. What lends these military constructions their particular interest is that they were designed to mount cannon. In the Claudine tower and the Boucle tower, the embrasures are evidently intended as firing points. The vaulted platforms, moreover, have openings to draw up the smoke. The exterior of these machicolated towers resembles the towers of earlier times, but they are nevertheless already casemates. If these works were really set up by 1425, they are the earliest known examples of the adaptation of feudal architecture to the new demands of artillery. The castle of Lassay, where the bases of the towers were strengthened to withstand cannon fire, dates only from 1458, and the castle of Bonaquil, where the same measures can be seen, is even later. These additions by Louis d'Estouteville are therefore even more interesting than Gout has indicated. It would be worthwhile to establish that this work was begun in 1425 on the basis of solid evidence.

In 1421, just as the defensive walls of Mont-Saint-Michel were rising, the choir of the old Romanesque church collapsed. There could be no thought of rebuilding it while the siege lasted, and there was none. It was Cardinal d'Estouteville,

Mont-Saint-Michel: choir of the abbey church. Second half of the 15th century, beginning of the 16th century.

archbishop of Rouen and administrative abbot of Mont-Saint-Michel, who began its reconstruction after 1446. The fifteenth century is, at Mont-Saint-Michel, the century of the d'Estoutevilles. The work continued without interruption from 1446 until 1452. During that period, the architect built the crypt and the radiating chapels of the upper church. Then, for no reason that one can discover for that eccentricity, the work remained unfinished for forty-eight years. It was not resumed until 1500. At that time the triforium was added and the tall windows of the choir. By 1521, all was completed. This choir of Mont-Saint-Michel is a magnificent piece of architecture, worthy of the great examples from the past that surround it. There is perhaps nothing in the art of the Middle Ages that gives such an impression of concentrated force as the great piers of the crypt. One thinks involuntarily of all that is most massive in Egypt. Flooded with light, the lofty church is supported by flying buttresses that are true masterpieces; in them, the granite takes on the appearance of metal.

Gout is persuaded that this choir is the work of Guillaume Pontifz, the renowned architect of Rouen. But this is an assertion that seems mere guesswork. The choir of Mont-Saint-Michel was begun in 1446, but only in 1462 was Guillaume Pontifz named master of the work at Rouen cathedral. There he remained for thirty-four years, until 1496, the year of his death. Is it really certain, is it even probable, that in 1446 Guillaume Pontifz was already recognized as a man capable of overseeing a task as difficult as the reconstruction of the choir of the church at the Mount? Apparently Cardinal d'Estouteville did not even hold him in particular esteem before 1462, for in 1459 when he was considering the enlargement of his palace, he asked Geoffroy Richier, master mason of the cathedral, for the plans.

The choir of Mont-Saint-Michel has in any case characteristics which associate it with the group of Norman churches. The chapel on the long axis is deeper than the others, following a tradition particularly dear to Normandy. The triforium has that pierced balustrade that one finds at Saint-Ouen and Saint-Maclou in Rouen, as well as at Caudebec-en-Caux. One could have hoped for Gout to point out these similarities and, here as elsewhere, one can reproach him for having seen nothing but his abbey, and wishing to make no comparison with it.

Nevertheless, in spite of its faults, his book remains a major work. Few French monuments have been examined so conscientiously. That zeal has been rewarded, since in several instances the author has thrown new light on a subject that was assumed to be thoroughly familiar. Neither the book nor its author will be forgotten. He has incised his name, like that Dom Garin who may have been one of the architects of the Merveille, on one of the cloister spandrels at Mont-Saint-Michel.

I N THE FAÇADE of Notre-Dame of Paris, the portal on the right, the subject of this study, is, as we know, called the Portail Sainte-Anne, despite the fact that it is almost wholly given over to the Virgin. A glance is enough to convince one that it is much older than the other two doorways. The bas-relief on the tympanum, one of the lintels, and the figures on the archivolts (with one or two exceptions) bear the stamp of twelfth-century art.[1] On this point the archaeologists are agreed. Some, on the authority of Viollet-le-Duc and de Quicherat, have declared that the Portail Sainte-Anne was the very door of the old Romanesque cathedral of Paris itself, and that it goes back to the opening years of the twelfth century. The artists of the thirteenth century, out of a respect for holy images, would have incorporated the work of their forerunners into the new façade. It must, however, be pointed out that French archaeologists had not thought to give close study to these bas-reliefs and statues to which they assigned so early a date. A foreigner and a German, Wilhelm Vöge, is the first to do so, who in a book devoted almost entirely to the old portal at Chartres, has in passing cast a penetrating eye on the doorway of Notre-Dame of Paris.[2] He has confined his study to a few figures only, but he has accurately observed what he claims to have noted; nevertheless, something remains to be added to what he has said.

I

THE MAJOR PART of the Portail Sainte-Anne, that which first draws the attention, consists of a tympanum adorned with an image of the Virgin. The Mother of God, majestically seated beneath an architectural canopy, holds the Child upon her knees; two angels, standing at her sides, are censing her; at her left, a king, and to her right, a bishop, unfurl a banderole, while a clerk writes in an account-book. The old portal at Chartres, in the tympanum of the right-hand doorway, presents us with a like scene but with fewer figures. The Virgin, seated between two angels who cense her, offers the Child in the same way for the adoration of the faithful.

If one compares these two works with care, one is aware that they are almost identical. The Virgin of Paris and the Virgin of Chartres face directly forward with the same grave air. The Child rests upon their knees as upon a throne. Both of

Revue de l'Art ancien et moderne (1897).

[1] The large statues standing on either side of the doorway were restored in the nineteenth century.

[2] Wilhelm Vöge, *Die Anfänge des monumentalen Stiles im Mittelalter* (Strasbourg, 1894). Let us recall that Paul Durand in the *Monographie de la cathédrale de Chartres* had been struck well before Vöge by the resemblance between the portals at Chartres and at Notre-Dame of Paris. "It seems almost certain," he says, "that they are from the same period and decorated by the same artist" (p. 50).

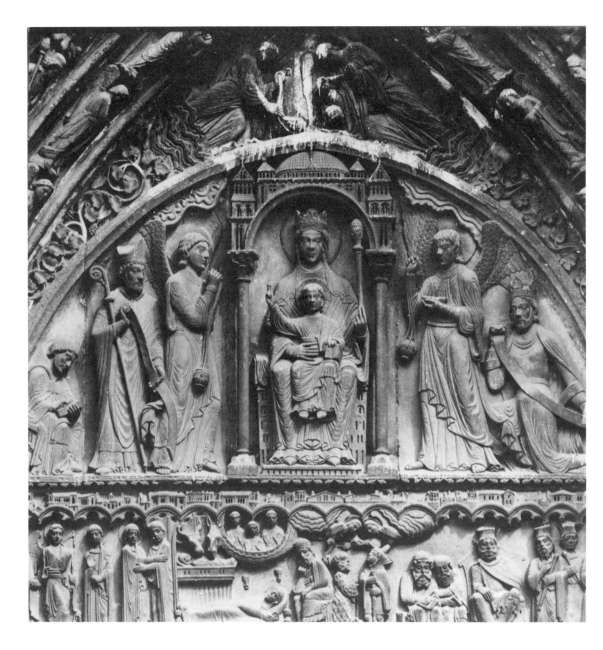

Notre-Dame of Paris: west façade. Tympanum and lintel of the Portail Sainte-Anne, 12th and 13th centuries.

them support Him with their right hand, and those hands, at Paris as at Chartres, are decked with a ring upon the middle finger.[3] They are clothed in a stuff that one feels is as fine as silk and that forms, as it falls about their feet, gathered pleating whose folds are absolutely identical. The same veil covers their hair and falls symmetrically beside their cheeks.

But there are even more curious similarities. Vöge has established that the author of the Chartres Virgin also carved with his own hand the charming figurines that decorate the archivolts of the three portals in the façade of Chartres. Now, one of these figurines, representing an Elder of the Apocalypse, displays the most remarkable similarities in detail with the Virgin and Child of the Portail Sainte-Anne. The Elder's crown is a diadem of goldsmiths' work, in which uncut oval or square jewels, separated by smaller stones, have been set: this is precisely the crown that is worn by the Virgin at Notre-Dame of Paris. The hair of the Chartres Elder is dressed with a curious affectation: four small locks of hair, sharply distinct from each other, fall across his brow. At Paris, the Child Jesus has the same symmetrical little corkscrews upon his forehead. The Elder has caught up in his right hand, onto his throne, a fold of his cloak so that it will not trail along the ground; the Virgin of the Portail Sainte-Anne has done the same. Let us add that the features have traits in common: the prominent nose, the somewhat protruding eyeball, the corner of the eye that slants lightly toward the temple.

All this evidence has appeared so convincing to Vöge that he has not hesitated to declare that the master of Chartres was summoned to Paris to carve the tympanum of the Portail Sainte-Anne, and has called him the "Master of the Two Madonnas." We will be less assertive than he. We thought for a long while that the two Virgins might be from the same hand: today, it seems to us that there is in the art of Chartres a richness, an abundance of beauty, that one does not find to the same degree in Paris. What we have there is not the work of the master but of one of his pupils. In any event, one cannot doubt for an instant that the Paris sculptor took as his model the Virgin of Chartres.

II

BUT A DIFFICULTY ARISES. From all the evidence, the western portals at Chartres were sculpted not long after 1145. On the other hand, according to the opinions held by Viollet-le-Duc and de Quicherat, the Portail Sainte-Anne, a fragment taken from a Romanesque church, would go back to the first years of the twelfth century. The Virgin of Paris would consequently be older by half a century than the Virgin of Chartres from whom we claim she is descended.

But what are the proofs put forward to indicate that the tympanum of the Portail Sainte-Anne is so ancient? Mortet, in the interesting study that he has devoted to Notre-Dame of Paris, gives two.[4] According to his argument, the old

[3] The left hand held a scepter; at Chartres that hand is broken; at Paris, the scepter has been restored.

[4] V. Mortet, *Étude historique et archéologique sur la cathédrale et le palais episcopal de Paris* (1888).

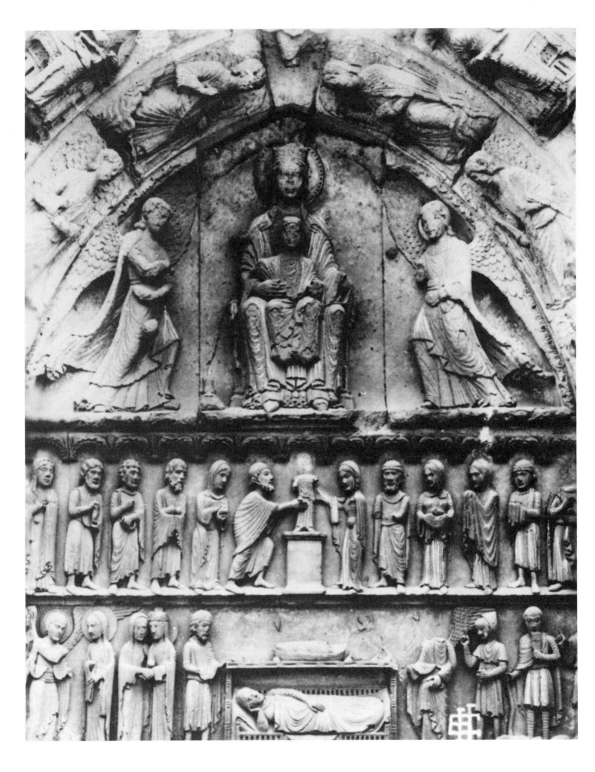

Chartres cathedral (Eure-et-Loir): west façade. Tympanum and lintel of the south portal, second half of the 12th century.

cathedral of Paris would have been rebuilt at the beginning of the twelfth century and the doorway that we see today would have been sculpted at that time. A charter of the year 1110 describes, in fact, the church of Notre-Dame as the new church (*ecclesia nova*). Another charter of 1125 tells us that the king of France gave a considerable sum of money for the church roof.

It does not seem to us that these two documents have the significance that is attributed to them. If a new church is spoken of in 1110, this does not prove that the cathedral had been newly rebuilt. The Abbé Lebeuf, who is familiar with that text, remarks very judiciously that Notre-Dame is called the new church so that it would not be confused with the nearby and much older church of Saint-Étienne, which the charter calls *ecclesia vetus*. Notre-Dame was a "new" church in 1110 only by comparison with the older church of Saint-Étienne. As for the other document, it is even less reliable. The sum given by the king of France was not intended for the completion of a new church which lacked nothing but its roof: it was an endowment making it possible to maintain that roof in perpetuity (*in perpetuum cooperari possit*)

Thus it is not in any way proven that the church of Notre-Dame was rebuilt at the beginning of the twelfth century. Once the hypothesis of reconstruction has been dismissed, there is no longer any reason to maintain that the tympanum of the Portail Sainte-Anne had ever been a part of the decoration of the Romanesque cathedral of Paris. To give its date as the beginning of the twelfth century is wholly arbitrary.

III

ON THE OTHER HAND, it is obvious that this tympanum is much older than the thirteenth-century bas-reliefs which decorate the other two doorways in the façade of Notre-Dame. How is that puzzle to be explained?

We know that the cathedral of Paris, as we behold it today, was begun by Maurice de Sully, who ascended the episcopal throne in 1160. It seems that he set about this great work in the first years of his episcopate. A tradition which, to be sure, one encounters for the first time only in the fourteenth century, would have it that Pope Alexander III, who was then in Paris, laid the first stone of the new church in 1163. The date is altogether reasonable, for in 1177 the choir was almost complete, according to the testimony of an abbot from Mont-Saint-Michel. Notre-Dame of Paris, like Saint-Denis, thus grew forward from its chevet. The building of the nave progressed steadily: nonetheless it had not yet been finished at the death of Maurice de Sully in 1196. The two final bays (those immediately behind the towers) carry the stamp of thirteenth-century art: the columns are no longer single but divided into four small colonettes.

The portals therefore could not have been begun until shortly after 1200. A decree of 1208 already speaks of the doors of the church. Maurice de Sully thus did not have the joy of seeing the marvellous façade that we admire today. But are we to believe that it was not often in his thoughts? Are we to suppose that he did not

ask the architect to draw up its design at the same time that he laid the foundations of the choir? Let us go further. Are we to believe that he did not give the order as early as 1163 to begin work on it? At Saint-Denis, Suger had the choir and the façade begun at the same time. We are convinced that Maurice de Sully asked the sculptors to set to work at once and that the bas-reliefs of the Portail Sainte-Anne were executed from 1163 onward.

A curious discovery made by Viollet-le-Duc, whose implications he did not fully grasp, gives this hypothesis the weight of certainty. During the course of the work of restoration that he had undertaken at Notre-Dame of Paris, he discovered a large twelfth-century bas-relief in the crypt. It represented a Christ in Majesty, surrounded by the four beasts of the Evangelists, which had been destined to decorate the tympanum of a doorway. Viollet-le-Duc observed that the bas-relief appeared completely fresh and bore none of the marks that time and the extremes of weather leave behind. He concluded from this that the work had never been fixed in its place and that it was no sooner finished than rejected. "It was replaced," he says, "by the present subject (the Last Judgement), prepared by the artists of the new school."

Such a discovery seems to us to be of extraordinary interest.[5] It proves that the façade of Notre-Dame of Paris, as it was visualized by the architect who directed the work from 1163 onward, was a re-creation of the one at Chartres. At Chartres, in fact, the Virgin and Child appear on the right-hand portal and the Christ in Majesty on the central entrance. The left-hand portal would doubtless, at Paris as at Chartres, have been filled by the Ascension of Christ.

One finds here evidence of the affiliation between Paris and Chartres. It was to the Chartres portal, so recently completed, that the master of the work at Paris went to seek inspiration.

Beginning in 1163 the sculpture workshop in Paris without doubt went about its task. It was then that the Madonna of Chartres was faithfully copied, but the artist in Paris ventured to create a larger composition. He introduced a bishop and a king at the sides of the Virgin. Who are these two figures? Several names have

[5] The Christ discovered by Viollet-le-Duc has once more disappeared. Vitry asked himself if Viollet-le-Duc, who speaks of a large Christ between the four beasts, had not been deceived by his memory. According to the former, the small bust of Christ bearing the sword in his mouth, which can be seen in the Louvre (and which comes from Notre-Dame of Paris), would be the supposed Christ in Majesty discovered by Viollet-le-Duc (*Revue de l'art chrétien*, 1910). It is difficult to accept this theory when one is familiar with the passage from Viollet-le-Duc, which it is well to recall here: "In repairing the sub-basements of the chapels situated on the north side of the nave, we discovered the fragments of a *colossal* Christ evidently belonging to a large tympanum, with portions of four animals and a book" (*Dictionnaire de l'architecture*, vol. III, p. 243). Nothing could be more precise. He spoke a second time of that Christ in Majesty in his *Dictionnaire*, vol. VII, p. 421: ". . . this sculpture," he states, "is stamped with the archaic style of the twelfth century, the stone of which it is made is wholly fresh. . . ." It does not seem to me possible to refute such evidence.

Notre-Dame of Paris: west façade.

been put forward for them, but, for lack of definite dating, one became confused in conjecture. If the date that we assign to this bas-relief is accepted, all difficulty ceases at once. The bishop is Maurice de Sully, the illustrious founder of the cathedral, who wished to be present for all eternity at the entrance of the church to which he had devoted his life; the king is Louis VII, who figures in the rolls as one of the benefactors of Notre-Dame.

While the artist in charge carved the tympanum of the Portail Sainte-Anne, and perhaps the Christ in Majesty brought to light by Viollet-le-Duc, his workshop prepared the lintel, the trumeau, the large figures that, as at Chartres, were to be placed on the two sides of the doorway and, lastly, the small statuettes destined for the archivolts.

IV

MORE THAN FORTY YEARS went by before the portals, whose decoration had been prepared so long in advance, began to be set in their places. Maurice de Sully was dead, and with him had vanished the first generation of the artists who worked on Notre-Dame. The new master of the work was a man of audacious genius. The façade sketched on parchment by his predecessor, forty years earlier, seemed to him timid. The three portals, whose dimensions would scarcely have exceeded those of the doorways at Chartres, (if we are to judge them by the tympanum of the Portail Sainte-Anne), the archaic style of the statues that had been made ready, even the choice of the subjects, did not satisfy him.

At a single stroke, he created the new façade of Notre-Dame, with its immense rose, its aerial arcading, its enormous towers. This great work possesses all the characteristics of a unified composition. Three large entrances, separated by robust buttresses, open into the façade. The vivid scenes of the Last Judgement, full of agitation and terror, replace the motionless Christ in the midst of the four beasts. In the left-hand doorway, the Resurrection and the Coronation of the Virgin, works of an incomparable beauty, occupy the space which doubtless would have been taken up by the Ascension.

Nothing like it had ever been seen before. The architect had the assistance, to be sure, of remarkable sculptors. The master who carved the Resurrection and Coronation of the Virgin did not fear any comparisons.

The artists who were capable of such masterpieces nevertheless did not consider that they had the right to set aside the bas-relief of the Virgin that had been prepared for such a long time. Did they retain it out of admiration for fine work, or from respect for a master whose name must still have been famous in the workshops of Notre-Dame? Nothing is more uncertain. Artists who possessed so much creative energy could not have been humble men. If they incorporated the old tympanum within the new façade, it was because Maurice de Sully was shown there and they had no wish to deprive the founder of his reflected glory. The tympanum of the Portail Sainte-Anne, whose commission was no doubt authorized by the bishop himself, was as it were his signature. To suppress it would have been to deny his work. They retained not only the tympanum but, guided by an artistic instinct that was wholly accurate, the lintel, the trumeau, and the statues prepared for the embrasures and the archivolts.

In the event, the whole retained its unity. Unfortunately, the new portal was found to be much larger than the one planned in the time of Maurice de Sully. The tympanum was too small; the statuettes on the voussures, which were intended to decorate the archivolts of a smaller opening, were too few.[6] It was, however,

[6] The lintel also was found to be too small; it was necessary to make an adjustment to lengthen it on the left. Indeed, the small Virgin who climbs the steps of the Temple dates from the thirteenth century, as the workmanship proves. It is enough to compare her with the young Virgin on the lower lintel, who also dates from the thirteenth century (the marriage scene): the same dress, the same coronet on her head.

necessary to make use of what was at hand. To begin with, it was decided to give this portal somewhat smaller dimensions than those of the other two. Next, the tympanum was slightly enlarged by surrounding it with a beautiful running spray of foliage and crowning it with two angels who seem to emerge out of the clouds. Within the archivolts, there were many spaces to fill. Therefore ten small figures of angels or prophets were added to the upper portions, in a very different style, but which from below cannot be distinguished from the others. Three figures were placed full-face at the meeting-point of the voussures: an angel, a lamb, and a Christ of the Apocalypse.[7] The original plan called for a single lintel only; it was necessary to add a second, which has all the characteristics of the thirteenth century and makes a striking contrast with the first. The archivolts are lengthened correspondingly at their bases. The artist who carved the second lintel filled them with interesting figures—four on the right; four on the left—that in their dimensions strike something of a discord with those of the other voussures. Lastly, the trumeau dedicated to St. Marcel was set in place, and on the two sides of the portal, the archaic statues of the persons of the Old Law, accompanied by St. Peter and St. Paul, took up their stand.

Drawing on all the available evidence, such is the history of the Portail Sainte-Anne.

<div align="center">V</div>

LET US NOW examine the details of this vast composition and attempt to show that at least four artists collaborated on it.

Can the hand of the master who carved the tympanum be recognized elsewhere in the portal? At first glance, one would be tempted to attribute to him the small angels stationed within the first archivolt.[8]

The first angel on the left-hand voussure (beginning at the base) noticeably offers curious similarities with the two large angels who stand within the tympanum to the right and left of the Virgin. The long delicate tunic that covers part of the robe of these angels, who are garbed like young Levites, is caught up at the back as though in a train with even pleats. The handling of it is contrived, but ingenious and elegant. In the voussure, the small angel shares with the two large angels of the tympanum this very characteristic arrangement of the tunic. But, on studying the head of this figurine with greater care, one is obliged to recognize that neither the treatment of the hair nor the facial features reflect the style of the master of the tympanum. The hair is gathered into a fringe, rather than falling in straight locks, and the corners of the less prominent eyes no longer slant toward

[7] The lamb and the Christ of the Apocalypse, whose originals today are in the Louvre, had very likely been prepared for the central doorway where the figure of Christ in Majesty, i.e., the Christ of Judgement, would have figured. See the article by Vitry mentioned above.

[8] With the exception of the four angels on high (two to the right and two to the left), who are from the thirteenth century.

the temples. The same observation applies to the other angelic figures stationed around the archivolts. One must therefore attribute them to an artist who had been under the master's instruction but nevertheless knew how to demonstrate his originality in the rendering of facial characteristics.

It is to this same artist that one must attribute the most finely-drawn, the most sensitive of the figures of the prophets and kings of Judea who are ranged within the other three archivolts of the portal. Examining these with the aid of a pocket telescope, one will observe more than one resemblance between the figures of the angels and those of the prophets. The way in which the hair is dressed, in particular, provides details that reveals the same hand. Let us compare, for example, the second angel in the archivolt on the left (beginning at the base) with the fourth figure (still counting from the base) in the second archivolt[9] and the second figure in the third. The king, the prophet, and the angel have on each side of their brow two round protrusions ending in a sort of burgeoning little horn that are quite simply two curls, treated in a stylized manner. One recognizes there the technique of the same chisel.

If one again compares the first angel at the base of the first archivolt with the fifth figure on the second, one will remark that both the one head and the other are crowned by identical fringes of hair.

All of the kings of Judea and the prophets that fill the archivolts of the Portail Sainte-Anne cannot however be attributed to the same artist. A few massive figures, stripped of sensitivity and animation, such as, for example, the third in the third archivolt, indicate that mere pupils worked on the decoration of the portal, under the supervision of the master. The archivolts on the right, which remain plunged in shadow during the brightest hours of the day, seem to have had these statues of lesser value intentionally assigned to them.[10]

VI

LET US MOVE ON to the earlier of the two lintels, the one immediately beneath the tympanum which was executed at the same period. There we will discover neither the hand of the master of the tympanum nor the hand that carved the angels and the prophets of the archivolts.

The artist who has portrayed in this lintel the Annunciation, the Visitation, the Nativity, and Herod's audience with the Wise Men, had not the slightest trace of that feeling for composition that distinguishes the master in charge. That talented sculptor knew how to fill the field of the tympanum with great skill: nothing could be more equably balanced nor satisfy the eye more fully. The symmetry is nonetheless not rigid. There are three figures on one side of the Virgin and two on the other. One angel is shown in profile and the other in a

[9] We begin counting with the archivolt of the angels, which we count as the first. All of the archivolts discussed are on the left side of the portal.

[10] It should moreover not be forgotten that in 1772 several of the figurines on the archivolts were restored and that they lost much of their personality.

three-quarter view. On the right, the king takes up the lower part of the tympanum by himself, but he is on his knees, in order to fill it completely. On the left, the bishop stands erect, but a seated clerk fills up the space that he leaves. Thus the symmetry is not forced and does not exclude movement and a restrained vitality.

Now let us cast a glance at the lintel. There is no concern here for the composition, no feeling for drama. The master of the tympanum knew how to give life to a static scene; the author of the lintel, on the contrary, has immobilized the actors of an ongoing drama. The angel of the Annunciation, the Virgin, St. Elizabeth, Herod and his councilors, the Wise Men—all face the spectator. Stiff, unmoving, stationed at regular intervals, these figures are not taking part in any action. The Virgin and St. Elizabeth make the gesture, to be sure, of reaching their arms out to each other, but without turning their heads, and keeping their distances. Each figure exists for itself: it is a little enclosed world. The figures in the tympanum share a common emotion: those on the lintel are taken up with their own thoughts and they have nothing to say to each other.

An artist who is limited to forms as rigid as these cannot be confused with the master of the tympanum. He is equally clearly to be distinguished from the artist who carved the angels and prophets of the voussures. Between them there is almost no common ground, neither in the fall of the draperies nor the molding of the heads. The large figures of Herod and the Wise Men, their beards shaped into a ruff, display striking idiosyncrasies that do not reappear a single time in the voussures.

VII

THE SECOND LINTEL, executed nearly half a century after the first, has, as we will see, all the characteristics of thirteenth-century sculpture.

Its composition is very skillful. It dates from a period when artists had already given a good deal of thought to the disciplines of their art. St. Anne and St. Joachim, the mother and father of the Virgin, are in the center of the lintel. From the place which they occupy, from their very height, they first attract the eye. The two principal protagonists of the scenes that are to follow thus draw the attention from the beginning. One could call it the exposition of a fine classical tragedy.

On the right, a pivotal scene is framed by two others: St. Joachim takes his wife by the hand and leads her to the temple to make an offering there. The high priest turns them away, reproaching them for their childlessness. That is why St. Joachim departs, a bundle on his shoulder, accompanied by a servant, to conceal his grief among the shepherds. But soon an angel arrives, bidding him return to St. Anne, who for long weeks has awaited him. The two spouses meet at the gateway into Jerusalem; Joachim falls at the feet of St. Anne and an angel (whose arms are broken) seems to draw them together for a holy kiss. According to legend, it was from this kiss that the Virgin was conceived.

On the left side of the lintel, the longed-for child has been born, has grown, and St. Anne, accompanied by St. Joachim, is present at her marriage. The scene is

skillfully composed; despite the number of persons, an impression of unity is created. The staves of the suitors have been placed upon the altar and St. Joseph's has miraculously blossomed. The high priest, who occupies the center of the composition as is fitting, takes the hands of Mary and Joseph into his hands and prepares to join them. In a charming gesture, St. Joachim holds the other hand of his beloved daughter, from whom he cannot bring himself to part. This sentimentality is altogether new in art. More resigned to God's will, St. Anne looks on. Meanwhile the disappointed suitors withdraw. They meet with others who, knowing nothing as yet, hasten onward, staff in hand, but they are told that it is too late. This last detail, which is not to be found in the apocryphal *Gospel of the Nativity of the Virgin* from which the scene is taken, illustrates the degree to which the artist had a taste for movement and action. It also demonstrates how perfectly he understood composition, for those two latecomers, who move toward the right, introduce variety into this long line of figures, all of whom (with the exception of St. Joseph) are turned toward the left.

There is thus an educated complexity in this bas-relief that was unknown to the greatest masters of the preceding age. The master of the tympanum himself, despite the attuned genius that his work reveals, never thought of staging such extended scenes.

A study of the details of its execution also leads us to recognize in our lintel a work of the thirteenth century. The robes with their loose pleating, the veils, the flowing mantles, no longer bear any relation to the delicate stuffs, so carefully worked, that cling to the bodies of the twelfth-century statues. Neither does the treatment of beard and hair, arranged in large masses and treated as a whole, resemble the clever interweaving, the ingenious ringlets of French archaic artists. No experienced eye will be deceived.

There is nevertheless something surprising here. This lintel suggests the art of the time of Saint Louis. At first glance, one would instinctively assign the date of 1250 to it, far more than that of 1220. I find here, for my part, nothing that recalls the magisterial simplicity of the figures on the portal of the Virgin. With their multiple pleats, the draperies do not present those large smooth surfaces and beautiful calm lines that seem to clothe the apostles with serenity. Certain gestures that are studied and somewhat affected, like the inclination of St. Joachim as he turns to take the hand of St. Anne, remind us of the art of the second half of the thirteenth century. Must one conclude that the Portail Sainte-Anne was the last to be completed, even long after the others? We confess that we would be inclined to think so.

The artist who worked on this lintel is the same who carved the figures that fill the lower sections of the archivolts. They are closely linked to the scenes shown on the lintel. On the left, one sees a prophet holding a banner and three Jews of the tribe of Judah, three suitors for the hand of the Virgin, who carry staves. On the right, four picturesque scenes in miniature complete the history of St. Joachim. He sits in the midst of his flocks and wears a shepherd's knapsack cross-wise over his shoulder. An angel appears from the clouds and declares to him that God will

send him a child. He makes his way, staff in hand, toward Jerusalem. Finally, he meets St. Anne at the Golden Gate.

It is enough to compare one of the young Jews on the archivolt with one of the suitors on the lintel, to recognize the same hand. The shape of the cap and the cloak, even the pleating of the robe, are wholly identical.

Of the four artists whom the study of the Portail Sainte-Anne has revealed to us, only one is truly memorable: the sculptor of the tympanum. He knew how to reproduce the wonderful Virgin of Chartres with a majesty almost equal to that of the original. There is nothing finer than this Virgin by the Chartres master. As we know, he has imitated the seated Virgin of the Byzantines but his work is not inferior to that august model. The Virgin holds her Son with the sacerdotal gravity of the priest who bears the chalice. She is the seat of the Almighty, the throne of Solomon. Moreover, the Virgin of Chartres was the image of the Virgin most venerated throughout northern France.[11] And it is surely for that reason that Maurice de Sully sought to see her reappear on the face of Notre-Dame of Paris.[12]

[11] I have explained this at greater length in *L'Art religieux du XIIe siècle en France*, p. 284.

[12] De Lasteyrie, in an article in *Memoires de la societé de l'histoire de Paris et de l'Ile-de-France*, which appeared in 1902, hazarded that the tympanum of the Portail Sainte-Anne must be slightly later than 1180. The reason that he gives is that Louis VII, who is shown clean-shaven on his seals, wears a beard on the tympanum of Notre-Dame. This error on the artist's part can only be explained, he thinks, if one assumes that the figure of Louis VII was sculpted at a certain interval after his death; now, Louis VII died in 1180. The argument will doubtless not seem very convincing, for who can prove to our satisfaction that Louis VII never wore a beard? We will therefore continue to believe that the Portail Sainte-Anne, so closely linked by its style to the Chartres portal, is slightly later than 1163, rather than 1180.

T HE PORTAL of Senlis cathedral is a major landmark in the French sculpture of the Middle Ages. I should like here to make an attempt to show that, for almost thirty years, French sculptors kept it before their eyes and imitated it.

The cathedral of Senlis was begun toward the year 1153 by Bishop Thibault, the friend of the great Suger, and consecrated on the 16th of June, 1191. Despite the fact that the church was not wholly complete on the day of its consecration, we may agree with Marcel Aubert, the cathedral's most recent historian, that the bas-reliefs and the statues for the main doorway were in their places at the time.[1] On what date precisely did the sculptors begin their work upon this beautiful composition? That is what we are most anxious to know and of which we are unfortunately ignorant. It has more than once happened that the sculptural decoration for a cathedral has been prepared long before its completion. While the apse and the nave were rising, work was going forward in the workshop on the figures for a portal that did not yet exist. But events do not seem to have occurred in this way at Senlis. The early stages of the cathedral's construction were difficult; funds were lacking, and it became necessary to send petitioners into the neighboring dioceses with relics and royal letters. Even this appeal was less fruitful than had been hoped and the work went forward only at a slow pace. Therefore it is probable that, at Senlis, the decoration of a church that was so difficult to construct was not of immediate concern. It was only when resources subsequently became more available, thanks to the generosity of bishops and private individuals, that the ornamentation of the portal could have come under consideration. I think that we would not be greatly mistaken in assuming that statues and bas-reliefs were begun a few years before the dedication, toward 1185.

What is at once so striking, when one stands before the Senlis portal, is the originality of the concept. We step here into a new world; the thirteenth century is beginning fifteen years before its time.

The beautiful poem to Our Lady that had been hesitantly sketched out, a few years earlier, on the tympanum of Saint-Pierre-le-Puellier at Bourges is here fully realized.[2] On the lintel at Senlis, the apostles surround the Virgin at her death, while two angels bear her soul away; next, the angels come to lift up that sacred body and carry it gently from the tomb. Finally, in the tympanum, the Virgin (already wearing a crown) comes to take her seat at the right hand of her Son for all eternity. This is the earliest known architectural representation of the resurrection and coronation of the Virgin. The archivolts of the tympanum again speak to us of her: the Tree of Jesse, of which we have here the oldest sculptural representation

Revue de l'Art ancien et moderne (1911).

[1] Marcel Aubert, *Monographie de la cathédrale de Senlis* (1910).

[2] *See L'Art religieux du XIIᵉ siècle en France*, p. 435.

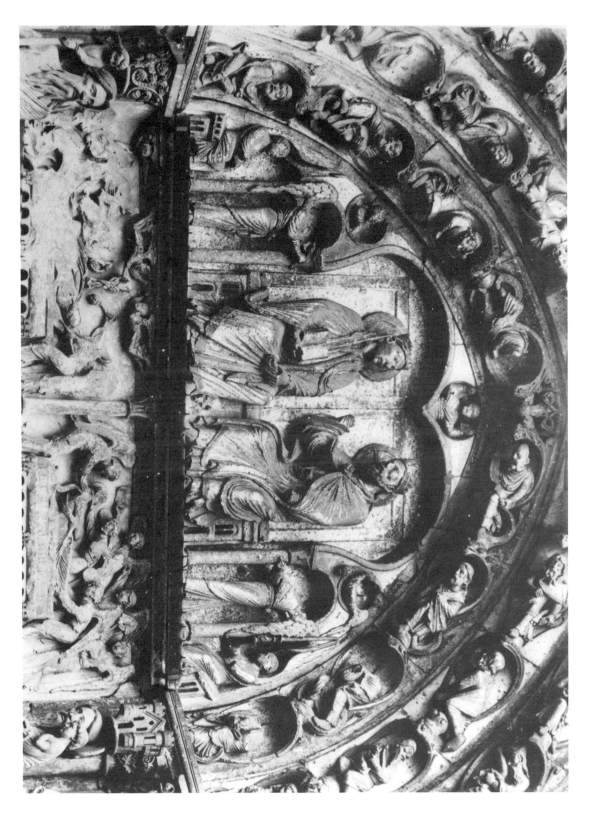

Coronation, death, and resurrection of the Virgin. Tympanum and lintel of Senlis cathedral, end of the 12th century.

also, is the genealogical tree of the Virgin.

The unknown theologian who suggested the Senlis portal to the artists was an innovator of daring. He ventured, in a cathedral that has but one historiated portal, to dedicate that portal to the Virgin. He did not, however, entirely neglect Jesus Christ. The statues standing against the columns all bear some witness to the Christ. On the left of the observer, Abraham, Moses, Samuel, and John the Baptist prefigure or announce Him. On the right, David, Isaiah, Jeremiah, and the aged Simeon foretell His Passion.[3]

These entirely new ideas are expressed at Senlis in a language that is still archaic but which takes some successful risks. It is above all the large statues that carry on the old traditions. Curiously enough, these Senlis statues are not descended from the statues on the royal portal at Chartres, which was completed about 1150, but from the older figures on the doorway at Saint-Denis. The line of descent is unmistakable, and to Vöge belongs the distinction of having been the first to draw attention to it.[4] The Saint-Denis statues, as we know, no longer exist, but are known to us only from Montfaucon's drawings in his *Monuments de la Monarchie française*. But let us compare John the Baptist at Senlis with Montfaucon's drawing that shows us a figure gathering up the folds of his cloak in his left hand, and we will be struck by the similarity. The unusual pleating of this cloak that becomes a kind of girdle is not arrived at twice. The David at Senlis is distinguished, too, by the oddness of his stance; his legs are crossed as if he were about to dance. This archaic trait is again borrowed from the Saint-Denis statues, several of which display this typical feature. It is worth noting that on the royal portal at Chartres, which is much closer in its date than that at Saint-Denis, no statue's legs are crossed. It is again from Saint-Denis that the idea comes (accepted with a certain distrust at Chartres) of supporting the bases of the statues with small figures of men and animals. The Saint-Denis portal was so patently the model for the artists at Senlis that they imitated it to the extent of including a minor architectural anomaly. They have repeated the two engaged colonettes that seem to support the lintel at either end, an arrangement that is relatively unusual. Thus, even though the Saint-Denis portal was dedicated to an entirely different subject and celebrates Christ alone, in the person of the Son of Man, and not the Virgin, that major work, the first of its kind to be seen in northern France, continued to attract admiration. By virtue of its technical example, it remained a fertile source of inspiration.[5]

But the discipline of Saint-Denis is transcended by what is most beautiful at Senlis. We have entered into an age of creativity where development is rapid.

[3] These figures were very badly restored in 1846. Aubert, with the help of the casts in the Trocadero, which predate the restorations, has given each figure back its true name.

[4] Vöge, *Die Anfänge des monumentalen Stiles im Mittelalter* (1894), p. 306.

[5] We have said elsewhere (*L'Art religieux du XII^e siècle en France*, pp. 183 and 436) that the subject of the coronation of the Virgin is probably Suger's creation, with the result that the Senlis portal derived from Saint-Denis both its iconography and its style.

Coronation, death, and resurrection of the Virgin. Mantes cathedral: tympanum and lintel of the center portal in the west façade, end of the 12th century.

Respect for tradition did not prevent the artists from attempting new ideas. The resurrection of the Virgin's body by angels is a new concept in religious iconography, one for which they had no precedent; they transformed it into a masterpiece of vitality and grace.

Scarcely was it completed, before the Senlis portal must have excited profound admiration, for we see it imitated almost immediately at several churches.

We find its earliest imitation in the collegiate church at Mantes. The date of the Mantes church is not known, but it offers such striking analogies with Notre-Dame of Paris that the two buildings must be contemporaneous. One would even be tempted to think, when one studies the exaggeratedly archaic galleries of Mantes with their pointed vaulting and their windows shaped like a rose, that the collegiate church at Mantes is a little earlier than the cathedral of Paris and may have been begun before 1163. In the case of the façade, its lower portions date from the last years of the twelfth century. The center portal at Mantes logically comes after that at Senlis. It is similar, but it is however somewhat more elaborate. The archivolts are surrounded by a band of foliage that does not exist at Senlis; the capitals are a little less archaic. It is probable that the center portal at Mantes was begun not long after the dedication of the one at Senlis, *i.e.,* a little after 1191.

We must assume that at this time nothing was thought finer than the Senlis portal, or more worthy of the Virgin, whose worship was growing within men's souls, for the sculptors at Mantes were given orders to copy the work of the Senlis sculptors. Some of the artisans from Senlis may even have been summoned to Mantes. From the first glance, the resemblance between the two works is striking. One sees in both tympana, near Christ and the Virgin, who are seated beside each other, a standing angel and a small angel sitting on a stool. Both lintels show us the death of the Virgin to the left and the resurrection of her body by the angels to the right. The two Trees of Jesse in the archivolts are identical; the small figures are seated here and there in odd octagonal niches formed by the shoots of the tree.

At one time, the similarity between the two works must have been even more striking, for the portal at Mantes was decorated, like that at Senlis, with eight large statues. Destroyed during the Revolution, those statues were replaced in 1819 by columns. It is clear that the eight Senlis statues were copied at Mantes, as the bas-reliefs were copied. I hoped to come upon some fragments of those statues in the galleries at Mantes, where a great deal of sculptural debris has accumulated; but the heads of kings and prophets that one sees there are from a later period and never belonged to the statues in the center doorway.

If the two portals resemble one another, in several instances they are also different. At the fortunate period in which we find ourselves, the sculptors had so many new ideas to express that they never followed their precursors slavishly. The great scene that takes place in heaven between the Mother and the Son has been placed in a better setting at Mantes. The arch that is so awkward at Senlis, the round openings that accompany it, the cramped little arches to which the angels are confined, all these have disappeared. A pointed trefoil arch encloses the bas-relief at Mantes. In its upper portion, two angels with censers (today hardly

visible) fill up the space that separates the Virgin and her Son. Freed of all unnecessary complexity, the composition gains in nobility. The lintel also offers us its innovations. In despair, no doubt, of equalling the delicious resurrection of the Virgin by the master of Senlis, the Mantes sculptor gave up the attempt. He has kept the parallel sweep of the angels' wings and the position of the Virgin whom they lift up, but the charm has vanished. The Mantes artist, however, also had his happy discovery. The resurrection of the Virgin is here accompanied by a fine scene that we did not remark at Senlis. As the text of *The Golden Legend* tells us, St. Michael the Archangel bears Mary's soul to heaven and presents it to Christ, so that He may reunite it with the body of His mother. The archangel's graceful silhouette, his stretched wings, his veiled hands, his lines that are almost classical, raise us above the charm of Senlis and give us a foretaste of the nobility of the thirteenth century. In this Mantes tympanum, the drapery remains archaic still in the multiplicity of its pleats, but the affectations of earlier times, the spirals, the flourishes, the agitation, have disappeared. The archivolts at Mantes are stylistically very close to the art of Senlis. The last has a mysterious character that arrests the imagination: we see a figure that holds a fish; another with a lion cub on its knees; another with a lamb. One seems to be carrying a vase; a woman appears higher up, and over her two persons are joined together in the same voussoir. One thinks at first of the fish of Tobias, the lion of Judah, the lamb of Abel. Next, one asks if there is not a mysterious zodiac to be identified here: fish, lion, ram, water-carrier, virgin, twins. The idea of placing the astronomical symbols in the hands of allegorical figures was not new; over a half-century earlier, at Saint-Sernin in Toulouse, the sign of the ram and the sign of the lion had been represented in this way. The existence of a calendar on the Virgin's portal at Mantes ought in no way to surprise us, since the portal at Senlis also shows us one. At Senlis, the labors of the months are placed beneath the large statues; at Mantes, since the statues extended much lower, the calendar might have been inscribed in the archivolts. But since at least half of these small figures have been mutilated and no longer have any attributes, it is difficult to be sure. The artist's concept has taken on the insubstantiality of a dream.

The Mantes portal was no doubt almost completed when, in 1194, the cathedral of Chartres burned. Only the western front, with its statues and its windows, could be saved. The rebuilding of the choir was begun at once. While it was rising, thought was given to the sculptural decoration of the portals that were to open to the north and south, and the first idea that occurred to the chapter at Chartres was to devote one of these portals to the Virgin. And it was once again the Senlis doorway that was chosen as a model. Evidently it was at that time not thought possible to pay homage to the Virgin with greater tenderness, nor to observe the memory of her Son with greater splendor. The great allegorical statues of patriarchs and prophets were the first to be prepared. Work may have begun on these toward 1200. Indeed, they are too closely akin to the art of Senlis to be dated very much later than this. The drapery, to be sure, already clings less closely to the body, but the complexity of the pleating makes it possible to detect the ties

between the two workshops. The imitation becomes wholly obvious when one studies the two series with care. The individuals are the same: Abraham, Moses, Samuel, David, Isaiah, Jeremiah, the aged Simeon, and John the Baptist. The attributes (when they still exist at Senlis) nearly always appear identical: Samuel holds the sacrificial lamb, its head downward; Moses indicates with his right hand the head of the pole that he holds in his left; Abraham, his feet resting upon a ram, has before him the small Isaac, who peacefully folds his hands. But at Chartres the splendid vision of Senlis, more carefully thought out, has taken on a character of incomparable grandeur. Standing in chronological order, these symbolic personages narrate the history of the world and proclaim the hope of the generations. Two additional statues, one at the start of the series and the other at the end of it, complete its meaning. Melchisedek, the first priest, appears at the beginning of time, his chalice in his hand; and St. Peter, on the threshold of the new age, when the cycle has been revealed, again holds up the chalice before us.[6]

The influence of Senlis is no less plain in the tympanum, on the lintel, and in the voussoirs. If one compares, for example, the two scenes showing the resurrection of the Virgin's body by the angels, one will be struck by their similarities. At Chartres, as at Senlis, one sees on one side of the sepulcher an angel who supports the Virgin's shoulders while, on the other, a second angel lifts up the shroud in which her feet are enfolded. If one chooses to see in this a fortuitous coincidence, the gesture of the angel, who raises the head of the Virgin with one hand and her winding-sheet with the other, would remove all doubt. The Chartres artist has imitated the master of Senlis, but his work is as rigid as the other's is full of life. The body of the Virgin, into which the soul has not yet returned, seems very heavy, and the parallel arms of the angels create an impression of effort; the lightness, the vivacity, of the Senlis angels has vanished without leaving a trace.

But in the tympanum, the sculptor of Chartres regains the advantage. The trefoil arch that encloses Christ and the Virgin is a much happier choice than the bifurcated arch of Senlis. The group of Mother and Son is conceived with a delicacy of feeling that is altogether new. The Christ, modelled upon the one at Senlis, is nobler, more regally seated upon His throne. The Virgin is immeasurably lovelier; she bows her crowned head with humility and her lifted hands express astonishment and respect. It is as if a dialogue were taking place between Jesus and His Mother. The Chartres artist was no less successful in the figures of the two angels who take part in the scene. The naïve device of the Senlis sculptor, who placed a small seated angel within the angle and a larger angel in front of him, increasing the height of his figures with the curve of the tympanum, was shocking to the sculptor at Chartres. The Mantes sculptor had not found it necessary to make any changes here, but within a few years the feeling for balance had grown more finely-tuned. At Chartres, there is only one angel on each side, but this kneeling angel fills up the space harmoniously and, at the same time, its height remains in proportion with that of the Virgin and of Christ. It is difficult to imagine

[6] Only the base of the chalice remains.

Resurrection of the Virgin: north portal of Chartres cathedral (Eure-et-Loir). Lintel of the center bay.

a happier solution. In their narrow pleating, these beautiful figures still remain associated with the large prophetic figures in the portal, but the sense of harmony revealed here might allow one to think that they are later by a number of years.[7]

The archivolts at Chartres lead us once again to the Senlis portal. They are visualized in the same manner. Two orders of the arch are devoted to the Tree of Jesse, the others to the prophets. The Tree of Jesse still closely follows the Senlis prototype. Each figure is seated within the little oblong niche formed by the interwoven shoots of the Tree; but those shoots, upon which leaves are sculpted, begin to take on an air of naturalism. The Chartres portal, which is somewhat larger than the one at Senlis, has an extra archivolt; it is filled with angels. The second archivolt exhibits an extremely interesting feature that we have not yet encountered, either at Senlis or at Mantes. The bracket beneath the feet of each prophet is delicately carved and becomes a canopy over the head of the prophet beneath. Here, therefore, there appeared the canopy that will soon become an indispensable element of the archivolt.

The rebuilding of Chartres cathedral was well under way when the cathedral of Rheims burned in its turn in 1210. Those conflagrations that coincided with the early years of the Gothic genius must have appeared providential. At Rheims, as at Chartres, immediate thought was given to the decoration of the portals. The façade proposed at that time in no way resembled the one that we see today. The school of Champagne had not yet thought of replacing the tympana with rose windows. Three portals were apparently planned that would have been dedicated to the Virgin, to the Last Judgement, and to the diocesan saints.

The sculptors must have set about their work shortly after 1210 and begun preparation in the workshop of the statues for the Virgin's portal. Those statues still exist today; they have been set in the right-hand portal of the western façade, where their archaic style contrasts with the elegance of everything around them. Placed within a composition for which they were never intended, they lose their symbolic significance. At first glance, the similarity of these statues to those at Chartres is startling: the same individuals, the identical attitudes. Let us compare the two Abrahams, the two Moses, the two Isaiahs, the two Simeons, and we will determine whether a gesture could be reproduced with greater fidelity. The only differences are those of style: at Rheims, the statues are more collected, the beards rougher and less flowing, the folds a little less tightly pleated. What we have here is thus the work of artists who are not those of Chartres but who had just seen the newly-completed Chartres portal. From this we must conclude that at Rheims a

[7] After 1200, and perhaps even earlier, two things were in preparation at Chartres: a portal of the Virgin and a portal of the Last Judgement. The statues of the patriarchs for the Virgin's portal and those of the apostles for the portal of the Last Judgement were begun at the same time. The two tympana are slightly later than the statues. The tympanum of the Virgin was probably set in place after 1205, for it was in that year that the skull of St. Anne came to Chartres, sent from Constantinople by the Count of Blois; and it was as a reminder that the cathedral of Chartres possessed this significant relic that the statue of St. Anne holding the Virgin was set before the trumeau of the portal.

Resurrection of the Virgin, Senlis cathedral. Lintel of the portal in the west façade, end of the 12th century.

portal dedicated to the Virgin had been planned, like that at Chartres; in effect, like that at Senlis. The large statues of prophets and patriarchs called for a tympanum dedicated to the coronation of the Virgin and a lintel devoted to her death and resurrection. Were that tympanum and that lintel ever executed? Probably not. It appears that this first Rheims workshop prepared only the large statues that were to decorate the three doorways of the façade. After the figures of patriarchs and prophets, which are the earliest and may have been begun by 1211, came the figures of local saints and the apostles. Later on, these statues were placed in the two portals on the north side, but it is clear that the apostles who traditionally accompany the Last Judgement were intended for one of the doorways in the western façade, for the Last Judgement is always on the side toward the setting sun.[8] It appears that this first workshop produced only statues and never carved a tympanum. For reasons that are not clear, it was closed down for several years. When it reopened, sculpture had made astonishing strides. In addition, the Rheims architect had modified the plans of the first master of the work and drawn up an infinitely more impressive façade. The old statues were used wherever they could be fitted in. The tympanum of the Last Judgement and that of the life of St. Remi were then prepared. As for the tympanum of the coronation of the Virgin, it was never executed.

We have just disinterred at Rheims the intention of once again giving a form to the thought that was first incorporated at Senlis. But, at Rheims, the influence of Senlis was mediated by Chartres. In Laon cathedral, we find vestiges of Senlis and traces of Chartres at one and the same time. No document is in existence that allows us to date the sculptures on the western portals at Laon with any degree of precision; but, in consideration of their style, one would normally assign to them a date of about 1215 or 1220. The center portal is, as at Senlis and Chartres, dedicated to the coronation of the Virgin. The influence of Senlis can be recognized in the shape of the arch that frames the scene. This shape is better chosen than that at Senlis, but it remains somewhat awkward; one notices an unusual small column persisting there that carries the springing of the arch. This solitary column nonetheless represents an advance, for there are two at Senlis, which is even more awkward. The two angels, placed one behind the other, are likewise a reminder of the Senlis tympanum, but at Laon the second is kneeling rather than seated; the attitude is more pleasing, the line better adapted to the angle of the tympanum. The influence of Chartres betrays itself as soon as one examines the archivolts. The shoots on the Tree of Jesse that frame the figures are exactly like those one sees at Chartres: the same curving stem, decorated with small leaves, the same flowerets. As at Chartres, there are five orders of the arch, the first of which is filled with a series of angels. Even in the gesture of the Virgin, who is no longer motionless but lifts her hand in token of astonishment and lightly bows her head, one detects an echo of Chartres. The two sources thus have merged. To

[8] At Chartres, it has been placed on the south, because one did not wish to rebuild the western façade, which was preserved just as it had been sculpted in the twelfth century.

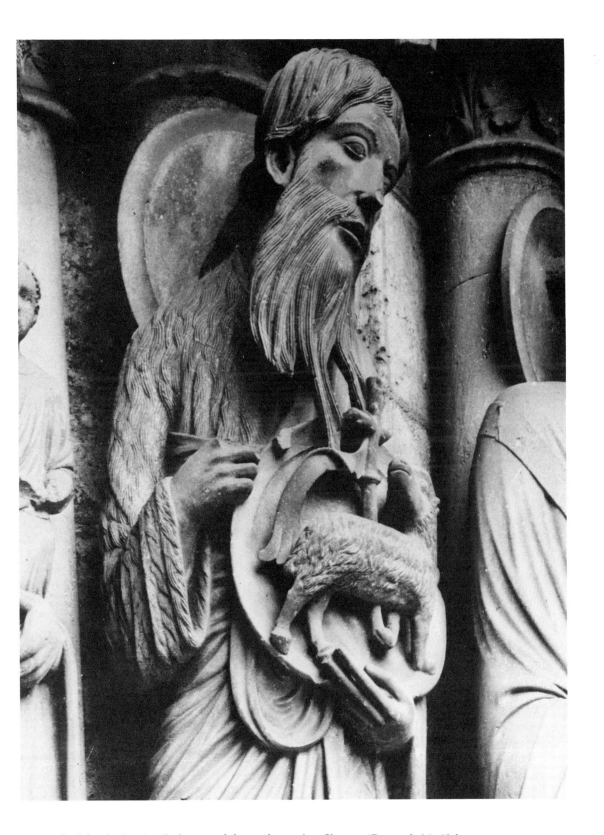

St. John the Baptist: Embrasure of the north portal at Chartres (Eure-et-Loir), 13th century.

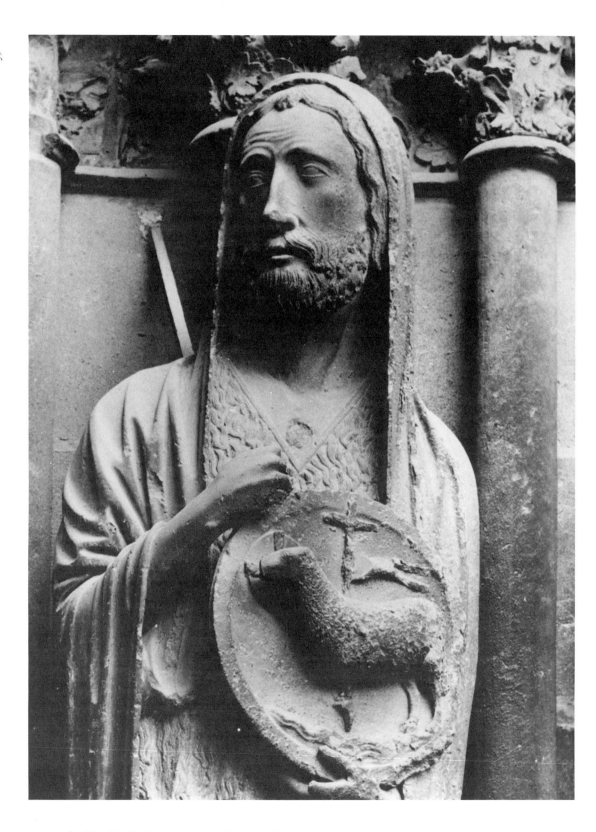

St. John the Baptist: embrasure of the portal in the west façade of Rheims cathedral (Marne), 13th century.

know the full extent of these imitations, one would need the lintel. The lintel at Laon had already disappeared by the eighteenth century and been replaced by a decoration in the style of the period. Nothing could have held more interest for us than to be able to compare the resurrection of the Virgin at Laon with that at Senlis; here we would have been able to judge the degree of the Laon artist's originality. The large statues that stood along the two sides of the portal are also missing. They were destroyed during the Revolution without leaving, I believe, any trace. There were eight of these, as at Senlis, and it is more than probable that they represented the same personages: Abraham, Moses, Samuel, David, Isaiah, Jeremiah, Simeon, and John the Baptist.[9]

Such was the extent of the influence of the Senlis portal. Directly or indirectly, it inspired the artists of Mantes, of Chartres, of Rheims, and of Laon. It was at Senlis that the iconography of the resurrection and the coronation of the Virgin evolved. From 1185 until 1220, the Virgin was celebrated by artists according to the formula—one would almost say, the liturgy—of the Senlis sculptors. A new masterpiece appeared toward 1220 that caused the old one to be forgotten. The splendid tympanum at Notre-Dame of Paris showed the resurrection and the crowning of the Virgin in a new guise. There, also, one feels the influence of Senlis but everything is felt more deeply. That matchless work will influence art in its turn. For a quarter of a century, one will see an angel emerging from the heavens, as at Notre-Dame, to place the crown upon the Virgin's brow.[10]

[9] The fragments that still exist at Saint-Yves de Braisne prove that the church at one time possessed a portal belonging to the group that we have studied here. *See* A. Boinet, *Congrès arch. de France.* Congrès de Reims (1911); vol. 2, p. 259.

[10] Since this chapter was written I have discovered in Italy, at Vezzolano (Piedmont), a new imitation of the Senlis portal, dating from 1189. I have examined this copy in *Rome et ses vieilles églises*, 3rd edition (1946), p. 207.

IX A NEW STUDY OF RHEIMS CATHEDRAL

I HAVE RETURNED to Rheims cathedral since its recent injuries: a phantom church in the midst of a ghostly city. In that wilderness, everything was illusory. Many houses appeared to be intact, but their windows opened onto the empty sky and behind their doors nothing awaited. The strands of barbed wire that lay strewn across the rubble seemed the natural vegetation of those ruins. The measured march of German prisoners kept time in the silence.

The charred cathedral, covered with deep scars, exposing its naked bones, was shocking at first. The statues on the north tower, gnawed by fire, were returning to the elements. Art's divine imprint was fading from the stone. But soon an emotion arose that caused all others to be forgotten, a tender and profound veneration. The cathedral resembled a martyr who had just undergone torture and whom her tormentors had not been able to overcome. She, too, had experienced her Passion; to her beauty, sainthood was henceforth added.

Nevertheless, I could not prevent myself from thinking of that distant day when I saw her for the first time, untouched, dazzling, decked with her thousand statues. No other work from man's hand has ever moved me as much as the three stupendous porches, as they were that day. The mutilated cathedral will no doubt prove equally moving; its sad smile will touch hearts no less deeply; but will that past magnificence become no more than a fading memory? Must the coming generations remain unaware of it forever?—that is what I asked myself before those broken voussoirs, those violated statues that laid the heart of the stone open to view.

But what I longed for was in the process of coming to birth; an album was in preparation that is today completed, restoring the cathedral to us in all its glory.[1] By a happy chance, all of these magnificent photographs had been taken shortly before the war.[2] Among them are some that today alone preserve the image of what no longer exists. They have become the true originals for us; posterity will forever see a figure from Rheims as it is presented here. These two hundred and twenty-five plates, all of which are deserving of interest and many of which are

Gazette des Beaux-Arts (1921). We have devoted another study to Rheims cathedral in *L'Art allemand et l'Art français du moyen age.*

[1] *La Cathédrale de Reims*, 2 vols., with an introduction and notes by Paul Vitry, Curator of the Louvre. The book has been published by the Central Library of the Beaux-Arts. The editor, Émile Lévy, who began work upon it in the middle of the war with a veritable passion, died before he had the happiness of seeing it completed. There is only one regret, in regard to this admirable collection, to be expressed: it is not wholly complete. Several plates are missing that would have given us all the interior decoration of the inner side of the façade; the interior north and south portals are almost entirely absent.

[2] They were made by Trompette, Rothier, and L. Doucet. Some were borrowed from the Collection of Historic Monuments.

Rheims cathedral (Marne): nave viewed from the choir.

superb, constitute a monument worthy of the cathedral. One can spend hours studying them. We seem to stand before the portals; we take in the whole composition with our gaze to begin with, and then we examine the statues one by one. A plate brings the face of the most beautiful before our eyes. These astonishing photographs allow us to see the smallest abrasions and that delicate traffic of time which gives life to the skin of statues and makes the face of stone resemble a human face that has been a little bruised by the years.

Several of these photographs offer us masterpieces that we had never seen before; such is, for instance, the bas-relief of the finding of the Cross by St. Helen, placed too high for one to be aware of its beauties from the parvis. The upper panel is somewhat crude, but the lower one is very fine. The grouping is arranged with consummate skill. St. Helen, slender, elegant, the hem of her robe gracefully caught up over her arm, is the very image of the great lady of the thirteenth century refined by poetry. One of her listeners has the noble profile of an antique philosopher. We will have come to know this masterpiece too late to take pleasure in it, for it is destroyed.

After showing us the statues, the voussoirs, and the bas-reliefs of the doorways, the album lifts us to the heights. We are beneath the slender bridges of the flying buttresses here; we are here at the level of the rose windows. We see, face to face, that beautiful figure of the Church, today obliterated, whose pure features are so full of soul. Before our eyes are angels, kings, prophets, comic and tragic masks, that were seen only by the swallows. What one did not see is as perfect as that which one saw. Art flourishes everywhere with a prodigality, an indifference to admiration, that recalls the work of nature.

The album next leads us inside the cathedral. We enter among its lights and shadows. We see it from the far end of the nave, then from the depths of the choir; the rose appears between the pillars, in the distance, like a thinly veiled star. We walk through the aisles, the transept, the ambulatory; all is limpid, pure, whole as before; no stone has been dislodged, no vault has crumbled. It is as if nothing has happened, as if it were in a dream that we saw the mutilated cathedral. We climb to the triforium to plunge our glance into the nave, the better to assess its height. It is here that one admires, close at hand, the fresh bouquet of foliage that unfolds at the head of each colonette. It is from here that one should gaze upon the great wall covered with statues that closes off the nave. Some of those magnificent statues, lost in the shadows and truly unknown, reveal themselves to us for the first time in these illustrations. Some are calm and grave; some are high-strung and trembling. No doubt nearly contemporaneous, they bear witness to the astonishing variety of the genius of the Rheims masters.

This lavish collection is offered to the public by Paul Vitry, curator of the Louvre. A short historical introduction is followed by a descriptive and critical table of the plates. Vitry is an excellent guide; his admiration is based on knowledge and the reader need not scruple to share that admiration. He tells us in a few words what is known or what is conjectured concerning all these masterpieces, never offering us hypotheses disguised as facts.

Rheims cathedral (Marne): statue of an angel on the west façade.

He has noted, with a conscientiousness that must have caused him acute suffering, all of the injuries to the cathedral. After having pointed out a statue for our admiration, in a brief line of italics he tells us that its head has been broken off, its draperies shattered. Introduced into the text are some drawings of an eloquent sadness that show us what *is* beside what once *was*. It is from such losses that eternal regret is born. The world knows that the angel of Rheims smiles no longer, but it does not know that battered statues exist on all the portals; that the most beautiful of the angels that surrounded the church are shattered; that several of the splendid kings on the transepts no longer exist; that the charming baptism of Clovis, on the north portal, has suffered major damage; that the fine Passion of Christ that filled the voussoirs of the left-hand doorway in the west façade has been almost entirely destroyed. Posterity will be unwilling to believe that one of the world's most magnificent monuments, whose smallest carving would, in a museum, be protected by glass, was bombarded throughout four years like a fortress. But the broken statues will act as witnesses.

II

THE CAREFUL STUDY of Vitry's text, and of the illustrations in the album, has suggested several observations to me that I should like to put forward here.

For twenty-five years, archaeologists have agreed that Jean d'Orbais was the original architect of Rheims cathedral. Demaison advanced him to this position in an article in the *Bulletin archéologique* of 1894. He recalled that in former times one saw a maze, inlaid in the pavement of the cathedral, that was decorated in its four corners with the portraits of the four architects of Notre-Dame of Rheims. The maze had been destroyed in 1779 but its inscriptions were preserved. Those inscriptions gave the names of the architects and indicated the part that each had played in the work; unfortunately, they provided no dates that made it possible to place them in any particular order.[3] Demaison insisted that Jean d'Orbais should be ranked first, because it was he, according to the inscription, who began work on *"la coeffe de l'église."* The *"coeffe,"* according to Demaison, was the chevet. Jean d'Orbais thus appeared to be the great man who had conceived Rheims cathedral and begun to erect it. For a quarter of a century, Jean d'Orbais remained in possession of his glory. But recently Deneux, an architect, has maintained that by *"coeffe"* must be understood not the chevet with its radiating chapels, its ambulatory, and its apse, but simply the vaulting of the choir, together with the timber framing and the roof that cover it.[4] If this interpretation was accepted, it became impossible to maintain Jean d'Orbais as first in importance.

[3] Here are those inscriptions, according to Cocquault: "Master Jean le Loup, who was master of the works of this church for the space of sixteen years and began the portals of the same; — Gaucher de Reims, who was master of the works for the space of eight years and executed archivolts and portals; — Bernard de Soissons, who built five bays and worked on the O, master of the works for the space of thirty-five years; — Jean d'Orbais, master of the said works, who began the coeffe of the church."

[4] Deneux's argument was presented to the Society of French Antiquarians at its meeting of March 19, 1920.

I re-read the inscriptions in my turn and I sought the drawing of the Rheims maze, which is preserved in the Bibliothèque Nationale.[5] It was made toward the end of the sixteenth century by the architect Jacques Cellier. But with surprise I became aware that, in addition to the four architects set within the four corners, there was a figure at the center, larger than the others, who also seemed to be an architect. This figure had already become worn in the sixteenth century by the feet of the generations; neither its head nor its hands nor its feet were visible, but its outline differed little from that of the others. It even appeared to have, as they do, a sort of short cloak about its shoulders. Demaison had disposed of this inconvenient individual by declaring that it represented the archbishop-builder of the cathedral. This was how it had been done, he says, in the maze at Amiens. But nothing proves that such was the case in the Rheims maze. Cellier's drawing, indistinct as it may be, does not seem to support such an hypothesis; this three-quarter length figure does not have the grave appearance of an archbishop. But there is an apparently decisive argument. Cellier, who was able to read the inscriptions engraved beside the five figures (but who unfortunately did not reproduce them), wrote beneath his drawing, "This is the labyrinth that is within the nave, and the personages who are within it represent the architects who directed the work of building the said church." It is plain that for him the five individuals represent five architects. In the seventeenth century, Canon Pierre Cocquault, who reconstructed the writing inscribed beside the four architects within the corners, did not for an instant assume that the figure in the center would have been an archbishop. On the contrary, he believed, with a certain naïveté, that this individual was the artist who had designed the maze, and if he does not give us the inscription that accompanied it, it was because this was no longer legible. In 1779, the journalist Havé, who described the maze at the moment when it was broken up, says in his turn, "The inscription for the central figure is entirely obliterated. It must be that of the architect Libergier." The name of Libergier, the architect of Saint-Nicaise de Reims, is given here at random; but it is ascertained that none of our three witnesses—who represent three centuries—thought to see an archbishop at the center of the Rheims maze. What must one conclude from this, if it is not that the principal architect of Rheims, who first conceived the work, was at the center? He had been set in the place of honor and shown as greater than the others because he was indeed judged to be greater. We now understand why the four other architects are represented to us as having worked only on the upper portions of the choir, on the vaulting of the nave, on the portals, and on the rose. The beginnings of the work escaped us. There was a problem here that, with all the ingenuity in the world, could not be explained. Today the puzzle is solved. The first master of the work remains anonymous; an accident has prevented his name from emerging from the shadows where it will no doubt remain buried forever. If the historians imagined that they could see justice done, if they believed themselves charged with assigning men to their

[5] Bibliothèque Nationale, French manuscript no. 9152, fol. 77.

proper station, their disappointment will be severe, for some of the greatest will remain forever unknown to them. *Debemur morti nos nostraque.* Let us resign ourselves, then, to not learning the name of the master who bore within his imagination the cathedral of Rheims.

There are many other mysteries at Rheims; there is a host of statues that we are unable to identify and whose true names we will probably never know. But there are others to which a name can be given, and it is surprising that there has been uncertainty for so long as to their true identity. Among these are the statues at the level of the rose window, on the buttresses of the façade. Vitry has well understood that they commemorate Christ's Resurrection. He has grasped the essential; nonetheless, he will permit me to complete, and even to rectify, his explanation. The two figures standing near the rose are, without question, the two pilgrims to Emmaus; Christ, attired himself as a pilgrim, accompanies them. But the three-quarter length figure of a woman, placed beneath a pinnacle, could not represent the Virgin; she is Mary Magdalene on the morning of the Resurrection, announcing the great tidings to St. Peter who, from the other pinnacle, seems to listen to her. Why is St. John the pendant to St. Peter on the opposite side of the façade? Because he also hears the words of the Magdalene and goes with St. Peter to the tomb. But the witnesses to the Resurrection continue on the opposite face of each of the towers. On the north side, Christ shows his side to St. Thomas, who stretches his hand out toward the wound. On the south side, two apostles are standing: the one is St. Paul, to whom Christ appeared on the road to Damascus; the other is St. James (not St. James the Greater but St. James the Less), who also, according to St. Paul, had his personal revelation. He had vowed, the *Golden Legend* adds, not to eat until he had seen his Master raised to life, and on Easter Day, since he had not yet taken any nourishment, the Lord appeared to him and said, "Arise, my brother, and eat; for the Son of Man is risen from the dead." St. James, in his role as high priest, has drawn his cloak about him and carried in his hand a fuller's club, the instrument of his martyrdom. The ten statues that we have just named constitute the cycle of the Resurrection. They preside over the Passion depicted on the portal; Christ, on high, triumphs over death.

Among the large statues on the three portals there are only a few that we can identify with complete certainty. There should at least be no confusion about those that it is possible to recognize. Not a single commentator on Rheims cathedral, I believe, has failed to designate by the name of the prophetess Anna the figure of a woman that stands behind the aged Simeon. Plainly, she is a member of the group of the Presentation in the Temple, but how is one to believe that this elegant young girl with curling ringlets can be a widow of eighty-four, wasted with fasting and visited by the Holy Spirit? The artists of France did not take such liberties with the Gospels. It is enough to have studied the manuscripts and the windows of the thirteenth century with some care, to recognize the young attendant who traditionally accompanies the Virgin to the Temple. She appears more frequently than St. Joseph himself in this scene of the Presentation. On the

small south portal of Rouen cathedral, where she represents (as at Rheims) the pendant to St. Joseph, she holds the taper of Candlemas in her hand, so that there can be no doubt. It is time to rescue the charming young girl of Rheims from that solemn designation that gives her youth, her lovely ringlets, and her smile the appearance of an error in taste.

We conjecture that a number of the large statues on the west portals are dedicated to the saints of the diocese of Rheims, without however being able to give them names with any certainty. One sees in the left-hand doorway, just beside the martyr who advances between two angels, the figure of a crowned woman. The scholars sometimes identify her under the name of St. Célinie, the mother of St. Remi, and sometimes under that of St. Clotilde. But St. Célinie was not a queen, and St. Clotilde is venerated at Paris rather than at Rheims. For my part, I am convinced that this crowned saint is none other than the empress, St. Helen, who in the Middle Ages became a local saint in Champagne. In the ninth century, indeed, a monk from Hautvillers carried off her body from Rome and brought it to his abbey.[6] The ancient Benedictine monastery of Hautvillers, which stands in the midst of the vineyards between Epernay and Rheims, was one of the most famous in Champagne. It was there that some of the most picturesque manuscripts of the Carolingian age were illuminated; it was also there that Dom Pérignon, himself an artist, invented the wine called champagne at the end of the seventeenth century. At the time when Rheims cathedral was rising, it was St. Helen's relics that were the glory of Hautvillers. The pilgrims of Champagne came seeking miracles from her who had miraculously discovered the Cross. St. Helen was so celebrated at Rheims that the cathedral buttress adjacent to the portal where her statue stands was decorated with the history of the finding of the True Cross. We have already spoken of this beautiful bas-relief. St. Helen appears within it four times, and four times she resembles the large statue on the portal; she wears the same veil on her head, the same cloak held in place by a braided cord, the same jewel on her breast. There are here, it seems to me, probabilities that are close to certainties. In the same way, the presence of the statue of St. John that stands in this portal, not far from that of St. Helen, is explained. St. John is here the author of the Apocalypse, whose opening is carved on one of the buttresses, as a pendant to the history of the finding of the Cross. The two statues refer to the two bas-reliefs.

One of the doorways in the north façade, the one dedicated to St. Sixtus or to the saints of the church at Rheims, presents us in the same way with a bas-relief and a statue whose meaning has remained unclear until now but which can, I believe, be explained.

The third register of the tympanum relates, in its left portion, the story of Job. One sees him stretched upon his midden, an object of pity to his friends, an object of disgust to his wife, who holds her hand before her mouth. On the right, in the same panel, a woman and several men seem to listen to the words of a young boy.

[6] *See* Flodoard, *Histoire de l'église de Reims*, book II, ch. VIII.

One of the listeners is seated, his eyes fixed, his brow furrowed. It is, the commentators tell us, the beginning of the story of the young girl of Toulouse healed by St. Remi; the parents of the young victim confer to decide if they should bring her to the saintly bishop. Such an episode would be, one must admit, of slight interest and, set in the midst of the history of Job, wholly incomprehensible to the spectator. Such is not, in fact, the meaning of this scene. Here the artist is simply recounting the opening of the story of Job. A messenger arrives from the fields, enters the house of the patriarch, and announces the misfortune that has befallen him; the Sabeans have carried away his oxen and his she-asses and put his servants to the sword. Job, seated, remains silent, but his wife wrings her hands and mourns. Three messengers will soon follow after the first, to announce to the patriarch that he has lost his ewes, his camels, and, lastly, all his children. It is only then that Job will arise and rend his robe. The third register of the tympanum is thus entirely dedicated to the history of Job.

Once this explanation is accepted, here are its consequences. Let us compare the seated Job in the bas-relief with the portal statue standing to the right of St. Remi: here is the same physical type, the same skull-cap upon his head, the same robe worn over a tunic that is deeply slashed beneath the arms. The conclusion seems inevitable: St. Remi's mysterious neighbor, in whom an attempt was made to see Clovis—as if Clovis would be represented with a skull-cap and an aureole— this enigmatic figure can be no other than the patriarch Job. Moreover, nothing could be more natural. The statues ranged along the two sides of the portal are the very heroes who were celebrated within the registers of the tympanum: St. Nicasius and his sister, St. Eutropia, St. Remi and, lastly, Job. This Job in thirteenth-century costume is a figure of the most pleasing naïveté. He is a rich bourgeois of Rheims, a great proprietor of vineyards that have been ruined by the hail and who, as a final blow, has become leprous. Visualized thus, he was more familiar to the Christians of the thirteenth century than the formidable desert poet who disputes with God.

III

THIS ADMIRABLE COLLECTION, which brings the historic building before our eyes, will soon prove fruitful. All manner of truths will emerge from it. Let similar collections be published on our other French cathedrals and it will soon be possible to chronicle the history of French thirteenth-century sculpture. Already Houvet's album devoted to Chartres cathedral is nearing completion. It is no less beautiful and will be no less instructive than this one on the cathedral of Rheims. They complement and illuminate each other. Here is what a preliminary study has brought to my attention.

Comparing their illustrations, one begins to feel certain that the earliest of the Rheims sculptors looked to Chartres for their models. It has been apparent for a long time that the archaic statues on the west front at Rheims took their inspiration from the astonishing figures on the north portal at Chartres.[7] A comparison of the

[7] We have indicated these ties in chapter VIII of this volume, "The Portal of Senlis and Its Influence."

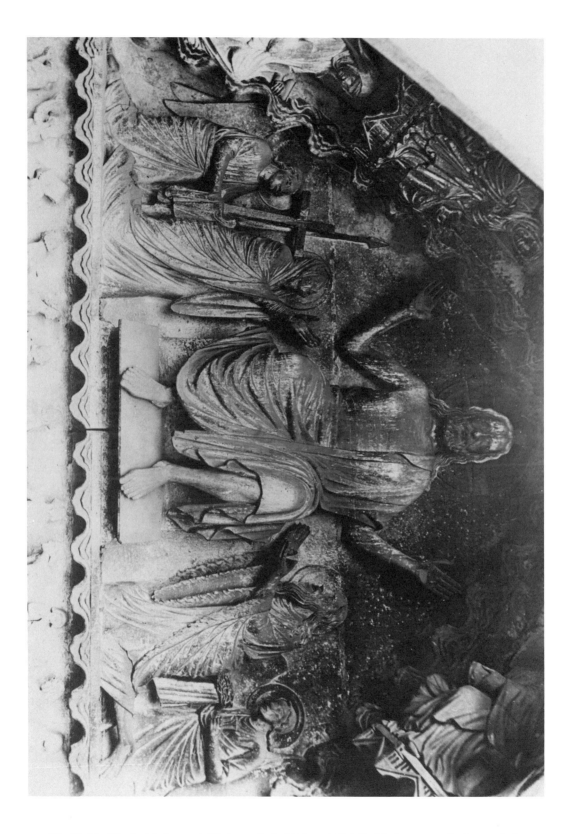

The Christ of the Last Judgement, Rheims cathedral (Marne). Detail of the tympanum in the portal of the north transept.

plates renders the similarities even more striking: the two Simeons, for example, are almost identical; but that comparison also makes the dissimilarities apparent. The rules of proportion are different. The statues at Rheims that, toward 1250, become elegance itself, were in the beginning too short.

The three north doorways at Chartres were the models that the Rheims artists at first had before their eyes. They copied some of these figures on the north portal. It seems clear to me that the St. Eutropia at Rheims is a copy of the St. Elizabeth at Chartres; there is the same veil over her head, the same curling hair, the same fall of the draperies, almost the same stance. The tight pleating of Chartres reappears at Rheims, but more deeply incised, more vivid, richer in its shadows and its lights. The affiliation between the two schools seems clearly demonstrated here.

The most curious imitation is that of the bas-relief of Job, an imitation that is indeed not strictly literal but that certain typical details render undeniable. At Rheims, as at Chartres, one of Job's friends grasps his beard with both hands as he meditates. Job is stretched in both compositions upon his midden, his left leg drawn up in the same manner. The devil, his mask twisted in a frightful grimace, lays his right hand on Job's head, his left hand beneath the sole of one of his feet,[8] to tell us that Satan "afflicted Job with loathsome sores from the sole of his foot to the crown of his head."[9] Such identical details are not invented twice. The truly odd appearance of this story of Job in the midst of the legend of St. Remi is probably accounted for by the admiration that the Chartres bas-relief evoked among the Rheims artists—an admiration that was entirely justified since, however talented the Rheims sculptor, he did not rise to the level of his model. The Chartres master is more forthright, simpler, grander. His bald patriarch, who scrapes his ulcers with a potsherd, who remains unmoved beneath Satan's claw that grips his skull, is almost as impressive as the Job of the Bible.

The artists at Rheims not only found inspiration in the north portals at Chartres; they were also inspired by one of the doorways in the south façade, the portal of the Last Judgement. One would hardly suppose, at first glance, that this portal of the Judgement at Rheims, where fine figures abound, where art has almost reached the peak of its perfection, owes anything to the still-archaic work of the Chartres masters. But a closer study leaves scarcely any doubt. Few of the figures are actual copies, but the inspiration of Chartres is everywhere. Christ displaying His wounds—which is by far the oldest part of the Rheims portal— imitates the one at Chartres almost exactly; a few years at most separate the two works. The six apostles standing to either side of the Rheims portal appear to be very different from the apostles of Chartres, and so indeed they are. By their pronounced features, by the deep folds in their tunics, they speak of another artistic age. Nonetheless, the impressive apostles at Chartres remained for those younger masters the prototypical apostles. They have copied several of the details

[8] At Rheims, Job's foot and the devil's hand have been broken off, but the general attitudes do not leave any doubt as to the original appearance. [9] *Job*, II, 7.

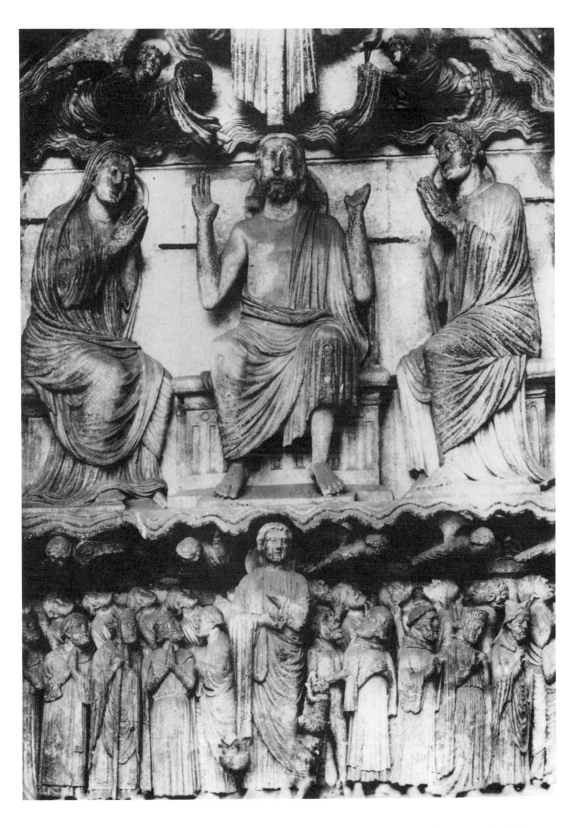

The Last Judgement. Detail of the lintel and the tympanum in the south portal of Chartres cathedral (Eure-et-Loir), 13th century.

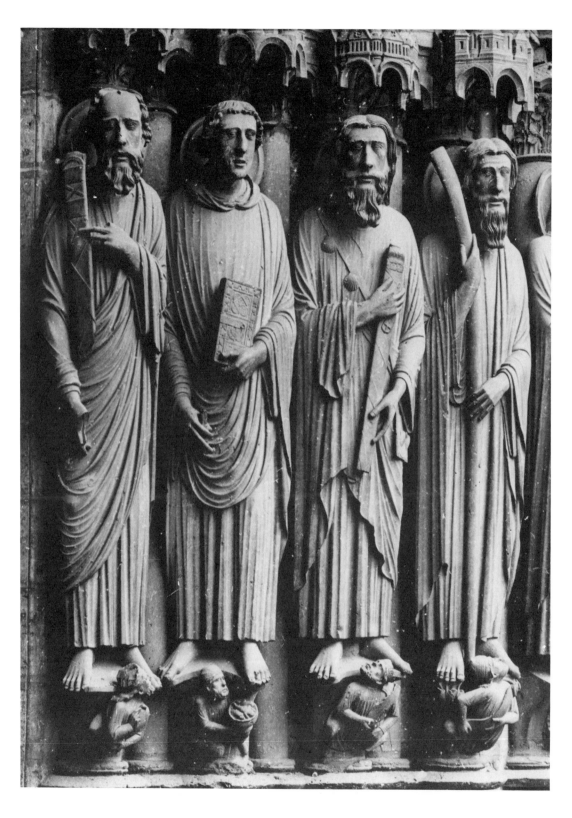

Statues of the Apostles. From left to right: St. Paul, St. John the Evangelist, St. James the Greater, St. James the Lesser. Embrasure of the south portal of Chartres cathedral (Eure-et-Loir), 13th century.

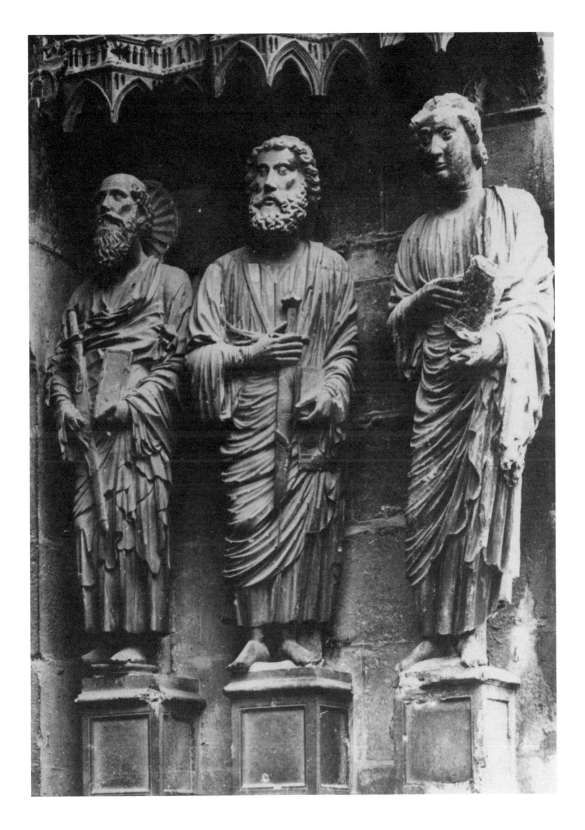

Statues of the Apostles. From left to right: St. John, St. James, St. Paul. Embrasure of the north portal of Rheims cathedral (Marne).

from those great models with a reverent fidelity. St. Andrew, his head slightly bowed, holds his cross in the same way.[10] St. James wears his baldric cross-wise and clasps his sword in its sheath against his breast. He would be in every way like his model if he did not hold the book of the Gospels in his left hand—a difference that can also be noted in the two St. Pauls.[11] But it is above all in the registers of the Rheims tympanum that the thought and the imagination of the Chartres masters can be recognized. We were until now not aware of it, for we did not have before us, as we do today, the archivolts of the Chartres portal. It was with the creations of these archivolts that the Rheims masters peopled their tympanum. It was at Chartres that they saw an angel bearing the souls to Abraham's bosom; from Chartres that they took that charming detail of the angels stretching their hands out to the blessed; from Chartres that they borrowed those figures of the dead stepping from their tomb, the shroud about their heads, or raising their clasped hands in a gesture of prayer. But what was only a beautiful impulse at Chartres, clothed in a form that is still rude and sometimes inaccurate, has at Rheims become almost always a marvel of nobility and purity.[12]

Thus, for over at least a quarter of a century, the Rheims masters kept their eyes raised to the portals of Chartres. That work, in which there was so much of genius, remained their supreme model, and they never ceased, for all their technical skill, to return to it for inspiration.

But if Rheims imitated Chartres, Chartres in its turn followed the example of Rheims. The last two statues to be set up in the south portal at Chartres, St. Avit and St. Laumer, visibly carry the stamp of the art of Rheims. The statue of St. Avit is particularly curious. The artist who carved it had carefully studied the head of the fine prophet at Rheims who wears a Greek cap and stands beside the Queen of Sheba. He is, as we know, clothed in splendid antique drapery, but his head, with its carefully curled hair and beard, is much closer to French than to Greek art. Now, this head from the Rheims prophet is almost that of the St. Avit at Chartres. The broad face is treated in the same manner; the beard and the hair are made up of ingenious spirals about a central opening whose design is almost identical, always with the difference that they are more loosely, more generously treated at Chartres than at Rheims. There the resemblance ends, for St. Avit's sacramental robes, with their horizontal folds, are carved quite differently from the prophet's cloak. This figure of St. Avit, which had been dated in a vague way from the close of the thirteenth century, is therefore much older. It is later by only a very few years than the Rheims prophet, which must date from about 1250.

This hasty sketch demonstrates what we may expect from these great collections, which we hope will continue to appear. It is the task for today. Nothing could be more tempting for archaeologist and publisher. From it will emerge the history of French art, and soon that of European art, for in the thirteenth century French sculpture achieved the conquest of Europe.

[10] At Chartres, the horizontal arm of the cross is broken.

[11] Imitated at Rheims, the series of apostles from Chartres was also copied on the façade of Amiens.

[12] Certain details on the Rheims portal (the damned who are bound together by a long chain and dragged by a demon) come from Notre-Dame of Paris.

I N THE EARLY YEARS of the fourteenth century, there was no place in Paris where the memory of Saint Louis was more faithfully enshrined than in the convent of the Cordeliers of Lourcine, in the suburb of Saint-Marcel. Newly completed paintings recounted his history, and on feast days his royal mantle, preserved in the church, was exhibited for pilgrims.

The convent of Lourcine had been founded in 1289 by Queen Margaret, widow of Saint Louis. Having lived with one of the most perfect of men, she wished to spend her remaining days in silence and prayer. Withdrawing to this remote neighborhood, she dwelt in an isolated house near which, at the end of her life, she built a convent. There she summoned the spiritual daughters of St. Francis of Assisi, the Sisters of St. Clare. Although Saint Louis never belonged to the Third Order of St. Francis, whatever has been said; although he never went to Perugia, as legend would have it, to clasp Brother Egidio in his arms, his love for St. Francis was not for this reason less. Twelve years old at the time of the great saint's death, he must have heard his wonderful history retold. Between the beggar and the king there was a deep affinity of soul. For that reason, Saint Louis loved the Franciscans always, and it was he who brought about the building of their convent in Paris. The royal family shared the sentiments of the king. His sister Isabelle founded a Franciscan convent at Longchamp and we see his wife, in turn, summoning the Sisters of St. Clare to Lourcine.

When Queen Margaret died in 1295, the church of the Cordeliers had not yet been completed. But another widow, her daughter Blanche, came to take her place in the little house. Blanche, who at Burgos had married the Infante of Castile and might have become a queen, found herself at twenty-two a widow. For a few years she lived in the world and then, like her mother, vowed herself to solitude. A neighbor to the Cordeliers, she became their benefactress; she saw to the completion of their church and to its decoration. In the seventeenth century, the amateurs of antiquities recognized her arms in its colored glass and its panelling.[1]

She had been in retirement at Lourcine for two years when, in 1297, she learned that Pope Boniface VIII, after an inquiry lasting many years, had just canonized Saint Louis. Veneration of her father thenceforth became one of the expressions of her piety. She sought to honor him in every way. She began by asking Guillaume de Saint-Pathus, a Franciscan who had been for eighteen years Queen Margaret's confessor and was now her own, to write the life of Saint Louis. The good monk had not Joinville's talent; his book is nonetheless invaluable to us.[2] He assembled it from the documents of the canonization process that were

Mélanges Bertaux (1924). [1] Jacques Du Breul, *Thèâtre des antiquités de Paris,* 1612, p. 400.
[2] *See* the edition prepared by Count François Delaborde, in the collection of texts to be used in the teaching of history, 1899. Count Delaborde rediscovered the name of the author who had until then been identified as "the Confessor of Queen Margaret."

sent to him. It is the king, it is the chevalier, that Joinville depicts for us; it is the saint in all of his heroic charity that Guillaume de Saint-Pathus makes us know. Each of his chapters is devoted to one of his hero's virtues and he lacks none of them. It is to Blanche that we owe this rare book, which enables us to glimpse, as Voltaire himself said when speaking of Saint Louis, "the pinnacle of perfection, beyond which man cannot raise himself."

Blanche sought to honor her father in another fashion. For those who would not have the leisure to read the book, she had scenes painted in the Cordeliers' convent, chosen from the life of the saintly king. None of the early historians of Paris have referred to these paintings; they would have remained entirely unknown if, at the beginning of the seventeenth century, Peiresc, with his curiosity that seized upon everything, had not taken pains to describe them and to have drawings made of several of the figures.[3] Scarcely three hundred years old, they were already seriously damaged by the weather; some had almost entirely disappeared and many inscriptions were half-effaced. That premature damage indicates that these paintings were frescoes badly protected against the northern climate. It is probable that they did not decorate the walls of a church, but the inner side of a cloister. The date of these frescoes is provided for us by their inscriptions, in which philologists recognize the language of the early fourteenth century. As for the two or three drawings that Peiresc has left us, they are scribblings without character. One sketch only, of the Egyptian Sudan, has been reproduced with care; its style in no way contradicts the date suggested by the inscriptions. The work was certainly done in the lifetime of Saint Louis' daughter, who died in 1320. That it was executed on her orders is beyond question, when the subject of the paintings is known. Almost all of them, in effect, have to do with the piety or the charity of Saint Louis. One sees him arranging the baptism of the heathen, founding churches, receiving the discipline at the hands of his confessor, washing the feet of the poor, feeding a leper, kneeling as he tends the sick. Now, there is not one of the subjects we have just spoken of that is not taken from the book that Guillaume de Saint-Pathus wrote for the daughter of Saint Louis. The text of the inscriptions is itself very close to that of the book. It is probable that Blanche herself, still greatly moved by what she had read, suggested the subjects to the painter. Guillaume de Saint-Pathus' work was finished at the end of 1303.[4] One will hardly be in error, I believe, in assuming that the paintings were begun in 1304. The official painter at that time to Philip the Fair was Étienne of Auxerre, newly returned from a journey to Italy. Was it he who was given the task of glorifying the king's ancestor? We have no way of knowing.

Why have we discussed at such length a work that is no doubt interesting but that no longer exists? Because we believe that we have found a copy of it.

In 1910, Léopold Delisle published a reproduction of a charming little Book of

[3] Description and sketches have been published by A. Longnon, *Documents parisiens sur l'iconographie de Saint Louis* (1882).

[4] F. Delaborde, *op. cit.*, p. x.

Hours from the collection of Baron Maurice de Rothschild, illustrated by the celebrated miniaturist, Jean Pucelle.[5] It was illuminated between 1325 and 1328, on the orders of Charles the Fair himself, for his wife, Jeanne of Evreux. Now, the book concludes with a series of miniatures in grisaille devoted to the life of Saint Louis. In leafing through these pages, I seemed to recognize the subjects of the Lourcine frescoes, as Peiresc has described them for us. A closer examination dispelled all my doubts.

This, for example, is what Peiresc tells us about the eleventh fresco in the Cordeliers' convent:

"He kneels beside a sick man's bed, to whom he offers food; whose coverlet is of fur and who, in place of a nightcap, wears a linen cloth wrapped about his head and hanging down his back. In another bed there is another poor invalid. And the king is accompanied only by two young servitors who carry the meats behind him." The inscription concludes thus: "So in God's houses he served all the penniless sick upon his knees."

Peiresc had no drawing made of this painting, but if we return to Jean Pucelle's miniature, we will find it exactly as it has just been described. Here is the sick man, stretched upon a bed and wearing, not a cap, but a sort of turban whose ends hang down about his shoulders. Here is the second sufferer, the king upon his knees, the two young serving-men carrying platters. Peiresc's description corresponds in every detail to the miniature. Such a similarity would seem miraculous, if it were not so easy to explain. It is clear that Jean Pucelle had copied the work of the Lourcine painter.

Let us go on with our comparison. Peiresc describes the tenth fresco at Lourcine for us in these words:

"He is on his knees before a seated Bernardine monk, clothed in white, whose hands are folded and whose face is covered with the sores of leprosy, before a table spread with a cloth, on which are a platter of fish, bread, soup, and a bowl, which the king holds up to his mouth for him to eat from. And he is accompanied by a Trinitarian wearing the Cross, by another robed religious, and by one of his bodyguard, who carries a mace." Peiresc was evidently not very familiar with this episode in the life of the saintly king. Guillaume de Saint-Pathus recounts it for us thus. There was, he says, a leprous monk at the abbey of Royaumont named Brother Laurence. He lived at some distance from the community in an isolated dwelling. His appearance was repugnant: he no longer had any nose, his lips were cracked, and his ravaged eyes were two bleeding wounds. On the feast day of Saint Remi, after hearing mass, the king went to pay him a visit. He allowed no one to accompany him except the abbot and a monk who waited upon the sick man. The leper was at table. The king greeted him with kindness, inquired after him, and, having knelt down, began to serve him. He cut up the morsels and placed them himself in the mouth of the blind man. He asked if he would enjoy

[5] *Les Heures dites de Jean Pucelle,* with an essay by L. Delisle, Paris, 1910. (Today in the Cloisters Collection of the Metropolitan Museum, New York.)

eating a partridge; upon his reply in the affirmative, he sent for one that had been prepared for himself and during all the while that it was being brought, remained on his knees before the leper, as if he had been Christ Himself. The partridge having been brought, he asked the sick man "with what seasoning" he wished to eat it. "With salt," responded the leper. The king then cut up the pieces, salted them, and put them in his mouth while taking care not to bring the salt against the wounds on his lips. At the same time, he comforted him with kind words. As he went away, he besought him to pray for him as if he had been a great sinner. Each time that the king came to Royaumont, he paid a visit to the leper; "Let us go and see our patient," he would say, but he did not permit his barons to follow him. Once he fed the sick man with a gruel that he had salted himself, but the too-heavily salted gruel caused the lips of the leper to bleed. Abashed, the king humbly begged his pardon.

That is the scene that the Lourcine painter had shown. It is evident that Peiresc had been a careless observer, for the religious who accompanied the king could not have been a Trinitarian; he is the abbot of the Cistercian monastery of Royaumont.

Let us now go back to Jean Pucelle's manuscript: there we will again find the episode with the leper.[6] The king, kneeling, is feeding gruel to the leper; the artist, however, instead of representing two religious figures beside the king, has simply repeated the two young servitors that he had already shown us near Saint Louis in the scene in the Hôtel-Dieu. But there can be no doubt that the central figures were copied faithfully. Peiresc himself brings us the proof. In effect, he has had copied another work devoted to Saint Louis. It consisted of a painting in four sections (or perhaps four separate paintings) that was to be seen in his day in the lower church of the Sainte-Chapelle. However mediocre these reproductions may be, one recognizes in them a work from the beginning of the fourteenth century.[7] The panels in the Sainte-Chapelle must have been nearly contemporaneous with Pucelle's miniatures. For the subjects are identical and are treated in the same manner, so much so that we can detect a common original behind these two series of works of art. This original could only have been the great composition in the Lourcine cloister. Those paintings must have been celebrated among artists, for we see them imitated by two different masters; they determined for a time the iconography of the life of Saint Louis. If we compare the panel in the Sainte-Chapelle that shows the king and the leprous monk, with Pucelle's miniature, we will find the two works to be almost the same; the monk's gesture is the same, the king's position as he lifts the spoon to the leper's mouth is the same. There is only one difference: in place of the two servants, in the Sainte-Chapelle, we see two religious, which proves that the painting was more accurate than the miniature. We gather that Jean Pucelle's copies were somewhat freely rendered.

To the three remaining panels in the Sainte-Chapelle, there correspond three

[6] Folio 50.

[7] These drawings have been reproduced by A. Longnon, *op. cit.*

Jean Pucelle. Miniature from the Book of Hours of Jeanne d'Évreux, 14th century. St. Louis feeding a leper. New York: The Metropolitan Museum of Art, Cloisters Collection.

new miniatures by Jean Pucelle and the two sequences exactly answer the descriptions that Peiresc gives us of the Lourcine frescoes.

To begin with, one sees Saint Louis washing the feet of the poor. He washed them, Guillaume de Saint-Pathus tells us, not only on Holy Thursday but each Saturday.[8] After washing and drying them, he kissed them humbly. Then he bestowed forty deniers upon each poor man, kissing his hand; thereby uniting alms-giving with true love. Joinville, for all that he was a good Christian, could not understand humility carried to this extreme. Saint Louis one day asked him if he washed the feet of the poor on Holy Thursday; "Sire," he replied, "the feet of those peasants! What misfortune! Never shall I do so." Joinville, beside Saint Louis, is that little figure which draftsmen place beside a cathedral to illustrate its height.

Peiresc speaks of the fresco of the foot-washing in the Lourcine convent without describing it for us. We assuredly have it in the Sainte-Chapelle panel and in Pucelle's corresponding miniature.[9] The king, kneeling, washes the feet of a beggar. Other poor men, whose feet have just been bathed, hold out their hands toward a royal official who places coins within them. The Lourcine artist had thus of necessity been unfaithful to his text; he had not been able to show, in the same fresco, the king washing the feet of the poor and distributing alms to them himself. A less scrupulous painter would perhaps have done so; he would have included these two scenes within the same painting, but the Lourcine artist had a feeling for dramatic unity.

Another panel from the Sainte-Chapelle and another of Pucelle's miniatures show us the king on his knees, before a monk who is giving him his discipline. Each Friday, Guillaume de Saint-Pathus tells us, he shut himself up with his confessor, Geoffroy de Beaulieu, of the Order of Preaching Friars, and had his discipline given to him in the greatest secrecy,[10] for he concealed his austerities with as much care as others conceal their vices. The king kept the instrument of his discipline in one of those little coffers in which jewels are placed.

Peiresc, describing the Lourcine fresco, says only, "He kneels before his confessor, who is giving him absolution, and holds one hand against his breast as though recounting his faults, receiving the discipline from the hand of his frocked confessor."

Miniature and painting correspond to this description, always with the exception that Saint Louis does not smite his breast. In both works the king, in his gown, kneels beside his bed; that is to tell us that he administered his discipline in the privacy of his chamber. Surely such was the placement of the original. An altogether similar miniature can be found, nearly half a century later, in the breviary of Charles V.[11]

The last of the Sainte-Chapelle's panels to which there corresponds a minia-

[8] G. de Saint-Pathus, edit. Delaborde, pp. 63, 82, 104.

[9] Folio 56. [10] G. de Saint-Pathus. *op. cit.*, pp. 122–3.

[11] Bibliothèque Nationale, Latin manuscript no. 1052, folio 374.

ture by Jean Pucelle, showed a remarkable episode. One saw Saint Louis shut up with a companion in a sort of cage; an angel, penetrating this prison, was presenting the king with a book. We would search in vain for the explanation of this scene in Guillaume de Saint-Pathus or in Joinville. But other texts refer to it. In the office that was composed in honor of Saint Louis shortly after his canonization, at vespers was sung:

Cum mancipatur carceri
Liber amissus cernitur

"While he was in prison, there now appeared the book that he had lost."[12] It illustrates the tale told by an anonymous fourteenth-century historian of a breviary which the king had lost in battle and which was miraculously restored to him in his prison.[13] The painter of the Sainte-Chapelle had the breviary carried by an angel; Jean Pucelle, by a dove. However, the miniature resembles the painting in that detail of Saint Louis' having a companion with him in his prison. But in the version by Pucelle, who loved an architectural touch, the prison has become a kind of fortified castle.

The episode of the breviary had been represented in one of the Lourcine frescoes. There, one saw Saint Louis and his companion enclosed in a sort of barred cage but, curiously enough, Peiresc does not mention either the angel or the dove; he is content to tell us that there was a book in the hands of Saint Louis' companion. It may be that the account of the miracle, still somewhat nebulous at the beginning of the fourteenth century, had taken on more precise details a few years later.

From this analysis it follows that the miniatures of Jean Pucelle and the panels from the Sainte-Chapelle reflect a common source. That source can only be the series of frescoes painted a short time earlier in the Cordeliers' convent at Lourcine. Thus the work whose disappearance we so regret exists, at least in part, still.

II

THERE ARE two scenes in Jean Pucelle's manuscript that one does not find either in the Sainte-Chapelle panels or in Peiresc's account.

One shows Saint Louis placing skulls into a sack, while his companions cover their noses and mouths with their hands.[14] It is the illustration of an episode recounted by Guillaume de Saint-Pathus.[15] When Saint Louis arrived at Sidon, he found before its walls the corpses of nearly three thousand Christian knights, massacred by the Saracens some weeks earlier. These he had interred, and himself set the example. Every morning, after hearing mass, he said to those about him, "Let us go and bury these martyrs." He could then be seen to lift up the

[12] Office transcribed by Peiresc after the Book of Hours of Joan II, Queen of Navarre. *See* Longnon, *op. cit.,* p. 62.

[13] Text reproduced by Peiresc. *See* Longnon, *op. cit.,* p. 14, note.

[14] Folio 60. [15] G. de Saint-Pathus, *op. cit.,* pp. 100–1.

Jean Pucelle. Miniature from the Book of Hours of Jeanne d'Évreux. St. Louis burying the bones of the Crusaders. New York: The Metropolitan Museum of Art, Cloisters Collection.

corpses that were falling into putrefaction, to place them in sacks, and to load them upon camels. The stench was such that the boldest grew faint; Saint Louis alone showed no sign of disgust. Those who were with him said later, during the process of his canonization, "that they never saw him once cover his nose." And, going even further, he put aside his gloves, that he might be blessed by the contact with these Christians, whom he considered to be saints. "Do not despise these bodies," he said, "for they are martyrs and in Paradise."

The other miniature shows Saint Louis' death. The king is stretched upon his bed. He has one last thought for his people: "Dear Lord God," he says, "have mercy on this people and bring them into your peace." Then, after murmuring in Latin, "Father, I commit my soul into your keeping," he gives up the ghost. His household, who seem already to have put on the garments of mourning, make gestures of desolation all around him. On high, two angels carry the pure soul of the saintly king to heaven in a napkin.

Had these scenes been depicted in the Lourcine cloister? Peiresc does not mention them to us, but there is every reason to think that he has not described the entire sequence of frescoes for us. It is highly unlikely that this account of the king's life would not have concluded with his death. That death, according to Joinville, seemed to raise him not among the ranks of the confessors but among those of the martyrs. A number of the paintings must have been in such bad condition that Peiresc did not even attempt to guess what they might have represented. The episode of the corpses buried by the king at Sidon could scarcely have been omitted from this gallery of his finest deeds. How could Blanche have overlooked such superhuman love?

The hypothesis is substantially reinforced by the study of a window, dedicated to Saint Louis, that was once to be found in the sacristy at Saint-Denis. We know it through a drawing by Montfaucon which also makes it possible for us to assign to it a date near the middle of the fourteenth century.[16] In this window we find again the scenes with which we are familiar and that were most certainly sacrosanct: Saint Louis with a companion, in prison, beholding his breviary in the hands of an angel; Saint Louis receiving the discipline; Saint Louis feeding the leprous monk at Royaumont. But we also see Saint Louis placing the skulls of the dead in a sack, while his companions cover their noses and mouths with their hands. Lastly, we see Saint Louis in death, upon his bed, surrounded by his household, while angels bear his soul to Heaven.

These last two scenes, while not wholly identical with those in Jean Pucelle's manuscript, resemble them in more than one detail. Here again we sense a common source. Once more, we become aware that the Lourcine frescoes, a work by one of the great artists of the age, created a tradition that was long honored.

[16]Montfaucon, *Les monuments de la Monarchie française* (Paris, 1929–33), vol. II.

III

ONE CAN SEE the interest that lies in these miniatures by Jean Pucelle. They bring back a great work for us, but they bring it back somewhat muted. There is nothing of the monumental remaining in these delicate grisailles. Pucelle's art, which appeals to us by its elegant austerity, its refined sensitivity, is often distorted and at times awkward. The figures are somewhat crowded in the narrow frame of the miniature. One imagines that in the originals there was more space, more calm, more simplicity.

The comparisons that the panels from the Sainte-Chapelle allow us to make (however poorly reproduced they may be) prove that Jean Pucelle took more than one liberty with his models. He copies one detail faithfully, but he changes another. One should take care, for example, not to assume that his Saint Louis is a portrait; it is only a stylized figure. Indeed the original could have been nothing else. Saint Louis had been dead for at least thirty-three years when the Lourcine frescoes were painted and the recollection of his features, even in his daughter's memory, must have grown dim. There is nothing to indicate that a wax impression was made of the king's face after his death, as would be done at a slightly later period. Certain details had not been forgotten; it was recalled that he had been tall, slender, a little gaunt. In the Sainte-Chapelle panels, Saint Louis wears a beard; he also sometimes has one, barely suggested, in Pucelle's miniatures. It is probable that this particular feature could be observed in one or another of the Lourcine frescoes.

Examining this manuscript by Jean Pucelle, we have had occasion to point out elsewhere that two of the miniatures, those of the Crucifixion and the Entombment, were inspired by Duccio's great painting, the celebrated Maestà at Siena.[17] In this little book we find at one and the same time the echoes of an Italian work and of a French fresco. Jean Pucelle's originality, as a result, is unquestionably lessened. But, on the other hand, we glimpse a valuable fact. Miniatures are not always, as has been supposed, the inventions of the miniaturists; they are at times reproductions of well-known works. They thus take on an interest of another kind. Perhaps it will one day be possible to rediscover in the manuscripts of the fourteenth century a record of the work of Évrart of Orléans, of Girard of Orléans, of John of Orléans, those masters who were once so illustrious and who for us are no longer more than names.

[17] *L'Art religieux de la fin de moyen age,* 2nd. edition, p. 6 and ff.

XI THREE NEW WORKS BY JEAN BOURDICHON
Painter to Charles VIII, Louis XII and Francis I

S IXTY YEARS AGO, Jean Bourdichon, one of the finest painters of France's first Renaissance, was entirely unknown. The Marquis de Laborde discovered his name on some ancient parchments that had been carried off to the arsenals during the Revolution and there transformed into cartridge cases. Thus our past history flew, together with bullets, across all the battlefields of Europe and the great men of our past, like the Cid, still won victories after their deaths. The name of Bourdichon was rescued by chance. Once curiosity had been aroused, everything that touched on our artist was carefully unearthed from the archives.[1] Little by little, the outline of his biography took shape. It was learned that he was born in 1457 and that he lived at Tours.[2] It was known that from the age of twenty-one onward he was in the service of Louis XI, and decorated with his paintings the chapel at Plessis-lès-Tours. From the beginning of the reign of Charles VIII, his reputation must have been well established, for from 1484 onward he bears the title of "Painter to the King." Like the Italian artists of the Renaissance, he is adept at all things. He creates the models for the coinage struck at Nantes; he draws up the plans for the town of Caudebec; he makes the model for the funeral mask of St. Francis of Paola; he designs lamps and a reliquary for the chapel at Bourbon-l'Archambault, and he paints banners. But at the same time he does the portraits of the king and queen, works on an Adoration of the Magi, and paints an image of the Virgin seated beneath a canopy carried by angels. He remained steadily in favor throughout three reigns. Dear to Louis XII and Anne of Brittany, he was equally beloved by Francis I. In 1520, the king had chosen him to decorate the pavilions for the Field of the Cloth of Gold. In 1521 Bourdichon was dead, for an ordinance rediscovered at Tours mentions his widow.

The man having been brought into the light, his work remained to be discovered. The painter to four kings would doubtless have done nothing commonplace. But which masterpiece should one attribute to him? Bourdichon, who succeeded in everything he undertook in his lifetime, was equally fortunate after his death. In 1868, Steyert found pages from the account-books of Anne of Brittany in a consignment of old parchments in Tours. A receipted bill made it clear that one of the most beautiful illuminated manuscripts in the Bibliothèque Nationale, the Hours of Anne of Brittany, was Bourdichon's work.[3] This re-

Gazette des Beaux-Arts (1902).

[1] *Archives de l'Art français*, vol. IV, pp. 3–23 and *Nouvelles Archives de l'Art français,* vol. I, p. 146 and vol. VIII, pp. 3–5.

[2] It is not certain that he was born at Tours. His name is so common in the Department of the Allier that it is possible to think that Bourdichon was of Bourbonnais origin.

[3] The document was not published until 1880, in the *Nouvelles Archives de l'Art français,* vol. VIII, pp. 3–5 (1880-81).

nowned book had, on the strength of a misinterpreted text, until then been attributed to Jean Poyet. The injustice was corrected and Bourdichon entered triumphantly into the history of French art.

This celebrated manuscript is familiar to us. Curmer's reproductions, as misleading as they sometimes are, have inspired our admiration from a distance. Opening it, we seem to enter into a beautiful garden, near the midsummer festival of St. John's Eve. In every margin a flower unfolds. They are our old French blossoms, before the invasion of the exotic plants of the tropics and the Far East: the carnation, the lily, the wild rose, the iris, the marguerite. Each flower is identified by a simple name that adds to its charm; "Marion's flower," "Our Lady's glove," "little Joan," "pure-gold pear," and "morning-clock." As in a lush orchard at the close of spring, the fruits mingle with the flowers: the gooseberries are green; the curves of the raspberries begin to redden; we know that the rosy cherries are still sour. About each flower hovers a dragonfly with diaphanous wings, a blue butterfly, a gilded greenfly, a black velvet bumblebee. A wonderful caterpillar, whose fur one feels able to touch, climbs up a stalk. Those insects are even more wonderful than the flowers; it is not possible to carry curiosity and love any further. The flowers, perfect as they are, sometimes appear to be glued onto the page; they do not always have finesse, balance, freedom. The insects, on the other hand, soar, climb, and alight.

But it is in the fifty great scenes from the Gospels and the *Golden Legend* that Bourdichon's talent must be studied. One recognizes at the outset that his is not an emotional genius; to show passion and all the violent sentiments is distasteful to him. He expresses sorrow by a face gently lowered, by eyes lightly reddened, by a tear as brilliant as a pearl which, on the Magdalene's cheek, becomes yet another object of beauty. Motion itself seems vulgar to him. Over the body of her Son, Jean Fouquet's Virgin raises her arms in a gesture of tragedy;[4] Bourdichon's clasps her hands and lightly bows her head. The only movement in his groups consists in their symmetry. A deep silence reigns over his gatherings of saints; their eyes are lifted to heaven or bent upon their books. Likewise, nothing could reveal less emotion than the two or three scenes of martyrdom that appear in his work; he does not know how to show suffering, death, the hideousness of the torturers. The scene on Calvary, so dramatic in the hands of the Flemish or Italian masters, does not move him to emotion, and Jesus' death on the Cross is the most commonplace page in his book.

Jean Bourdichon's is thus not one of those profound souls that echoes with all the emotions; he loves repose, silence, and graciousness. Among the painters of France, he was one of the first to seek deliberately after beauty. He is linked to the school of the North only in the occasional style of his drapery; his faces exhibit a tenderness that is wholly new. Franco-Flemish art, expressive to the point of parody, "relaxes," as Courajod has said, beneath his hand. Ugliness is so distasteful to him that he is obliged to beautify his models, as one may judge from the

[4] The Hours of Étienne Chevalier, at Chantilly.

portrait of Anne of Brittany. No doubt the kings of France were not indifferent to that form of flattery. If he had the skill to transform poor Charles VIII into a young hero from the Round Table and thus to realize his secret fantasies, one understands Bourdichon's popularity. It must be admitted that the resolute sincerity of a Fouquet hardly became a court painter. This horror of ugliness was the reason why Bourdichon removed any trait that was too individual from his faces. His young female saints are all delightful, but they are all the same; these pretty countenances promise us a soul like that of the artist, a sensitive soul that will be charmed by a flower or a beautiful butterfly. Let us beware of rebuking the painter too severely for the repetitiousness of his feminine types and instead be grateful to him for having been the first to love grace with so much enthusiasm. Among all these appealing faces, the most charming is that of the Virgin. Here Bourdichon shows himself the equal of his peers. His young Virgin is all that is most pure. She is still almost a child and her white coif, covered by a blue veil, gives her the air of a young nun. She hardly dares to lift her eyes and clasps together her long fingers, whose tips are touched with a faint rose. One could hardly believe that this is a mother, if one did not see her Child upon her knees and a drop of milk suspended at the tip of her breast. This figure of the Virgin is the master's most original creation.

Bourdichon is thus a lyric poet who tirelessly expresses the ideal of beauty that he bears within himself. But he did not only introduce charm to the Frenchmen of the late fifteenth century; he introduced them as well to another sort of poetry, light and shadow. Jean Fouquet, copying the Limbourg brothers, had, before Bourdichon, depicted the night. In the Book of Hours that he illustrated for Étienne Chevalier, the soldiers who arrest Jesus in the Garden of Olives move in transparent shadow; a servant holds up a lantern from which gleams of gold spill onto a Roman's helmet. The Nativity also is a nocturnal scene; the figures are plunged in a blue night, out of which the star is shining and one glimpses the shepherds gathered around a fire in the distance. Bourdichon was enchanted by these innovations. It seems clear to me that he was Fouquet's pupil and that the old artist taught him how to create translucent shadows. But this time he surpassed his master. In the Hours of Anne of Brittany, there are imaginative details in the scene in the Garden of Olives that are not to be found in Fouquet. The crescent moon glimmers in the sky and makes the hazy golden reflection that surrounds the figures appear natural. Elsewhere, Malchus, whom St. Peter has struck down with a blow of his sword, holds a lantern that illuminates the hem of Jesus Christ's robe with brilliant light. Bourdichon studies a different kind of light at other times. The shepherds that Fouquet had shown us sitting about a fire in the distance, he places in the foreground; a great brazier throws its ruddy light upon them and the effect is so right that the Dutch painters of the seventeenth century will do nothing better. But the most poignant page is that which he has devoted to Mary Magdalene. The saint arrives at the tomb on the morning of the Resurrection; a blue shadow still bathes Jerusalem and the temple, but streaks of gold begin to show themselves in the star-filled sky. Beyond a dark hill crowned with a

tower, spurt the first rays of the sun and the distant mountains quiver as the light touches them. Nothing like this had ever been attempted before, and this charming sunrise would be enough to place Bourdichon among the ranks of artists who were also innovators.

II

MY JOY was therefore great, while only recently studying the illustrated manuscripts of the fifteenth and sixteenth centuries in the Bibliothèque Nationale, when I came upon three in which, at the first glance, I recognized the hand of Jean Bourdichon. A closer examination left no doubt in my mind. Whoever wishes to leaf through the three manuscripts, moreover, and compare them with the Book of Hours of Anne of Brittany, will soon be convinced.

In the meantime, let us try, with the aid of some comparisons, to give this new recognition a solid foundation.

The first of these three books is the Latin manuscript no. 10532, which is often referred to as the Hours of Aragon or the Hours of Frederick I, King of Naples.[5] This exquisite volume is unquestionably, together with the Book of Hours of Anne of Brittany, one of the Bibliothèque's most ravishing possessions. In placing it before the eyes of the public, the curators have demonstrated the esteem in which they hold it. But, by an unfortunate error, the book has always been attributed to the Italian school and is represented as one of its masterpieces. I am aware that the calligraphy and the style of the decorations may lend some verisimilitude to this attribution, but it is enough to look at the miniatures to recognize that they come from a French hand. The mildness of the expressions, the treatment of the drapery that is still somewhat Flemish, the charm of the azure landscapes and the milky skies, the style of the little manor-houses with their pointed roofs that one can see on the hillsides—everything speaks of the school on the banks of the Loire. From the very first page, I thought of one of Fouquet's pupils. But as soon as I saw the figure of the Virgin, the name of Bourdichon arose of itself. That candid face, those downcast eyes, those folded hands, that total innocence, are the master's signature. A little further along, I came upon those nocturnal effects so dear to our artist. The scene in the Garden of Olives is in fact like that in the Hours of Anne of Brittany: a young crescent moon glimmers in the sky and Malchus' lantern throws its light on the hem of Jesus' robe.[6] The annunciation to the shepherds is identical; the red glow of the brazier illuminates the figures, while an azure glow bathes the horizon.[7] The Nativity also presents us with an effect of light that reappears in the Hours of Anne of Brittany: St. Joseph is holding a lantern that casts golden gleams on his hand and his face.[8] There is only,

[5] The Abbé Leroquais, *Livres d'Heures mss. de la Bibliothèque nationale,* has shown that the book was executed not for Ferdinand but for Frederick of Aragon (1494-1509).

[6] Aragon Hours, folio 178 and Hours of Anne of Brittany, folio 227, v.

[7] *Ibid.,* folio 140. [8] Aragon Hours, folio 134.

Jean Bourdichon. Miniature from the Aragon Hours; end of the 15th century. The Annunciation to the Shepherds; folio 140. Paris: Bibliothèque Nationale, Latin ms. 10532.

· ÊNŪCIO · VOBIS · GAVDIŪ · MAGNŪ · Q·A · HODIE · NAT⁹ · EST ·

Jean Bourdichon. Miniature from the Hours of Anne of Brittany; end of the 15th century. The Annunciation to the Shepherds; folio 58 v. Paris: Bibliothèque Nationale, Latin ms. 9474.

among all these scenes, a difference of scale, for the Hours of Aragon are much smaller than the Hours of Anne of Brittany and required even greater care, if such a thing were possible.

These proofs are weighty, but there are others more convincing still that will not leave room for any doubt whatsoever. In the two manuscripts, there are pages that are identical in every way. Let us compare the two St. Catherines[9] and we will be obliged to admit that the author of the two manuscripts was one and the same artist. Nor does God the Father in the Hours of Aragon[10] differ from God the Son in the Hours of Anne of Brittany:[11] the drapery, the attitude, and that globe beneath their feet, all are the same, save for the beard and the tiara. But that very head of God the Father itself reappears unchanged in the Hours of Anne of Brittany, in folio 155. A host of other similar details could be pointed out. Let it be enough for us to call attention to one or two more. A gathering of saints shows us, in the one manuscript and in the other, two bishops with their hands clasped and their eyes raised to heaven, who differ only in minor details.[12] In both books, Saint Luke is shown holding a portrait of the Virgin in his hand, and those two portraits, which wholly conform to the type created by Bourdichon, are identical.[13] The two St. Marks are writing at similar tables. In turning the pages of the two manuscripts, one will observe a thousand little examples of the same kind.

It seems to me thus well established that the Hours of Aragon and the Hours of Anne of Brittany are by the same artist and that Bourdichon is that artist.[14]

The wholly Italianate splendor of the settings and the margins remains to be explained. Each miniature, as well as the page opposite, is framed between the posts of a golden door in the purest classical style. Those straight lines and those noble cornices, relieved with dentil work, recall some of the doorways in the palace at Urbino. In the margins, on a background that is by turns red, blue, green, or violet, stand great antique candelabra. They are of gold, but inlaid with areas of blue, green, or white enamel. Here and there hang chains of coral, attached to dolphins or acanthus leaves. Elsewhere a precious stone stands out, set in the gold and framed by two pearls. Further on there is a jewel so marvellous that no Renaissance goldsmith ever invented one more beautiful: a siren in enamel and gold, armed with a buckler made of an emerald, a sapphire, and a ruby, does battle with a serpent.

Is it possible to associate Bourdichon with a decoration so purely Italian? An odd detail makes one hesitate.

We observe, when we look closely at the miniatures, that they have been

[9] Aragon Hours, folio 378 and Hours of Anne of Brittany, folio 203, v.

[10] Folio 288. [11] Folio 209.

[12] Aragon Hours, folio 383 and Hours of Anne of Brittany, folio 181, v.

[13] Aragon Hours, folio 354 and Hours of Anne of Brittany, folio 19.

[14] In folio 78 of the Aragon Hours, on the hem of the officiating priest, I believe that I can see "J.B.," the initials of the artist.

Jean Bourdichon. Miniature from the Aragon Hours; end of the 15th century. The Nativity; folio 134. Paris: Bibliothèque Nationale, Latin ms. 10532.

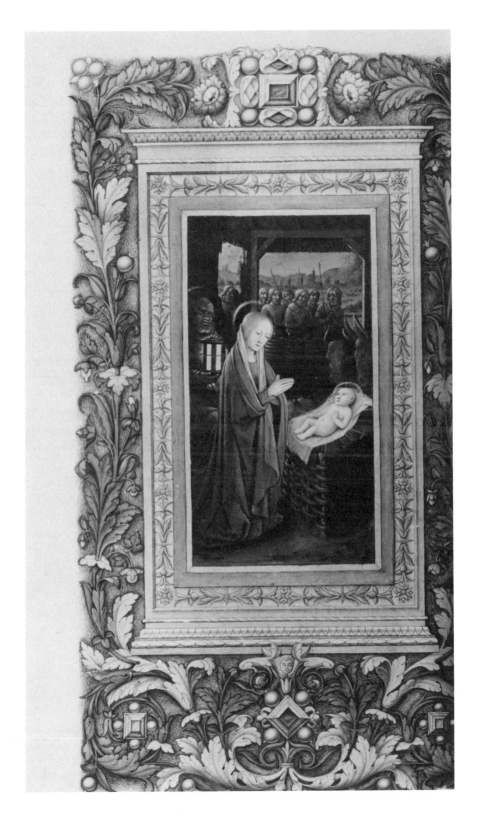

Jean Bourdichon. Miniature from the Hours of Anne of Brittany. The Nativity; folio 51 v. Paris: Bibliothèque Nationale, Latin ms. 9474.

glued onto the pages of the book. It thus would be possible that the candelabra painted on the vellum of the manuscript were from another hand. One might even hazard that Bourdichon sent his miniatures from Tours to Naples and that he never saw the manuscript for which they were destined. But one would be mistaken, for Bourdichon and his apprentices often imitated the candelabra and the antique ornamentation of the Hours of Aragon. Nevertheless, it must be recognized that those imitations are inferior to the originals and give us neither their happy proportions nor their exquisite delicacy. For this reason, it seems probable to me that Bourdichon collaborated on the Hours of Aragon with an Italian craftsman who was familiar with all the sophistication of the Renaissance. Did Bourdichon journey to Naples or did the Aragon Hours come to Tours? It is an acutely interesting problem, for it raises the question of whether Bourdichon knew Italy and came under its influence, but a problem difficult to resolve; one is obliged to admit that the examination of his work does not furnish us with an answer. The architecture that figures in the background of his miniatures provides us with nothing that could be accounted proof. The pilasters in an antique style that frame the marble facings, the classical scallop shells bordered with a torus, are borrowed from Fouquet, and it is possible that Bourdichon learned all that he knew of the architecture of Italy from his master's sketchbook. And yet the reflection of a new light is cast over his figures; one would say that he has made a journey through a realm of beauty. That feeling of harmony everywhere, those heads so gently bowed, those eyes lifted to heaven, often remind us of the art of the Quattrocento. We sometimes think of Perugino, sometimes of the Lombard masters; of Vincenzo Foppa or Ambrogio Borgognone. Perhaps it was enough for him to have seen the paintings and miniatures brought back by French kings, to have assimilated Italy, but perhaps, like Jean Perréal, he also accompanied Louis XII to Milan. As long as no document provides us with certainty, it will be wise to venture no opinion. But whatever revelation the future may hold for us, I believe it will always be recognized that Bourdichon owes infinitely more to Touraine than to Italy.

III

THE SECOND BOOK in which I recognized the hand of Jean Bourdichon is the Latin manuscript no. 886. This is a large and magnificently bound missal, which must also be counted among the finest items in the Cabinet of Manuscripts. The catalogue of the exhibits informs us that it was made for Martin of Beaune, archbishop of Tours from 1520 to 1527. The date seems a bit late, if one is to attribute the book to Bourdichon, who died in 1521—although it would not be altogether impossible, on the other hand, for him to have illustrated the book in one year. But, looking at it more closely, I realized that the manuscript had been illuminated for another person. To be sure, the arms of Martin of Beaune indeed appear on the first page. But in the body of the work one sees other arms,

frequently appearing, which certainly were a part of the original decoration.[15] These arms (azure, with two fesses or and six roundels argent: three in the middle chief, two in the fess point, one in the middle base) are those of the Fumées, one of the great families of Tours. Adam Fumée, physician to Charles VII, became under Charles VIII minister of justice for France. In the Tours missal, the shield of the Fumée family is supported by a reversed crozier, which is an abbot's crozier. Now, two members of the family of Fumée were abbots of Beaulieu, near Loches: Hugh Fumée from 1485 to 1494 and Hardouin Fumée from 1494 to 1521. It was one of these two, probably the latter, who commissioned the splendid missal that later passed into the possession of the archbishop of Tours.

When one has just finished examining the Hours of Anne of Brittany and the Aragon Hours, one is not slow to recognize the author of the Tours missal, for there is almost nothing in this book that has not been borrowed from the other two. Bourdichon, who was at no time very inventive, had no scruples about repeating himself.

The Tours missal (as we may continue to call it) opens with an illustrated calendar that is nothing more than a slightly simplified version of the one in the Hours of Anne of Brittany. One recognizes that charming work, several of whose pages deserve special praise. January is a burgher of Tours, well wrapped in his tassled cloak, who defies winter and the snow falling in thick flakes. April is a young girl in an orchard, weaving a crown out of the flowers that her companion is gathering. May shows us two young men who bring home from the woods the flowering branches that they will fasten to the window of their beloved. In June two peasants, their whetstones hanging at their girdles, are mowing a field full of flowers, not far from a village whose roofs steam in the sun. In September, a vine-dresser crushes the black grapes in the press, while another pours the wine into barrels from which rivulets of purple are escaping. In December, a villager and his wife are slaughtering a pig whose blood spurts into a basin, while another pig, hanging head downward and already eviscerated, lets its blood drip into a platter; outside, snow covers the roofs of the village and the little church. There is a good humor in all these scenes, a rustic air, that must have pleased Queen Anne. It is certainly the work of the man who, in his margins, painted with such simplicity the flowers of garden and field.

In the Tours missal, Bourdichon copies all the subjects in Anne of Brittany's calendar precisely but, as a measure of economy that was no doubt justified by the more modest sum that had been promised him, he includes only one figure in each scene, rather than two. The month of January is the only exception, which contains only one person in both versions. In May, for example, we see only one youth bearing his branch of flowers and in June only a solitary reaper in the fields.

After the calendar, the miniatures that follow it at times recall the Hours of

[15] For example, folio 29, v., folio 190, folio 221, folio 227, folio 237, folio 312, v. These arms, as well as those of Martin of Beaune, had been covered with a blue wash. But they often may be recognized beneath the color.

Jean Bourdichon. Miniature from the Hours of Anne of Brittany; end of the 15th century. The Calendar: the month of April; folio 7. Paris: Bibliothèque Nationale, Latin ms. 9474.

Anne of Brittany and at others the Aragon Hours. The Nativity is taken from the Hours of Anne of Brittany: here are the same persons, the same shelter, the same lantern whose golden panes cast light upon St. Joseph. The scene of Pentecost is identical: the dove descends through an open cupola, amid beams of light and tongues of fire, above the Virgin seated in the center of the gathering of apostles.[16] The Magdalene is the same, but only her head and shoulders are shown; she has however the reddened eyes and the cheeks streaked with tears. It is true that she does not appear against the fair morning sky that we have admired, but one nonetheless sees behind her, as in the Hours of Anne of Brittany, a round building with buttresses that is the Temple at Jerusalem.[17] In the Tours missal, Bourdichon has reserved the effect of the sunrise for the Resurrection; Christ as He comes forth from the tomb has behind Him the same landscape as did the Magdalene.[18] One can compare, as well, the Trinity in the Tours missal with the one in the Hours of Anne of Brittany.[19] But these few examples, which it would be easy to multiply, will be enough.

The Tours missal owes a great deal also to the Aragon Hours. To begin with, it is obliged to this for the beautiful decoration of its margins. In less detail, here are the same candelabra inlaid with enamel, with precious stones, and with pearls, from which chains of coral are sometimes hung. These candelabra stand against a background of faded violet that one finds again in the Hours of Anne of Brittany, on the page where the queen's initials appear.

In its opening pages, the Tours missal shows us a priest preparing to go up to the altar; the same theme appears three times in the Aragon Hours. One will notice, comparing these miniatures, that the church, the altar and its furnishings, the priest and his chasuble, are all the same.[20] But let us be content to give an incontestable proof. There are, in the Tours missal and in the Aragon Hours, two identical gatherings of saints that differ only in a few minor details. The bishop at his prayers, who is the central figure in the group, also appears in the Hours of Anne of Brittany.

The study of the Tours missal thus demonstrates not only that Bourdichon is its author, but also that it is impossible for him not to have been the author of the Aragon Hours as well.

IV

THE LAST WORK that remains for us to discuss is a small Book of Hours that is no. 1370 in the catalogue of Latin manuscripts. It forms a part of the Gaignières Collection and is described to us as a prayer-book of Charles VIII.[21] I find this

[16] Tours missal, folio 226, v., and Hours of Anne of Brittany, folio 49, v.

[17] Tours missal, folio 317 and Hours of Anne of Brittany, folio 201, v.

[18] Tours missal, folio 203, v. and Hours of Anne of Brittany, folio 201, v.

[19] Tours missal, folio 237 and Hours of Anne of Brittany, folio 155, v.

[20] Tours missal, folio 10 and Aragon Hours, esp. folios 88 and 94.

[21] See Bordier, Catalogue of Manuscripts, new French acquisitions, 5813.

attribution entirely correct, for the arms of France appear several times entwined in the initial capitals. In addition, there is at the end of the manuscript, treated with particular care, a representation of St. Denis and one of St. Michael; that is to say, of the two patron saints of the king and of France. This book is therefore the property of royalty.

The volume is royal, as well, in the perfection of its miniatures. These are delicate drawings in grisaille, standing against a background of designs in sepia, picked out with gold. There are only two colored miniatures, the St. Denis and the St. Michael of the final pages.

In examining the calendar that appears at the beginning of the manuscript, one recognizes first of all that it could only have been executed at Tours. Indeed, one notes for the date of May 6 the feast of St. Gatien, which is not the bishop's usual feast day (December 18th) but that of the transferral of his relics, a special observance of the church at Tours. The same is true of the Hours of Anne of Brittany and the Tours missal, which is an indication of their origin.[22]

Charles VIII's Book of Hours therefore originated at Tours. The study of its drawings proves that it is Bourdichon's work. Certain identical figures, in fact, can be found in the Hours of Anne of Brittany; others in the Aragon Hours, and others in the Tours missal.

It is only necessary to observe the young Virgin with downcast eyes and clasped hands that opens Charles VIII's Hours to recognize immediately the innocent face that appears so frequently in Bourdichon's manuscripts. For the purpose of comparison, we turn back to the portrait of the Virgin that St. Luke is holding in the Hours of Anne of Brittany.

In another instance, the Aragon Hours shows us a St. Michael triumphing over a dragon that is exactly like the one in the Hours of Charles VIII. Here is the same gilded breastplate; here also the same monster, with a belly of yellow and blue-green, that one moreover finds in the Hours of Anne of Brittany.[23] A Job stretched upon his dung-heap is identically shown in the Hours of Charles VIII and the Aragon Hours.[24] His grey beard is rendered with an elegance of touch that no other contemporary miniaturist could have equalled.

Ought one to point out additional similarities in the Tours missal? One example will suffice. The two scenes of the Visitation offer the most striking parallels. The type that is so characteristic of St. Elizabeth—one finds her also in the Hours of Anne of Brittany—is the hallmark of the artist.

Charles VIII's Book of Hours, therefore, is Bourdichon's work. This comes as no surprise. It was wholly natural that the king should have asked his customary painter to decorate one of his books of prayer.

[22] The Aragon Hours has no calendar.

[23] One sees St. Margaret emerging from a similar monster.

[24] Hours of Charles VIII, folio 192, and Aragon Hours, folio 250.

V

WE HAVE EXAMINED these manuscripts of Bourdichon's in the order that clarity required. Now let us indicate, if possible, their actual sequence. The two earliest are the Aragon Hours and the Hours of Charles VIII. The first was very probably illustrated between 1494 and 1504; the second cannot be later than 1498, the year of Charles VIII's death. The Hours of Anne of Brittany comes next. The book was completed in 1508 but, as the accounts show us, the artist had worked on it over a long period. As for the Tours missal, which is, as it were, a summing-up of the three other books, it would seem to me to be the last in the series. It is the least perfect of the four and one seems, at times, to recognize the signs of fatigue. I feel that it is the work of Bourdichon's last years when, more than once, he needed the assistance of his pupils.

It is plain that our old master's genius was not a very fertile one. He repeated himself often. In him, there was neither a great innovator nor a profound dramatic poet. But he was a charming decorative artist and, in addition, the first of Frenchmen to love the beautiful; among his figures there are some that represent what the French art of our first Renaissance created at its most exquisite.

A FTER HAVING READ the preceding study, several persons have done me the honor of writing to consult me on works which they believe can be attributed to Jean Bourdichon. In this way, I have had the immense pleasure of coming to know a new manuscript by the master. Its owner, Baron Edmond de Rothschild,[1] with an enormous generosity for which I am extremely grateful, allowed me to examine it at my leisure and has authorized the reproduction of some of its pages in the *Gazette des Beaux-Arts*.[2] This charming book adds a new dimension to Bourdichon's reputation. Next to the Hours of Anne of Brittany and the Aragon Hours, it represents his most successful work; the Tours missal and the Hours of Charles VIII do not have the same richness, the same sustained perfection.

It is a Book of Hours that was undoubtedly illuminated at the request of some great personage; unfortunately, no coat or arms, no device, no portrait allows us to guess the name of its first owner. Not even its provenance can be established. It was purchased by Rothschild in 1854 at the sale of a famous bibliophile, the bookseller Renouard. But Renouard, although he speaks at some length of this manuscript in the catalogue that he prepared of his collection, does not say how he came by it.

One thing only is beyond question, that it was illustrated by Bourdichon. The proof of this will be simple to furnish; it will be enough for us to compare it briefly with the Hours of Anne of Brittany, with the Tours missal, and with the Aragon Hours.

It most closely resembles the Hours of Anne of Brittany. Many pages, indeed, are framed in marvellous boughs laden with roses, with foxgloves, and with cherries. All around are darting butterflies, gnats, and dragon-flies. Here is the same simplicity and the same perfection. As in the Hours of Anne of Brittany, one can count the fibers in the iris stems or the long hairs on the caterpillars. The same hand reveals itself. Above all, one recognizes the same emotional freshness when faced with nature. Here are raspberries that are half-pink and half-green, marguerites that do not yet dare to open, and stalks of forget-me-nots curled in upon themselves. Bourdichon, like all true artists, retained the capacity for wonder and admiration throughout his entire life.

The nocturnal effects that make up part of the charm of the Hours of Anne of Brittany reappear here. The Annunciation to the shepherds is almost identical. A fire throws its ruddy light on the men's legs and on a dog's muzzle, while from the

Gazette des Beaux-Arts (1904).

[1] Today this work belongs to the National Trust, Waddesdon Manor, Great Britain.

[2] These reproductions will be found in the issue of December 1, 1904 of the *Gazette des Beaux-Arts*.

depths of the translucent night a radiant angel suddenly emerges, who sheds golden gleams over the faces of the shepherds. Elsewhere, Jesus Christ the Crucified appears against a night sky in which the moon is shining against a background of stars.

The arrangement of the scenes, the human characteristics, are the same. The Virgin offers her innocent face; Job displays his splendid beard; the angels' long hair is clasped in a diadem of precious stones.

But there is further proof. Several of the themes, indeed, reappear in the Tours missal. Let me mention the antique candelabra that figure in almost all of the margins of the Book of Hours. The Tours missal shows us ones that are absolutely identical. Bourdichon was wholly familiar with this decorative motif, which he had learned from the Italians at the time when he was illuminating the Aragon Hours. He brings together the dolphins, the horns of plenty, the *bucrania*, the antique breastplates with skill. He had more enthusiasm than knowledge, however; on a cartouche like those that crowned the standards of the legions, he has written SVPR rather than SPQR. It would seem that Bourdichon made candelabra fashionable. The famous Beaune fountain, which was constructed in a square at Tours during the period when he was illuminating his manuscripts, is in the shape of one of his antique candelabra.

I would like to point out yet another similarity between the Book of Hours that we are examining and the Aragon Hours. Both manuscripts show us a Virgin and Child sitting beneath a canopy carried by angels. This is a theme that was particularly dear to our artist. An archival document informs us that he had done a painting which was in every way similar: "The said image [of the Virgin] is sitting in a chair, and there are four angels who support the sky up above."[3]

Since Bourdichon did not hesitate to repeat himself, we may be certain that the two miniatures give us an exact idea of this painting of the master's.[4] They provide precious evidence of what this major painting, that we are so unfamiliar with, was like.

We have, thus far, pointed out the similarities between this new work by Bourdichon and those that we already know. It is now only fair to mention its innovations. Bourdichon may well have repeated himself, but in each of his books there is room for new ideas.

What is new here, to begin with, is the calendar. Not that we do not come upon scenes very like those that open the Hours of Anne of Brittany; many of the months are greatly similar. Others, however, are pictured quite differently. January is no longer a burgher of Tours returning home beneath the snow; he is a peasant striding under a clear sky, through frigid air in which the naked silhouettes of the trees stand out sharply. In February, a rustic carrying wood is crossing a farmyard; a pale sky and the crows perched on the rooftops suggest the melan-

[3] *Archives de l'Art français,* vol. IV, p. 11.

[4] Or at least of the center portion of the composition, for he had added in the margin "other angels, a sun [that is, a halo] and a cloud."

choly of the season. June is symbolized by hawking; a dashing huntsman seizes the heron that has fallen at his feet and at the same time looses his falcon. These little scenes have as their background the most delicate of landscapes. The foliage changes imperceptibly from green to blue as it grows distant, and Bourdichon's vision has never been more discerning. In the month of September, behind the peasant who is sowing there unfolds a landscape that will be familiar to all who have lived in central France: a gentle hillside divided into a multitude of small fields by blue hedgerows.

Following the calendar, the large scenes that decorate the body of the work also offer some novelties. The characteristics of the Evangelists, if one excepts St. John, are slightly different from what we have been accustomed to see in Bourdichon's work. The faces of St. Luke and St. Matthew, in particular, are done with a modified realism that is not without its charm. St. Luke, freshly shaven, is faintly shadowed about his chin and cheeks. As for St. Matthew, he is a fifteenth-century scribe, wearing a fur cap and dressed in good cloth, who writes at a pretty desk of carved wood; an apple sits on the corner of his table.

One should mention another scene that became famous in the studio at Tours and that was vulgarized in Books of Hours in wood engravings: it shows David gazing upon Bathsheba in her bath. Here, old French prayer books showed David kneeling before God, asking forgiveness for his errors. The French artists of the first Renaissance chose to show us the prophet-king at the moment when the idea of sinning comes to him. The spectacle was less edifying. Bathsheba, nude, is stepping into a fountain, her beautiful golden hair flowing over her shoulders; trees and flowers are all around her, while David watches from the rear of the garden. Bourdichon was certainly not the first to have had the idea of representing this scene, but it became one of the most popular subjects of his school.

Another novelty in the book before us lies in the design of its settings. The miniatures are surrounded by an architecture whose style is strikingly different from what we have seen thus far. On a high stylobate of gold stand columns of green or pink marble; they are arranged two-by-two and support a gilded archivolt upon their classical capitals. The effect is very rich but at times a little heavy, and the proportions are such that one thinks of Romanesque architecture rather than of the architecture of antiquity. The cusped archivolts reinforce that impression.

Such are the characteristics of this splendid book which, in the freshness of its colors, the variety of its ornamentation, and the appealing sweetness of its expressions, deserves to take its place among the master's major works.[5]

At almost the same time, I had the good fortune to come upon another manuscript by Bourdichon in the Bibliothèque de l'Arsenal. It is a little Book of Hours, modest in appearance, that is listed as no. 417. Unfortunately, it has been

[5] We have said that there is nothing to indicate the date of the book. However, it is reasonable to suppose that it is contemporaneous with the Hours of Anne of Brittany, or a little later, for one finds there the same flowers and the same fruits.

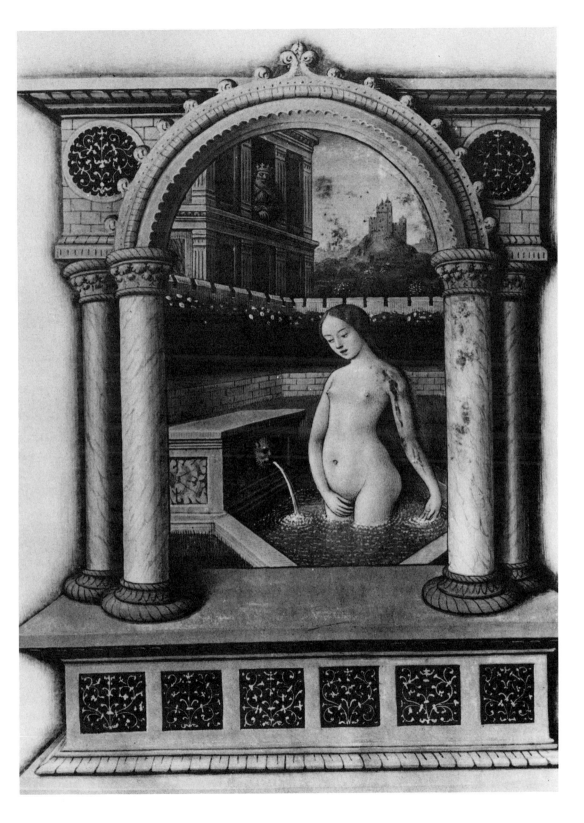

Jean Bourdichon. Miniature from a Book of Hours. David watching Bathsheba at her bath; end of the 15th century. The National Trust, Waddesdon Manor (Great Britain).

slightly damaged and several of the miniatures have lost their freshness. It was illuminated for a great nobleman whose arms can be seen and who is in all likelihood one of the counts of Vendôme. The miniatures are few and their size is restricted, for the figures are shown only at half-length, but they are from the master's hand.[6] A scrupulous critic will point out that two or three inferior pages (the Descent of the Holy Spirit; Uriah before David) and the carelessness of some of the margins betray the collaboration of a pupil. We would not deny this. But it is sufficient to glance at the charming figures of the Evangelists that introduce the book, or the pretty Holy Family in folio 9, to recognize Bourdichon's accustomed skill. Several other pages deserve mention. The meeting between the Virgin and St. Elizabeth takes place in a delicate landscape of greenery and streams, bathed in a misty light, which can only come from the hand that painted the background of the Aragon Hours. Modern painters, schooled in four centuries of art, do not observe with greater acuity.

The Annunciation shows us two figures that are alike in their celestial grace: the Virgin and the angel are equally blonde, guileless, and shy; facing them, the prophets, whose realism remains always noble, seem to play a part in the mystery.

Two scenes, above all, should be praised. One shows the Flight into Egypt, which Bourdichon has imagined in an entirely new way. The travellers are journeying on foot, staff in hand, through meadows in Touraine that are looked down upon by ancient manor-houses. St. Joseph, like some wayfarer on the roads of France, carries a sack over his shoulder. On one arm, he holds the sturdy Child, who leans His head against his shoulder and stretches out His little hand for the beautiful red apple that the Virgin offers Him. This scene, so far from the old sacred traditions, has a touching human sweetness.

Another fine page portrays the Vigil of the Dead. At the foot of a cemetery cross, a mummified corpse, half-covered by its shroud, brandishes a scythe. It menaces a pope, who bows his head and tries vainly to avert the blow, in a gesture full of realism. Meanwhile, another figure of Death bends its bow and launches an arrow that buries itself in the throat of an emperor. No doubt one ought not to demand of Bourdichon that vigorous horror others would have known how to inject into this scene; nevertheless, he has made a fine work of this and has injected more force into it than one would have anticipated.

We thus are now familiar with six manuscripts illuminated by Jean Bourdichon: the Hours of Anne of Brittany, the Aragon Hours, the Tours missal, the Hours of Charles VIII, the Book of Hours belonging to Baron Edmond de Rothschild, and, lastly, the Book of Hours in the Arsenal Library.[7]

[6] This article was written before the Exhibition of French Primitives. Since then the Arsenal manuscript has been on view in the Rue Vivienne and a number of persons have recognized it, as I did, as a work by Bourdichon.

[7] A manuscript in the library of the University of Innsbruck (no. 281) has been attributed to Jean Bourdichon by Hermann Julius Hermann (*Beiträge zur Kunstgeschichte Franz Wickhof gewidmet,* Vienna, 1903, p. 46 ff). The manuscript was executed in Bourdichon's studio and, as far as one may judge from reproductions, it seems probable to me that the best miniatures are from the master's hand. There is in this manuscript a very fine St. John the Evangelist that is the most Italianate figure I have yet discovered in the master's work.

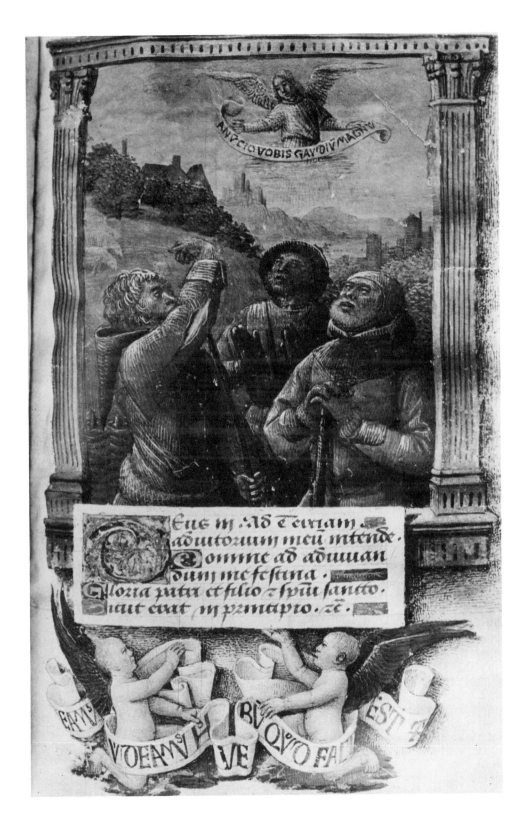

Jean Bourdichon. Miniature from the Book of Hours of François de Vendôme, around 1485. The Annunciation to the Shepherds; folio 40. Paris: Bibliothèque de l'Arsenal, ms. 417.

Jean Bourdichon. Miniature from the Book of Hours of François de Vendôme, around 1485. The Flight into Egypt: folio 46. Paris: Bibliothèque de l'Arsenal, ms. 417.

It is possible to ask, did the master work on all these projects unaided, or was he not obliged, in order to complete so many major works successfully, to seek the help of his pupils? Certainly, nothing would be more likely nor more in accord with the practices of the Middle Ages and the Renaissance. As we will see, there were around Bourdichon a number of artists of an exemplary obedience and it is probable that he made use of the most skillful in his task.

Indeed, I have found several manuscripts illustrated by Bourdichon's pupils in the libraries of Paris. These are prayer-books in which one finds all of the master's innovations: architecture, landscapes, nocturnal effects, costumes, facial characteristics, heads that are gently bowed. In the great scenes from the Gospels, the treatment of the characters is the same. It would be impossible to be more submissive. Several pupils have had a hand in these manuscripts; some were greatly gifted and not at all incapable, when the opportunity arose, of collaborating with the master, but the majority lacked talent.

It will not be unhelpful to describe briefly these works from the studio. Only one of these books was commissioned; the others were apparently made to be offered for sale. The Tours workshop must have produced a great many works of the same kind, which can be found in private collections or provincial libraries.

The most distinguished among the Books of Hours that were illustrated by Bourdichon's pupils is the Latin manuscript no. 1374 in the Bibliothèque Nationale. The miniatures in its opening pages are by a gifted pupil; the four Evangelists and the seizing of Jesus Christ in the Garden of Olives seem at first sight almost worthy of the master, but it is enough to open the Aragon Hours to recognize that neither faces nor landscapes possess the same delicacy. What follows after folio 25 is the work of a much less talented pupil. Everything becomes coarser: the Adoration of the Magi, the Presentation in the Temple, the Flight into Egypt give us a version of the Virgin that follows the model introduced by the master but from which all charm has fled. The distant landscapes no longer display those pretty muted greens that will blend into blue. The figure of Bathsheba at her bath is a fairly faithful copy but it lacks grace; no longer does she have those beautiful blonde locks shot through with gold upon her shoulders, but reddish hair without a gloss. It is clear that the best miniatures have been placed at the front of the book, to attract a buyer. The same is true of another manuscript from Bourdichon's studio where, as we can see, the interests of business were well understood.

A French manuscript in the Bibliothèque Nationale (no. 180) is again the work of some of Bourdichon's best students. This is a missal that follows the usage of Paris, in which the miniatures are infrequent and correspond to the great feast days of the year. To a greater or lesser degree, they all follow the formulas with which we are acquainted. While not lacking a certain amount of skill, they are not capable of conveying any sense of illusion. When one has just leafed through the delicious pages of the Aragon Hours and has still before one's eyes those faces with a bloom upon them, that hair dusted with flecks of gold, one cannot for an instant consider attributing even the best miniatures in this missal to Bourdichon.

Three of them deserve some praise; a Crucifixion[8] in which the figure of Christ upon the Cross is painted a little less awkwardly than was usual in the workshop; a priest before the altar,[9] the work of an excellent apprentice who at times almost attains the refinement of his master; and, lastly, a Resurrection[10] that closely resembles the one in the Tours missal. Jesus Christ comes forth from the tomb at the hour when the sun's first rays begin to gild the walls of Jerusalem.

A Book of Hours in the Mazarine Library (no. 507) should be next mentioned, although it is yet more uneven in quality. The better miniatures, as in the Hours in the Bibliothèque Nationale, are placed at the beginning. St. John, St. Matthew, and the Crucifixion are by a competent pupil who was entirely familiar with the workshop's techniques. Behind Jesus Christ upon the Cross, he has shown a wide and somber sky, lightened at the horizon with a band of orange. But after folio 38 the miniatures lapse into a shocking mediocrity. They are the work of pupils who copy rapidly, and badly, the originals before them. The Virgin's face, while retaining the character that Bourdichon knew how to give it, becomes insignificant or vulgar. In folio 82, we find an imitation of that unusual Flight into Egypt that we noted in the Arsenal's manuscript no. 417. Here one can well gauge the distance that separates master from pupil. The Virgin's face has as little character as does St. Joseph's, and nothing remains of what constituted the charm of the original. One may say the same of Bathsheba in her bath, which has retained nothing of the pleasing poetry that suffused Bourdichon's version. Toward the end of the book, the miniatures become execrable; the story of Job and that of St. Margaret have been entrusted to clumsy practitioners who do little honor to their school.

Manuscript no. 2705, in the Bibliothèque Sainte-Geneviève, although less uneven, is not a work of any great value; it provides the occasion nonetheless for a few observations that in themselves are of interest. This is a Book of Hours executed at Tours[11] for a gentleman and his wife whom we see kneeling beside Christ's tomb,[12] but whom it is difficult to identify.[13] The principal scenes take place within architectural borders that offer striking analogies with those we have mentioned in the Rothschild Hours. The Annunciation, in particular, takes place beneath a gilded and cusped archivolt that is supported by double columns of rose marble. The pupil has been content to copy what the master created, but his work is as commonplace as the other's is refined. The encounter between Job and his friends, which follows the traditions of the school closely, is the finest page in the book. As for the little Virgin in folio 15, with her downcast eyes, her bowed head, and her blue veil over a white coif, she is like the hallmark of the workshop. The

[8] Folio 80. [9] Folio 80, v. [10] Folio 82, v.

[11] The calendar shows, in the month of May, the Translation of St. Gatien, a saint of the diocese of Tours. [12] Folio 3, v.

[13] The armorial bearings of the man are obscured; those of the woman are very dim. Kohler (*Catalogue des manuscrits*) thinks to see: quarterly, in the first and fourth, gules with three fesses or; in the second and third, gules with a lion or.

color in this book is not laid on as a wash with imperceptible shadings; the artist, like some modern painters, works with little brush-strokes that blend together only when seen from a short distance. This technique, which Bourdichon did not ordinarily use, can however be found in his work. The calendar in the Hours of Anne of Brittany and a fairly large number of the miniatures in the Tours missal were painted according to this formula.

It would be tedious to give any further study to works of which none is distinguished. I will be content with listing some of the other manuscripts from the Bourdichon studio.

In the Mazarine Library, no. 420, a missal according to the usage of Poitiers, painted at Tours itself;[14] in the Arsenal, two breviaries, nos. 1245 and 1246,[15] and two Books of Hours, no. 437 and no. 1193. This last was painted at Paris by an illuminator who was familiar with other traditions but had passed through Bourdichon's school, as the figure of the Virgin in folio 201 indicates. In the Bibliothèque Sainte-Geneviève, no. 2704, a Book of Hours painted for the diocese of Autun, which is relatively faithful to the principles of the workshop; and, finally, in the Bibliothèque Nationale, a Book of Hours, Latin manuscript no. 828a, which is the work of a somewhat liberated pupil.

It follows from all of the preceding that at Tours Bourdichon had an important studio and many pupils, whose talents were very unequal. In his workshop, the decoration of Books of Hours resembled an industry. Buyers could always find finished volumes, doubtless at every price. The master reserved his own efforts for works commissioned by royalty or the great persons of the time. His best apprentices must have prepared the subject for him, painted in the ground, and worked on the margins. But they did not put the finishing touches on the works that the master gave out as his own. There is a perfection and a finish to the six admirable manuscripts that we have earlier described, of which none of his pupils was capable. We thus have the right to say that these are Bourdichon's.

The influence of this Tours workshop, the most important of the late fifteenth century, seems to me to have been considerable. What the best miniaturists of Rouen or Paris owed to it would be an interesting subject of research. Curiously enough, the sculptors themselves seem at times to have imitated the types created by Bourdichon. If one compares the fine bust of the Eternal Father at La Bénissons-Dieu (Loire) that Vitry has reproduced in his book on Michel Colombe,* with God the Father in the Aragon Hours, one will be struck by the resemblance. Here is the same papal tiara; the same arrangement of the hair, the same beard; above all, here is the same gravity and the same gentleness. Gentleness: it is the word that recurs repeatedly when one speaks of Bourdichon, as well as of the Tours sculptors. In that amiable Touraine, painters and sculptors seem to have lived in a perfect harmony of feeling and to have pursued the same vision of beauty. It was

[14] The calendar shows in May the Translation of St. Gatien.

[15] The miniatures have been glued onto the pages.

*Paul Vitry, *Michel Colombe et la sculpture française de son temps* (Paris, 1901).

here that the art of the Middle Ages, barely touched by the extravagance of Italy, made its last appearance, full of tenderness, modesty, and sincerity.[16]

Bust of the Eternal Father. Church at La Bénissons-Dieu (Loire).

Jean Bourdichon. Miniature from the Aragon Hours: God the Father; end of the 15th century. Folio 288. Paris: Bibliothèque Nationale, Latin ms. 10532.

[16] In 1913, Léopold Delisle published a volume entitled *Les grandes Heures de la Reine Anne de Bretagne*. He introduced two new manuscripts existing in England by Jean Bourdichon, one belonging to Colonel Holford and one in the British Museum. Both bear a resemblance to the manuscript belonging to Baron Edmond de Rothschild that we have discussed and to the Hours of Anne of Brittany. A new painting by Bourdichon has been discovered in the Naples Museum by Jacques Dupont (*Monuments et mémoires de la Fondation Piot*, vol. 35). The magazine *Verve* has just brought out a fine edition in color of the *Heures d'Anne de Bretagne* (1946).

I N THE EARLY YEARS of the sixteenth century, French glass-painters often found their inspiration in the wood- or copper-engravings that originated in the Low Countries, Alsace, or southern Germany. The respect for traditional iconography, the depth of religious sentiment, the sharpness of the line itself—everything in the work of Martin Schongauer or Albrecht Dürer attracted them. Thus they frequently copied those artists. From Schongauer, for example, they borrowed the magnificent battle-piece in which St. James, at the head of the Christians, charges the infidels; we see a somewhat free adaptation of it at Châlons-sur-Marne[1] and also at Roye.[2] From Albrecht Dürer, they borrowed the finest pages of his Apocalypse, which they never wearied of reproducing.[3] His life of the Virgin and his Great Passion also often inspired the draftsmen who designed windows and who picked up a scene here and a detail there. This art of Schongauer and Dürer was still the art of the Middle Ages, tender, sentimental, and familiar, such as French artists loved.

But toward 1540, the glass-painters began to draw on models that were altogether different. Engravings that originated in Italy introduced them to a new art, in which all was harmony, studied proportion, beauty. They were captivated, and one saw them copying Raphael and Michelangelo.

A careful study of the windows of the sixteenth century will, I am convinced, enable us to identify a great many of these adaptations. I should like to call attention here to those that have seemed to me particularly striking.

The great choir windows in the church at Conches (Eure) are one of the most beautiful achievements of the sixteenth century. Their date is not known, but they appear to be earlier by several years than the nave windows, which bear the dates of 1546, 1552, and 1553. They picture both the Passion of Jesus Christ and the history of St. Foy, patroness of the church. The Abbé Bouillet,[4] who was the first to study them, had no difficulty in recognizing the imitations of Dürer; he is more to be praised for pointing out what was borrowed from Hans Sebald Beham and the Master of the Star.* But, curiously enough, it did not occur to him to look elsewhere than among the German graphic artists for the sources of the Conches windows. He should have been warned, however, by the nobility of certain episodes and by the vigor of the design, that the artist had used other models. The Descent from the Cross, for example, is a composition in the grand manner: the

Mélanges offerts a M. Henry Lemonnier, (1913). [1] The church of Notre-Dame.

[2] The window, extensively damaged, was completely destroyed during the 1914–18 war.

[3] *See*, on this subject, *L'Art religieux de la fin du moyen age*, 3rd edition, p. 443, ff.

[4] *Bulletin Monumental* (1888).

*The Master of the Star is now recognized to be Dirck van Staren, whose works are dated from 1520 to 1550, and whose signature was a D and a V separated by a star.

body of Christ, supported by men standing on tall ladders, is suspended in space while, close to the Cross, the Holy Women raise the head of the fainting Virgin. This is no longer the version that we have seen a hundred times over of traditional Descents from the Cross; the scene conveys an impression of freshness and creative energy. And, in fact, this highly original Descent from the Cross is nothing less than a composition by Raphael, engraved by Raimondi.[5]

Marcantonio Raimondi died shortly before 1530; it was only in 1540 that the French glass-painters began to admire his engravings and to copy them. It was above all through him that they knew Raphael and could glimpse that world of beauty which he had created. All they knew of Raphael, they had learned from Raimondi; what they saw there was enough to make them aspire, in turn, to nobility and beauty. Examining the windows at Conches, one is struck by the fact that when the painter imitates German engravings, he refines them, ennobles them, gives them an Italian flavor. Even when he copies Dürer, he is under the influence of Raphael.

The Descent from the Cross is not the only imitation of Raimondi that the Conches windows have to show us. In the history of St. Foy that contains so many charming episodes, the scene of her martyrdom is particularly striking for its beauty. The judges are seated beneath a stately Corinthian portico; the young saint is plunged into an antique cauldron that rests on lions' paws, while in the sky hovers an angel resembling a Victory. We recognize one of Raimondi's most beautiful engravings, which portrays the martyrdom of St. Cecilia. It is a copy of a fresco that Raphael had painted for the papal villa at Magliana, built, it was said, on the very site of St. Cecilia's martyrdom. Raimondi's engraving shows us, to the right, a tragic episode: the executioner holds up before the saint, plunged in the boiling water, the severed heads of her husband, Valerian, and her brother-in-law, Tiburtius. Since the Acts of St. Foy contained nothing like this, the Conches glassworker, leaving aside this area of the engraving, has reproduced only the other half.

A careful study of this life of St. Foy will disclose, I believe, other borrowed elements.

If we move on from the choir windows to those in the nave, one will claim our attention by its Italian atmosphere. It portrays the Last Supper and bears the date of 1546. This Last Supper in no way resembles those painted by the French artists of the late Gothic period; one does not see Christ, the chalice and the host in His hand, instituting the sacrament of the Eucharist here. The moment chosen is a different one; it is the instant that follows the words spoken by Jesus, "One of you will betray me." Those terrible words unleash a tempest, but one that does not disrupt the linear harmony. Before the window at Conches, one thinks first of Leonardo da Vinci, who also chose this moment and was the first to give that classic problem a perfect solution. But upon reflection, one realizes that the glass

[5] The question has been raised whether the original drawing for Raimondi's engraving was indeed by Raphael; the reasons for attributing it elsewhere are not convincing.

The Descent from the Cross. Engraving by Marcantonio Raimondi after a composition by Raphael.
Paris: Bibliothèque Nationale, print collection.

The Descent from the Cross. Church at Conches (Eure). Choir window.

worker had before his eyes not a work of Leonardo's but one that was wholly imbued with his spirit. He was inspired by a print that Raimondi had engraved after a drawing by Raphael. Moreover he interpreted that print freely; for lack of space, he has crowded the apostles together and changed the position of those at the ends of the table, but the center portion is the same in the etching and in the window. Christ makes that telling gesture of despondency that Leonardo invented and Raphael alone could understand: the arms are outstretched and the hands rest upon the table. The Master has spoken and there is now nothing more to be said. But what proves that the Conches glassworker took his idea from Raphael and not from Leonardo, is that his Christ does not bow His head nor lower His eyelids; He remains erect, His gaze fixed, absorbed in His thought. This is indeed the Christ engraved by Raimondi. And what completes the resemblance is that neither in the engraving nor in the window is there that great open area, that interval of rest and silence, that Leonardo introduced between Christ and the apostles at His sides. In both window and engraving, St. John is on the left of Christ, rather than on His right, and makes the same gesture of loyalty, laying his hands upon his breast. Such similarities do not come about by chance.

The window at Conches thus freely interprets the Italian original. Indeed, at times the French glass-painters took liberties with Raphael's work that shock us today, but it must be recalled that this work did not yet have the almost sacrosanct character that time has conferred upon it. The master's paintings did not figure yet almost as archetypes of the beautiful. Toward 1548, a glassworker at Chalon-sur-Saône, charged with decorating the hospital chapel with a series of windows, assumed that he had the right to reproduce in his own manner the painting of the Transfiguration.[6] He had surely not seen the original but only an anonymous engraving that has sometimes been attributed to Raimondi. What struck him in that engraving was not so much the harmony of the whole but the newness of certain gestures. His Christ, arms outstretched, hovers in the air like Raphael's, but Moses and Elias, too near, do not leave enough space and light around that glorious body. Of the three disciples whose gestures remain so deeply graven on the memory, the Chalon glassmaker has copied only two: St. John, dazzled, shades his eyes with his hand and St. Peter, overcome, remains prone upon the earth. But St. James, instead of bowing down, raises his head and makes the most banal of gestures with an arm. The honest craftsman of Chalon evidently did not suspect that he was committing a sacrilege, and hardly imagined that the picture he adapted to his own purposes would one day be among the most celebrated paintings in the world.

As a rule, however, the French glass-painters respond to Raphael's genius with more sensitivity, and seem struck by the absolute rightness of his composition. At Montfort-l'Amaury, in the midst of a mediocre window devoted to the story of Joseph, one scene of dazzling beauty stands out: Potiphar's wife, seated

[6] The window has been reproduced in the collection published by the Historical and Archaeological Society of Chalon in 1846.

Martyrdom of St. Cecilia. Engraving by Marcantonio Raimondi after a composition by Raphael.
Paris: Bibliothèque Nationale, print collection.

Martyrdom of St. Foy. Church at Conches (Eure). Choir window.

upon her bed, attempts to hold back the young man. Among so many lack-luster episodes, this one delights us by the nobility of its lines. Here, at least, the artist was happily inspired, for he has reproduced Raimondi's well-known engraving exactly.

One sees to what a degree French glassworkers were familiar with the graphic works of the Italian master: they made use of them without hesitation. But if Raimondi is the greatest of Raphael's interpreters, he is not the only one. It would require a complete catalogue of the prints engraved from the work of Raphael in the sixteenth century to give an accurate idea of the resources that French glass-painters had to draw upon.[7] One is astonished, for example, to come upon a copy of Raphael's *Spasimo di Sicilia* in a fine window at Écouen that dates from 1544 or 1545. This is the famous Bearing of the Cross, painted for a church in Sicily, that is today in the Prado at Madrid. One asks oneself how this painting, which has had so many adventures, could have been known in France at that date. The answer is that it had been engraved as early as 1517.

These examples, which I am certain will be multiplied by a careful analysis of French windows, illustrate the extent to which Raphael was admired in the workshops of the glass-painters toward 1540. The study of his work, while giving French artists a lesson in nobility, led to changes in their style.

Was Michelangelo as well-known as Raphael? I think not, for much less has been borrowed from his work. He was, however, not unknown to the French glassworkers, as a curious window at Conches reveals. This window, which can be found in the left-hand aisle, is not dated but can only be from the last years of the sixteenth century. It portrays the fall of manna in the desert, which here has the meaning of a eucharistic symbol. Our gaze is first drawn to this window by the nude and muscular figures at its center. One seems to be drawing water from a river, while the other climbs its bank. These athletes are Michelangelo's Climbers, with whom the artist had adorned his window just as a humanist adorned his Latin verses with an echo of Virgil. But that is not all; one remarks a mighty figure in the foreground. It is a bearded Moses, carrying the tablets of the Law. This leader of his people, this heroic walker who crossed deserts, has legs girt about with leather thongs. By all these features, one recognizes the Moses of Michel-angelo. The statue from San Pietro in Vincoli stands erect here and strides forward. The concept would seem superb if the window's design were a better one.

Should one conclude that the Conches artist had visited Italy? In any event, the hypothesis is unnecessary, for it was possible to be familiar with the Climbers and with Moses without leaving France. The Climbers had been engraved by Raimondi, and his etching is one of the rare surviving fragments that we have today of Michelangelo's cartoon for the Battle of Cascina. As for the Moses, a large engraving, perhaps done by Nicolas Beatrizet toward the middle of the sixteenth

[7] There exists in the Bibliothèque Nationale's Cabinet des Estampes an attempt at a catalogue of this kind; it remains in manuscript form.

century, had made it known all over Europe.[8]

The window at Conches is a curious witness to Michelangelo's influence but it is, until now, unique. Michelangelo seems to have affected French glass-painters indirectly by way of the Fontainebleau masters. This would be a vast subject for research and one that could be of immense interest. I will content myself with one example. There is at Écouen a window given by Cardinal Odet de Châtillon which bears the date of 1545. It represents the story of Adam and Eve and the parable of the Good Shepherd. In the lower portion, near the donor, a fine figure of Christ, almost nude, standing in a niche like some piece of sculpture, holds His Cross. This Christ, who is like some hero of antiquity, evokes the memory of the Christ sculpted by Michelangelo in Santa Maria sopra Minerva. But the glass-painter did not find his inspiration in that original; he copied an engraving by one of the Fontainebleau masters who was a disciple of Michelangelo's. In Il Rosso's work, one comes upon an etching that shows Christ bearing His Cross as the glassmaker at Écouen has reproduced it. Il Rosso, in drawing his Christ, clearly remembered the Christ by Michelangelo, but the French glass-painter had himself only known Il Rosso's picture. One sees from this example that it was by way of his followers that Michelangelo influenced the artists of France.

The handful of examples brought together here indicates that French sixteenth-century windows should be subjected to careful study. The art historian who wishes to devote himself to this task must begin with an exhaustive knowledge of the German and Italian engravers of the sixteenth century. As a result, he will be able to judge the degree of originality of our French artists and to distinguish the innovators from the imitators.

[8] Cabinet des Estampes, Vx43, folio 227.

H OW OFTEN have we not had occasion to admire, in the treasury of one of France's churches or a glass case in one of France's museums, a little fourteenth-century ivory Virgin exchanging a smile with her Child! Sometimes it is a diminutive triptych representing the Passion that turns our thoughts to the serious masterpieces of architectural sculpture. In London, in the Vatican, at the Escorial, in the midst of foreign works of art, an ivory coffer wrought with historical scenes, a writing-tablet on which a lady is placing a crown of flowers upon the head of a knight, a shrine sheltering the Virgin between two torch-bearing angels, suddenly reminds us of the graceful genius of France. And we have frequently wished that these frail marvels, which have endured so long and journeyed so far, might be brought together in one compendium by a dedicated enthusiast who would inform us about them.

Today, that wish has been realized. Raymond Koechlin has just given us, in three volumes, the almost complete *corpus* of the French ivories of the Middle Ages.[1] He has been at work on this for nearly twenty-five years, for it was during the International Exposition of 1900, in those rooms where some of the most beautiful French ivories had been assembled, that he began his task. Years indeed well spent! How much time it has required, how many journeys, and often how much ingenious tact, to study and to photograph, in the museums of Europe and in private collections, all these shrines, these diptychs, these coffers, and these mirror cases!

This task, which already appears difficult, will appear much more so when one considers that among these ivories some are the work of clever forgers. False Gothic ivories exist not only in private collections but in museums themselves. Koechlin must have continually trembled, lest he be duped. Before undertaking the work of the historian, he was obliged to perform the work of the critic. At times he could only, in spite of his accumulated experience and his impeccable taste, reserve judgement and not venture to offer any opinion, so great is the skill of those who forge today's antiquities. Happily those cases are rare and Koechlin's compilation deserves our complete confidence. But how much more careful, after today, we must be! This book, which will educate the archaeologist, will do the same for the counterfeiter. Henceforth, it will be child's play for him to imitate the ivories "with a decoration of roses" or to continue the work of "the school of the Soissons diptych." Koechlin himself will no longer be able to purchase an ivory without knowing its history perfectly.

Revue de l'Art ancien et moderne (1925).

[1]Raymond Koechlin, *Les Ivoires gothiques français* (1924), 3 vols.; edited by Auguste Picard. The first volume is a history of the French ivories; the second, a catalogue of almost all the known French ivories; the third, a collection of illustrations that gives us, in 500 photographs, all that is essential.

Those were the principal difficulties facing this great undertaking, but there were many others. Confronted with those innumerable ivory carvings, which to begin with are very difficult to distinguish from each other, the scholar feels himself lost. Yet it was essential, in order to put together something more than a catalogue, to know how to group the works and recognize, if not the artists, at least the different studios. It was necessary to trace their development. It was necessary, taking into account all the most subtle nuances of style, to attempt to establish a chronology. Only a scholar of faultless taste, refined by a long familiarity with the works of the Middle Ages, could succeed here. It is because Koechlin had that thorough grounding and, at the same time, that wisdom which becomes in the long run almost instinctive, that he has succeeded. He had been preparing for these difficult studies over a long period. He had established his reputation with the *Histoire de la sculpture à Troyes*, which he wrote in collaboration with Marquet de Vasselot. There he had shown how, by means of careful study, one can rediscover the masters, restore their works to them, and write the history of a school of art whose names are lost.

I

NEARLY ALL the thirteenth- and fourteenth-century ivories that we admire in the museums of Europe are of French origin. These small masterpieces, which were once attributed to Orcagna or Nicola Pisano, were carved at Paris. The workshops of the ivory carvers were for a long time located in the neighborhood of the Rue Saint-Denis or the market stalls of Champeaux. There mirror cases and coffers for jewels were carved, as well as retables and statues of Our Lady. The same integrity is to be found in all this work, for the standards of the craft were rigorous. An apprenticeship lasted not less than seven years, and an apprentice was forbidden, as were his colleagues, to carve his diminutive figures by candlelight, "for the illumination of night does not suffice for the calling." Each piece of work that the authorities judged inferior was destroyed and it was often burned, with the exception of pious images, "out of respect for the saints." That admirable instruction and strict discipline assured the success of French ivories for over a century. Not all were masterpieces, but to all the artist brought something of himself. There are no wholly slavish copies, and one would not find two Virgins that lack their subtle differences.

The Paris of the late thirteenth century and the early fourteenth, where life had already become so elegant; where one breathed in the air of taste; where major works of art offered the most splendid models for the minor arts, was the chosen home of this noble craft of ivory, which did not invent, but which reflected the finest inventions. One can hardly visualize it elsewhere. And indeed Koechlin has not been able to discover any provincial workshops, for it is not certain that the ateliers of Dieppe go back as far as the Middle Ages. Foreigners thus scarcely attempted to challenge the French. Certain ivories have been attributed to England, to Germany, or to Italy, but many of these, under Koechlin's scrutiny, have

shown themselves to be French. He does not deny that there had been English, German, and Italian ivories. The ivory Virgin at Pisa was carved in Italy, and her sorrowful expression would make it possible to attribute her to Giovanni Pisano. There are certain ivories that too closely recall English miniature painting for one to hesitate long over their origin. But those foreign workshops scarcely knew anything except to imitate what was being done in Paris. The ivories carved in Germany were copies, often clumsily executed, of French originals. "When the folds are rigid," says Kehrer, an archaeologist from across the Rhine, "when the faces are ugly, it is because one is dealing with German craftsmen working from French originals." Exported everywhere, French ivories carried French taste to the limits of the Christian world, for our ivories went where our sculptors did not. It was thanks to French ivory carvings and, one should add, to French illuminated manuscripts, that the international style of the fourteenth century, in which analysis reveals so many French elements, came into being.

It was thus in Paris that Frenchmen and foreigners bought these precious ivories, then even more delectable than they are today, for they were often tastefully overlaid with a variety of colors. One can judge of this by the tunic and robe of Christ and the Virgin in the Louvre's celebrated group, delicately sprinkled with fleurs-de-lis. At times, the ivory was inlaid with gold, as in some of the works of ancient Greece. There were Virgins with a diadem of gold, a clasp of gold upon their breast, a flowering golden spray in their hand. The pedestals were of silver, of ebony, or of enamel. One of these Virgins seemed to rise out of a silver rose enamelled with blue. In the fifteenth century, the fretwork ivories stood out against a ground of gold or enamel. The account-books of great noblemen and the inventories of churches are all that preserve the memory of that magnificence. Ivory carvings were made beautiful because a fervent piety attached to them; morning and evening prayers were said before those diptychs and triptychs. Opening them, one transformed a room into a shrine; hence, one closed them again at once, as if to spare those holy images the sight of the vulgarity of daily life. It was in the same spirit that, in the castles of the Duke of Berry, paintings in which the Virgin or Christ were portrayed were covered by a curtain. Some of those diptychs, square and without external protrusions, gables, or pinnacles, were easy to carry on a journey, a pilgrimage, or a campaign. More than one would have been the knight's faithful companion within his tent. It should be noted that these little household altars were rarely dedicated to the saints. Although the saints were all-powerful in the hearts of the men of that time, when it was a question of choosing the images that one would see all the days of one's life, and at the hour of one's death, one would choose to have the Passion of Christ or the Life of the Virgin before one's eyes. Those were the subjects that the ivory carvers repeated endlessly. It should be remarked, in fact, that the triptychs in which scenes from the childhood of Jesus Christ appear are in reality dedicated to the Virgin, as is proven by the placement of her image at the center, larger than all that surrounds it. At other times, the Passion is found juxtaposed with scenes from the life of Our Lady in the same retable. Thus the ivories, like the great sculpture and

the windows, bear witness to the devotion that the Middle Ages had vowed to the Passion and to the Virgin; to the Redemption and to the Love that mitigates the Law. These works that never varied and of which the artists, no less than the faithful, never grew weary, are one of the most striking proofs of the depth of that twofold affection.

II

THE GOTHIC IVORIES do not seem to derive from the past, nor to carry on the traditions of the Carolingian ivories. A virtual eclipse of an art that went back to the Hellenistic Age occurred. In the twelfth century, workshops became so rare that one is scarcely able to point to any ivories from that period. The astonishing renaissance that took place in the time of Saint Louis was thus a veritable resurrection. Paradoxically, as a consequence of the degree of perfection of all the arts in the thirteenth century, the earliest ivories were the finest. The Coronation of the Virgin, the Descent from the Cross, and the Annunciation in the Louvre are masterpieces that were never equalled. One rediscovers in them the simplicity, the grandeur, and the emotion contained in architectural sculpture, and one is ready to admit that these truly classical works had their origin at Paris. These figures, which fall into groups, were no doubt derived from the great altar-pieces consecrated to the Virgin or to the Passion.

It was in the closing years of the thirteenth century that one saw appear those small diptychs, decorated with delicate superimposed bas-reliefs, that were to have such a long career. It is here that we are introduced to Koechlin's method and we may admire his expertise. All of those diptychs are the product of a single Paris workshop which Koechlin calls "the workshop of the Soissons diptych"; they are today scattered all across Europe, from Leningrad to Rome, from London to Berlin, from Lyon to Madrid. That they had their birth in one spot, that they are the work of artists laboring under the eye of the same master, cannot be questioned when one has followed his arguments. One finds here not only the same settings of arcade and pinnacle, but the same scenes of the Passion, arranged in four registers and treated in the same manner. Everywhere this art reveals the same noble simplicity; grief itself is restrained and finds its expression in dignified gestures. But that is not all. Koechlin gives us the history of that workshop; introduces us to its innovations. To satisfy the piety of the faithful, it increases the number of scenes, but at the expense of clarity; that is why it is not slow to add another leaf to its small retables, thereby transforming diptychs into triptychs. Soon it can be seen to make concessions to the new taste and to replace, little by little, antique nobility with elegance and charm. Details appear in that great drama of the Passion that suggest the idea of prettiness. It is the onset of decadence and gives notice of the imminent disappearance of a workshop that was, for a time, the most remarkable in Paris.

In Koechlin's book, rare and enigmatic works that once momentarily diverted the curious are now brought together, fixed within their proper time and back-

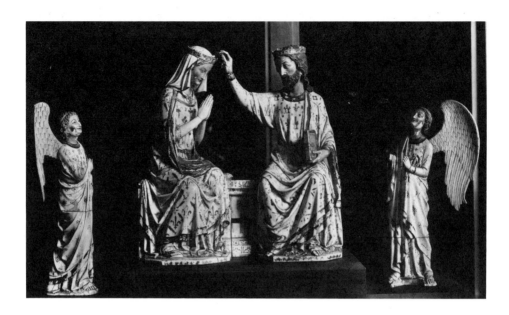

Coronation of the Virgin. Ivory, end of the 13th century. Paris: Louvre Museum.

ground, and reintroduced into history.

This is not the only studio that Koechlin has rediscovered; he has been able to reconstitute a number of others. He has restored to us several from the fourteenth century, notably the one which he calls "the workshop of the great diptychs of the Passion," which can be recognized by the pathos of its gestures. Here again, we find the same careful analysis, the same assurance in arriving at conclusions.

But the works do not always allow themselves to be brought together in that admirable unison which rejoices the spirit. How is one to classify, for example, those hundreds of Virgins, so often exquisite, which do not share enough characteristics to allow their assignment by workshops? Faced with so many pieces, each of which represents a puzzle to be solved, Koechlin must have felt dismayed, but his keen glance was not slow to detect revealing nuances. If it was not possible to identify the workshop, it was possible to recreate a chronology. Architectural sculpture, of which certain examples have been dated, served as a guide. The ivory Virgins of the thirteenth century, in fact, retain something of the majesty of the stone Virgins on the portals of the French cathedrals. The Virgin of Caen is among these. But soon she becomes a great lady, a sort of idealized queen of France, and at last that perfect example of aristocratic elegance which the Virgin of the Sainte-Chapelle, today in the Louvre, represents for us. It seems that a sophisticated court therefore imposes its tastes upon the artists. But these somewhat haughty Virgins were too remote from men's hearts; little by little, they were transformed into tender and attentive mothers who share in the play of their Child. The great lady becomes a charming young girl closely akin to the people. Her oval face becomes rounder and is lit by a smile; bending over her Son, she no

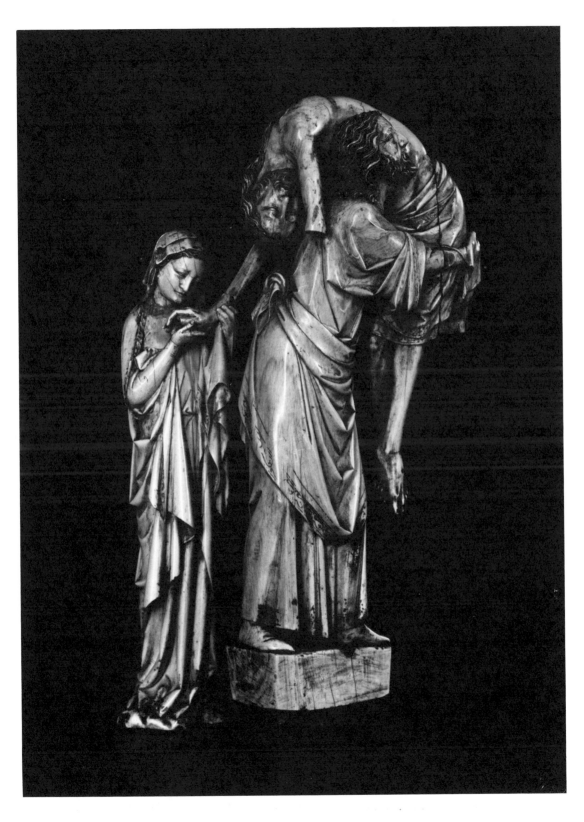

The Descent from the Cross. Ivory, end of the 13th century. Paris: Louvre Museum.

longer thinks of those who gaze upon her. Such is the gentle Virgin of Orléans. The drapery also changes; the mantle loses its fullness, becomes a sort of shawl, and is often gathered into a smock. All of these fine distinctions (some of which are apparent only to the eye of the most knowledgeable expert) have made it possible for Koechlin—if not to classify these Virgins by groups—to fix them in time, another method of introducing order into a situation that seems to allow of none. One cannot fail, in reading the two chapters that he has devoted to those ivory Virgins, to be struck by the purity of his taste. He has developed some fundamental principles, which he nowhere reveals but of which one is always conscious, and these constitute the authority for his judgements. The study of the great sculpture of the thirteenth century made plain to him a perfection in which he recognized the highest expression of the French genius. The nobility of those statues, where greatness is achieved through sacrifice, is always present in his thought. It is that truly classic art, where clarity and restraint are supreme, where there is neither an exaggerated gesture nor a superfluous pleat, which has formed his taste and stamped his opinions. They are often severe, for he is not one of those authors who inflates the subject he is examining. A drapery may well be elegantly gathered up, but if it is functionally illogical, he condemns it. The delicious Virgin of Villeneuve-lès-Avignon, which once we found enchanting, seems to him not without faults for all its charm, and we are obliged to recognize that he is correct.

One of the truths that emerges from Koechlin's book is that the ivory carvers were not original. Their style follows that of their times. They faithfully imitated all the techniques of monumental art, always with the reservation that they remained attached to those longer than did the sculptors themselves. They changed their style only with extreme reluctance, which accounts for the difficulty of drawing up an accurate chronology of their work. Nor was their iconography any more original than their style. Some of the idiosyncrasies that one notices there are explained by the necessity under which the artist sometimes worked to consolidate the action. If the angel of the Annunciation appeared in the heavens, it was because there was no room for it on the earth. There nevertheless exist some rather curious departures which seem to derive from originals that we no longer possess or have not yet identified. The great retables of stone—almost all destroyed today—may have served as models for the little retables in ivory. But the miniature seems to have been the usual source for the artists' inspiration. It became a sort of unwritten law. We know that the Carolingian ivories were adapted from contemporary miniatures, and imitated these with so much accuracy that those ivories can be classified according to the great schools of painting they reflect. Koechlin has pointed out analogies of this kind many times. There are actual conformities between the diptychs of the Soissons group and the miniatures in the manuscripts illuminated for Saint Louis. The *corpus* of our French ivories will make it possible to compare them with the manuscripts of their day and it may be that we will discover some of our artists' originals. It is such a certainty that the ivory carvers were not innovators, that in the fifteenth century

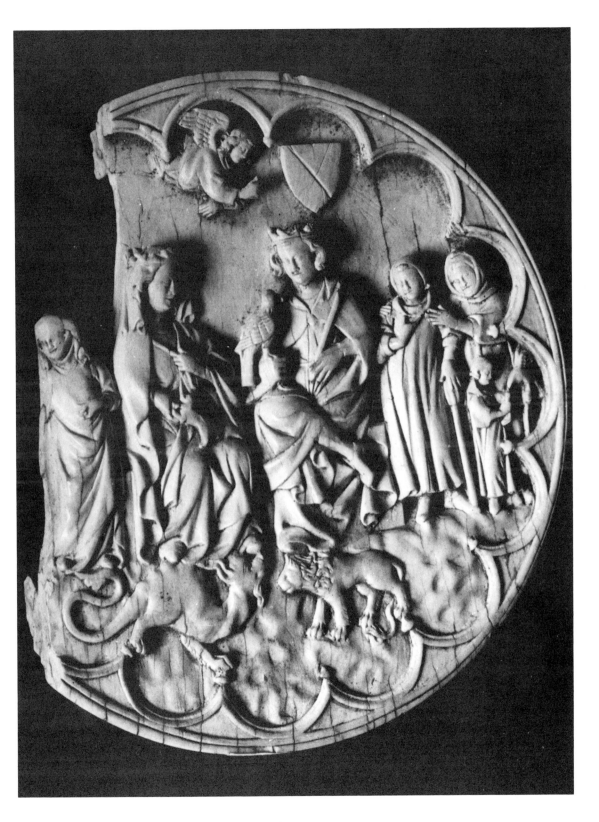

The Assembly. Mirror cover in ivory, 14th century. Paris, Cluny Museum.

we see them copy engravings.

This practice of imitation does not lessen the importance, in our eyes, of the French ivories. On the contrary, in them we may find all the traditions of Christian art and Christian thought, carefully observed. From this springs the sense of greatness that these small figures often express.

III

THE SECULAR IVORIES do not have the exalted beauty of the religious ivories, but they possess a different sort of charm; they introduce us to the world of romance. The mirror cases and the coffers were intended primarily for women. They wore the mirrors hanging at their girdles by a silver cord and kept their jewels in the coffers. According to a poet of the time, these were the gifts that a wife expected from her husband when he returned from a journey to Paris. The artist who carved these charming little masterpieces seems to have had the lady of the castle much more in mind than the lord. Thus, the ivory boxes were decorated with subjects taken from romances. There, the ladies could without difficulty recognize episodes from their books: Tristan and Iseult spied upon by King Mark; Gawain on the enchanted bed; Thisbe fleeing from the lion and letting her veil fall; the chatelaine of Vergi sending her little dog as a messenger to her lover, and other scenes of the same kind that have not yet given up all their secrets. Sometimes it is an allegory that is depicted, easy to interpret: the god of love, high in a tree, threatens a couple with his arrows; ladies defend with flowers a castle besieged by knights; old men, rejuvenated by the Fountain of Youth, begin to love again. The artist had but one idea: to celebrate the sweetness of love. It is, indeed, significant that he took his subjects not from the heroic matter of Charlemagne but from the matter of Brittany, all suffused with tenderness.

Some subjects do not seem to have been taken from literature, and these are among the most charming. On the mirror cases, one often sees a series of scenes between two persons: a young man is conversing with a young girl; he plays chess with her; he takes the kiss that is offered. Sometimes one sees them both on horseback, clinging together as they ride through the forest. But at other times the young man kneels to receive a crown of flowers, or he places his two hands between the hands of the young girl, as the vassal does between the hands of his lord—a gesture symbolic of the man who renders homage. All this is portrayed with a light gracefulness that is a little sensual, and not otherwise did the poets of the thirteenth century celebrate love. But at times it would seem that love lifts itself higher. An unusual writing-tablet in the museum at Chartres portrays, on one side, the young girl offering a crown to the young man and, on the other, the Virgin between two angels. Here earthly love, purifying itself, seems to lead man toward the love that is divine.

These charming groups are of vital interest to history, for here one surprises secular art at its source. This new manner of art was born in Paris in the second half of the thirteenth century. French ivories taught all the artists of Europe how to

represent reality, but with a bloom of poetry on it. The Italian painters of the fourteenth century did not admire those pretty mirror cases to no advantage. There is in the Cluny Museum one of these round boxes on which two seated figures can be seen: a lady with her little dog on her lap and a knight with his falcon upon his fist. A double writing-tablet in the same museum shows us, near some young girls reposing beneath the trees, a young female musician seated by a male musician who plays, as she does, upon the lute. How can one not recall the Triumph of Death in the Campo Santo at Pisa, where all of these figures reappear?

Koechlin's book will beyond any doubt make many more comparisons of this kind possible. In increasing our knowledge, he enlarges our horizons; we thus cannot thank him too much for having devoted so many years to his task. In his preface he speaks, with a certain sadness, of those past years in which he was not able to attempt the other books that he had dreamed of writing. Let him be consoled, for the one that he has written will endure.

This book consists of a collection of articles published by Émile Mâle between the years 1897 and 1927. The first edition appeared in 1927; the fourth, in 1947. It was prepared for publication at that time by Émile Mâle himself.

Since this edition went out of print, we felt called upon to bring out a fifth, given the caliber of this work by one of France's greatest art historians.

The text is identical with that of the 1947 edition with the exception of one chapter, dealing with O'Reilly's book on the cathedrals of France, which was left out as being of limited relevance.

Apart from one important illustration added, no new material has been introduced in this area. All of the photographs included are of works of art directly cited by Émile Mâle.

This book represents, in its different chapters, the state of the subject as it existed in 1947. Therefore the reader should not be surprised by remarks that, while they were appropriate in 1947, are no longer applicable today.

If the factual material has been since supplemented, the interest of Émile Mâle's insight, his methods, and his creative thought survives.

One chapter of this book will have special significance for the reader who might not have read Émile Mâle's great books on the religious art of France: a major work that at once became a classic in the history of medieval art, a creative vision burnished by the author himself.

In other chapters, Émile Mâle recounts his discoveries. They in themselves have become such classics that one even forgets that such a discovery took place (Arab Spain, the mosque at Cordoba . . .).

1968 —*Gilberte Mâle*